THE ART OF
RESISTANCE

THE ART OF RESISTANCE

❧ • • • • • • • • • ❧

My Four Years in

the French Underground

A MEMOIR

❧ • • • • • • • • • ❧

JUSTUS ROSENBERG

wm

WILLIAM MORROW

An Imprint of HarperCollins*Publishers*

Map of Europe, 1936–1939 and map of Western Europe, 1940: Courtesy of the Department of History, U.S. Military Academy at West Point
The spelling of "Grenoble," "Briancon," and "Koblenz" was corrected on the map of Western Europe, 1940.
Map of Occupied France: Courtesy of Wikimedia
Photos courtesy of the author unless otherwise noted

HarperCollins books may be purchased for educational, business, or sales promotional use. For information, please email the Special Markets Department at SPsales@harpercollins.com.

FIRST EDITION

Library of Congress Cataloging-in-Publication Data has been applied for.

ISBN 978-0-06-274219-3 (hardcover)
ISBN 978-0-06-299605-3 (international edition)

20 21 22 23 24 LSC 10 9 8 7 6 5 4 3 2 1

I dedicate this book to my wife, Karin Kraft, for her kind forbearance and intelligent feedback at every stage of the writing. She has literally kept me alive through these, my "post-senescent years"—and made it possible for me to write my memoirs.

CONTENTS

Part III

EUROPE, 1936–1939

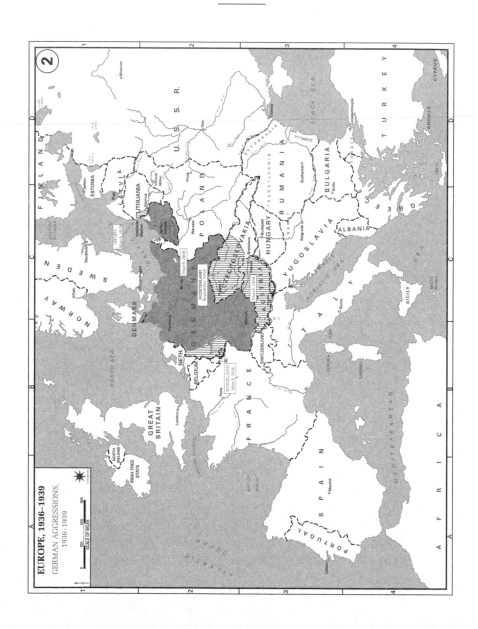

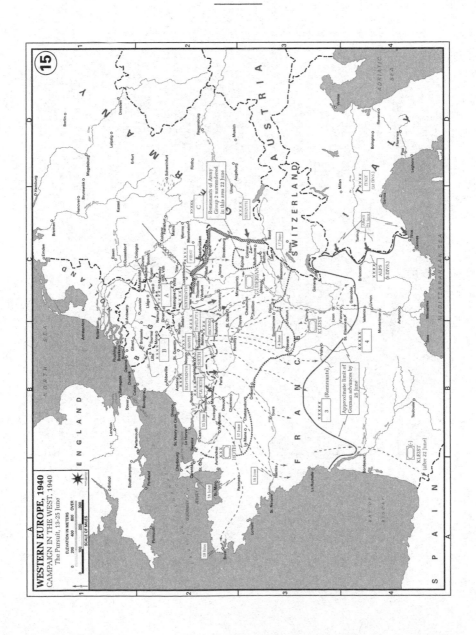

WESTERN EUROPE, 1940
CAMPAIGN IN THE WEST, 1940
The Pursuit, 13–25 June

OCCUPIED FRANCE

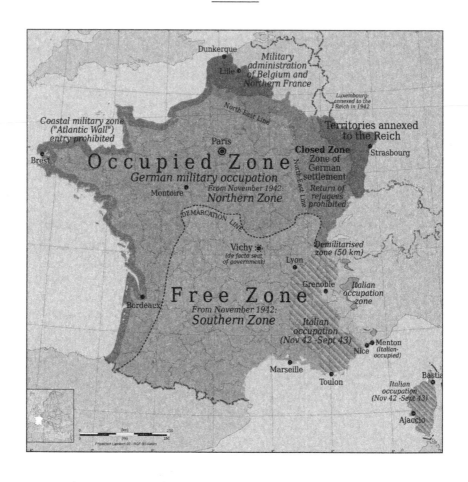

Parfois l'hazard fait bien les choses.
Sometimes chance itself occasions good fortune.

THE ART OF RESISTANCE

PROLOGUE

————

THE STREET CLOTHES placed behind the laundry pail in an unobtrusive corner of the hospital lavatory were right where they were supposed to be. I had managed to fake my way out of the Nazi internment camp by feigning agonizing stomach pains, but the last thing I expected was to have an appendectomy actually performed on my gut. The gash in my abdomen was far from healed, but I'd walked to the bathroom at the appointed moment and now, if I could slip into the clothes the Underground operative (disguised as a priest) had left for me, and if I could sashay out of the hospital without raising suspicions, the only thing I had to worry about was riding a bicycle to the halfway house in Lyon, without my intestines spilling onto the boulevard! I made it down the broad hospital stairway and out the heavy lobby doors, and the bicycle was parked by a bench just as planned. Gingerly I mounted the saddle and coasted down the long driveway to the main road, where, standing all the while with one hand on my stomach, I would hopefully pedal my way to freedom. Automobiles whizzed by me, the late summer breeze tousled my hair, but suddenly the whining crescendo of what I thought must be a police siren loomed up behind me. Had I been betrayed? Was I after all about to be sent back to the camp and from there to Auschwitz?

Part I

THE FREE CITY OF DANZIG

1921–1937

AS I WRITE this memoir, I am almost one hundred years old—ninety-eight to be exact. The first two years of my life are the hardest to remember. Whenever I try, I hear my parents' voices, see the contours of their faces, feel the softness of my crib. Everything else I know of my first years I picked up from stories my parents told friends and relatives about their smart son's first steps and words.

The only objective evidence of my early existence are two photos of an infant sitting on a bear rug, and a birth certificate issued by the Danzig registration office stating that on January 23, 1921, a boy named Justus Rosenberg was born to nineteen-year-old Bluma Solarski, wife of businessman Jacob Rosenberg, age twenty-three, both of the Mosaic faith, as Jewish people were commonly referred to at that time.

Unless you are a stamp collector or interested in the two world wars and the period between them, you've probably never heard of Danzig, a seaport on the Baltic, for generations a bone of contention between Germans and Poles. At the Versailles peace conference after World War I, to reward the Poles for having supported the Allies, the League of Nations decided to grant Poland the independence it had lost in 1796, when it

was partitioned between Prussia, Russia, and the Austro-Hungarian Empire. Per the Treaty of Versailles, Danzig was to be part of Poland, even though 75 percent of its population was ethnically and culturally German.

Then, to the dissatisfaction of both the Poles and the Germans, on November 15, 1920, the League of Nations declared the disputed territory to be a semiautonomous city-state with its own flag, national anthem, currency, and a constitution patterned after the Weimar Republic. It was to be called "the Free City of Danzig" and to consist of the seaport itself and some two hundred towns and villages in the surrounding area. The League appointed a neutral high commissioner to the infant parliamentary democracy to ensure that the rights of the 20 percent of the population who were Poles and 5 percent who were Jews would be respected. As the name suggested, the Free City had no entrance restrictions. Between 1920 and 1925, in the midst of continuing European political unrest, ninety thousand Jews from Poland and Russia passed through Danzig en route to Canada and the United States. Another six thousand, satisfied with the city-state's parliamentary democracy and liberal economic policies, or who identified with German culture, chose to remain. My parents, who had no intention of emigrating to America, were among these.

They had come from Mlawa, a Polish *shtetl* only a few miles from East Prussia, so they spoke German fluently and were familiar with German literature and music. Like most young people of their generation they knew hardly anything of Yiddish culture besides the language itself. My mother,

the daughter of a tailor, and my father, born into one of the wealthiest and most learned Jewish families in Mlawa, fell in love when they were very young, and my father had just begun to work in *his* father's business. Marriage was out of the question because they belonged to different social classes, so they eloped—to Danzig—and sought to become assimilated into German culture as quickly as possible. Immediately after my birth—which came not long after their elopement—they hired a nanny named Grete, who taught me traditional German children's ditties, German fairy tales, and the rhymed verses of *Struwwelpeter* and *Max and Moritz*. At age six I entered the *Volksschule* (primary school). I already knew how to read and write both German and Gothic script.

For all practical purposes, I was educated like a typical German child—as was my sister, Lilian, six years my junior. Our parents rarely spoke Yiddish in our presence except when they were discussing something not meant for our ears. Somehow, I picked it up anyway. They celebrated Jewish holidays irregularly and only occasionally attended services at a "reformed" synagogue. Like most Jews in Germany, my parents considered themselves Germans "of the Mosaic persuasion." They rejected political Zionism, which regarded Judaism as a nation. When I was ten years old, my mother enrolled me at the most prestigious gymnasium in Danzig, the Staatliche Oberrealschule. As was true of many young people in those years, the world of politics fascinated me. At the age of nine, I already dreamed of becoming a diplomat.

In the Danzig elections of 1932, the Nationalsozialistische

Deutsche Arbeiterpartei (Nazis, for short) won the largest number of seats in the Volkskammer (people's chamber), the legislative assembly. That gave them the right to appoint the "senate" (the executive branch), which until then had consisted of a coalition of liberal democrats, socialists, and moderate conservatives. However, the special nature of the Free City of Danzig, with its role as an international port and financial center, made the Danzig Nazis put a moderate face on their policies and ideology in spite of their victory, and this remained the case for the next five years.

There were, of course, pupils in my class who came to school dressed in Hitler Youth uniforms, but they rarely ostracized me or voiced their displeasure that I, a Jew, was always picked to recite (because of my perfect German diction) the ballads of Schiller or poems by Goethe and other classical poets; nor did they object to my being chosen for the school's *Schlagball* team (a German form of baseball). The teachers remained strictly professional. For instance, even after 1932, I was the history teacher's prize student. I also must have been the favorite of the director of the gymnasium choir, for he recommended me to participate in the all-boy angel-chorus of Bach's *St. Matthew Passion*, at St. Mary's Church in town. Thanks to him, I was also selected to sing in the children's chorus of Bizet's *Carmen* at the Danzig City Theater, a theater traditionally subsidized by the municipality that continued to be so under the Nazi government.

I owed my love of singing to my father. As soon as he came home from his office, he would sit down at our old upright pi-

ano, play and sing (by ear) popular arias from Italian operas, and invite me to join him, which I enjoyed doing until I developed a taste of my own in music.

One afternoon when I was about fourteen, I heard the "Liebestod" (love-death) aria from Richard Wagner's *Tristan and Isolde* on the radio and fell in love with it on first hearing. For reasons I didn't then understand, Wagner was anathema to my father and certainly not in his repertory. One summer's day in 1936, when I was fifteen, my parents planned to stay out late, while *I* planned to take the suburban train to Zoppot and attend whatever was being performed that night at their annual summer, open-air, Wagnerian opera festival. It was *Rienzi*. Since I had no money for a ticket, I managed to get through a hole in the wire fence that surrounded the place and find an elevated spot with an unimpeded view of the stage. I was also close enough to hear all the subtle harmonies of Wagner's music. Two years later, I learned that Wagner had been one of the most virulent anti-Semites of the nineteenth century and was Hitler's favorite composer.

THOUGH MY FATHER'S father had not aided him financially after his elopement with my mother, once I was born, tensions eased between them, and my grandfather's lucrative international business trading in grain was now supporting his son. My father owned a storage facility in town from which he fulfilled wholesale orders. It was on the ground floor of a three-story apartment in a pleasant Danzig neighborhood. A business office and the storage facility opened onto the street. We lived

upstairs. Other Jewish businesses flourished in close proximity. Two doors down, for instance, was Levi's clothing store. This was very convenient for my father and perhaps gave him a false sense of security.

A POGROM GERMAN-STYLE

Spring 1937

EARLY IN 1937, Nazi demonstrators began targeting Jewish businesses in Danzig. My father refused to take them too seriously. He didn't believe they represented a change in official policy. They were disturbing, of course, for they reminded him of the spontaneous outbursts against the Jews common since the early Middle Ages. In the familiar pattern, anti-Semitic feelings would manifest for a few months and then die down.

Under the Nazis, however, the character of anti-Semitism was changing. Outbreaks of hatred against the Jews would neither be sporadic nor temporary. One beautiful spring day in 1937, I stopped at the window of a bookstore to look at the colorful covers on display. Suddenly my attention was attracted by shouting so loud and so close that it made the windowpane tremble. I tore myself away and headed in the direction of the noise. It was the sound of a group of Nazis chanting slogans and a crowd of onlookers walking along with them. I turned at the end of the block and saw at least thirty people—young and

old—howling *"Judas verrecke!"* ("Let the Jews be slaughtered!"). I wanted to go and warn my parents, but I was curious to see what the Nazis would do. They were not in uniform, and they weren't alone: a crowd of bystanders in the middle of the street moved slowly along with them. The Nazis themselves were moving slowly, making funny movements with their heads, to the right, then to the left, to take in everything that was happening around them as they marched. The mob beside them kept growing. Soon I really did want to get away and warn my parents, but I was now in the midst of them. I couldn't move too quickly or I would appear to be abandoning the scene. I kept thinking, confusedly, wishfully, that perhaps they'd just disperse. I remembered my father's words: "Bah! They'll get over it; a few months from now everything will settle down." But things were not about to settle down. These Nazis were getting wilder and wilder, their cries of "Death to the Jews" more and more virulent.

Now I myself was being pushed forward. When would the police show up and prevent them from doing something violent? But the police were nowhere to be seen.

The crowd was being squeezed closer and closer together. The Nazi agitators had reached Steiner's grocery store, whose attractive shop front had been repainted the previous winter. The display window and the store's clean, modern interior struck me as strangely out of place in this ominous tumult. I saw several of the Nazis holding bricks in their hands, others brandishing truncheons or carrying buckets of paint.

It happened like a bolt of lightning: a crash of broken glass,

and Steiner's shop window was smashed into shards. The men weren't shouting anymore; they seemed to be in rapture over their fine work. The crowd remained silent, too, though the hiatus in the uproar didn't last very long. Steiner came out of his store, his big blue apron hanging over his big belly. The children in the neighborhood were accustomed to making fun of him, and he'd often come out of the store, just like that, to chase them away. Now he looked stunned, surprised, like someone who had been slapped without his knowing why, as if by mistake. He stepped toward the Nazis, his hands out in front of him—begging for mercy? to protect himself? to show peaceful intentions? to reason with them? Suddenly he brought his hands to his face. Someone had thrown something at him and struck him. He stumbled backward, his hands covered with blood, his body careening. Then, with a quick motion, he turned and ran toward a large door at the back of his store. Everyone was surprised to see him escape so deftly, since they had the impression his big bulk was about to collapse on the pavement. He had left his store wide open, but behind the big oak door he seemed to be safe. I let out a sigh of relief.

There was a moment of indecision among the Nazis, and again I had the wishful thought that they would be satisfied. I was wrong. They started shouting again and some of them tore into the store. Cans of food came rolling into the street— sardines and fruit preserves—and they were pushing over pickle barrels, barrels of herring, and wooden crates of smoked sprats. I saw one Nazi pour a big can of oil onto the sidewalk. Some of them were attacking cupboards and shelves. I could

hear, coming from inside, the noises of bottles clanking and various nondescript muffled sounds. The Nazis came out of the store one by one and eyed the crowd, each one sure of his strength. They were happy with themselves.

Then one of them noticed Mr. Klein, the tailor, standing next door in front of his shop, hurriedly attempting to close the shutters. The Nazis turned toward him. They seemed to be blaming him for Steiner's hasty retreat. Mr. Klein was a small man who always dressed sharply, as was appropriate for a tailor. But he had left his jacket inside, and in his suspenders he looked even more diminutive than usual.

"What's the rush, Dad?" said one of the Nazis, and the others burst out laughing. Before he could answer, another struck him in the face, first a slap, then blows with his fist, harder and harder, until the little man collapsed half unconscious; another kicked him again and again in the ribs, shouting, "Look! This is the way to treat a dirty Jew!" Someone corrected, "Not at all! He deserves the noose!" Mr. Klein wasn't moving.

Someone kept shouting that the Jews were a plague—the land had to be rid of this vermin. Some others were demolishing everything in the tailor's shop. Now the crowd was actively joining the Nazis. I was getting seriously worried about my parents and wanted to tear myself away. My father was probably downstairs in the storage facility. I feared the crowd would soon proceed to our street. On my right, I saw a small gap in the throng; I used my elbows and shoulders to make my way through to it. Too bad if they noticed my defection. I'd chance it. I kept moving in the opposite direction of the crowd, trying

to look natural, as if I had something to do, despite the "interesting" goings-on here. Little by little I was getting free.

Within a few minutes, I had broken clear and was heading in the direction of my home, perhaps two hundred yards away. I didn't look back but could hear behind me the sound of metal shutters rolling shut. The crowd was somewhat behind me now. I stopped to catch my breath and took a seat on a wall from which I could observe what was going on.

They were in front of Goldberg's, a clothing store. The shop was protected by shutters, but some Nazis had found a big iron bar, actually a small girder, with which they were rushing at the store using it as a battering ram. The metal sheets made a noise on the girder's impact like thunder. The window posts of the shop broke from the force, but the shutters held. The thugs dropped the girder in the middle of the street and tried in a concerted effort to force up the shutters manually. "*Eins, zwei, drei, heben!* (heave!) *Eins, zwei, drei, hoch!*" It still held. They tried again. The bolt gave way—slightly. The shutters lifted enough for a few of them to squeeze in underneath them. The crowd roared a cry of victory.

From inside, a woman's scream, long and high. They pulled up the shutters a bit more and out rolled Goldberg, the crowd dragging and kicking him onto the sidewalk. He raised himself on all fours—the kicking went on. He scurried along the sidewalk in agony as three booted Nazis went at him relentlessly.

More shouts and groans, from inside now. Two Nazis emerged from under the shutter, dragging Frau Goldberg by the hair and by her arm.

I saw all this from my perch as clear as can be, but it was as if I didn't understand what I was seeing. In films, there were images of violence a bit like it, but they were just films, unreal. Outside the theater everything would be normal again. The Nazis let Frau Goldberg stand up. Her clothes were torn, her face brutally battered, one black eye and eyelid terribly swollen.

I had always thought of Frau Goldberg as a beautiful woman, so beautiful that when I passed her on the street, I slowed down to look at her; when I approached the store, I tarried in hopes that she would be there and that I would see her long, blond hair and her large, soft blue eyes. What I was looking at now wasn't possible. And yet it was she. I was filled with rage and fear. I wanted to strike out, to smash my fists against the wall, but all I could do was stay quiet, gnash my teeth, and say nothing.

I came down from my perch. I shouldn't have stayed there. I shouldn't have seen what I saw. I began to run. How could this street, this street that I crossed every day and that had always been so peaceful . . . It wasn't real; it wasn't real; it wasn't possible. But I had seen it with my own eyes. It was the truth. I didn't need to turn around again to see. I didn't understand. That was all. These people weren't human beings; this street, this city, was not my city. I saw Frau Goldberg's face again, the beautiful one, at first, and then the other . . . I was ashamed.

I was out of breath by the time I reached my father's storage facility. I couldn't speak. He had just finished talking to a prospective buyer. I told him what I had just seen, spurting out everything at once, trembling with anger and fear. My father, placid as he always was, didn't seem surprised by my story,

as if it was all just part of the occurrences of life—but he *was* disturbed by my agitation.

"Calm down, calm down. Yes, I just heard about it. You shouldn't be upset, that's what they want probably. They'll end up quieting down. Anyway, what do you want us to do? Come now, everything will subside. These people are just louts. They're not the ones to be afraid of. It's the Nazi politicians who let others act like that that frighten me. Anyway, we'll see. It's just a bad time we have to get through, a crisis."

Nothing I said upset his placidity. My father thought the wave of violence wouldn't reach him. I was exaggerating, my imagination was playing tricks on me. "Let's wait a little," he said, "let's give ourselves some time." But I knew it wasn't my imagination, and that we didn't *have* time.

"Please, Dad, close up shop. I'm sure they're coming this way. When I left them, they were at the Goldbergs'."

My father was surprised to see me so upset. He put his arm around my shoulders and spoke to me gently.

"Come, come. Don't work yourself up into a state." But he saw that there was something really wrong. I remember his exact words. "You're pale as death. I'll close up, I'll close up, since you're taking it so tragically."

He went out to lower *our* shutters and I sat down on a sack of grain. I watched the metal panels come down one after the other as darkness filled the room. In the coolness of this half-light, I felt protected.

I could hear my father out on the street latching the three big padlocks. *This time*, I thought, *it's really over*. We were safe.

My father reentered the building through the back door, and it was he, now, who seemed agitated. He had heard the sound of boots on the pavement. Either they had made it all the way to our street or it was a second group, like another wave.

"Good Lord! You were right! They're here, a whole mass of them!"

We could hear shouts, the same ones as before. They must have been attacking the first shop on the corner, the bookstore. My father said we should go upstairs, that we'd be okay there.

"From the window, we'll be able to see what's happening."

My mother was coming down the stairs to meet us.

"You locked up? You did well!" she said, visibly relieved.

"I might not have done anything, but Justus was so insistent . . ." Then he changed his tone and lowered his voice and said to my mother, "He was there. Justus saw everything. Not nice to see. What bastards."

As we reached our landing on the third floor, we heard muffled blows from not too far away.

"They're at the Levis' now," my father said. "That's very close!"

There was only one store between the Levis' and our facility.

Down below we could hear the blows, redoubled in violence. My father had gone over to the window and opened the shutters carefully. He leaned a little outside, then pulled back in quickly. "They're here."

My mother had let herself fall into a chair and had begun quietly crying.

Below, they were working a girder like the one they used at

the Goldbergs', slamming into the shuttered door rhythmically with increasing violence. The window collapsed—we could hear the glass shattering. My father went over to the sink and poured himself a large glass of water and drank it in one gulp. He went to the window again, standing on tiptoe to see without having to lean too far out. Through the open window we could hear everything—the insults, the shouts—except when the battering ram struck the shutters and shook the building, about every five or six seconds.

"The shutters must be holding. Maybe they'll give up," my father said in a whisper, turning toward us.

One of the demonstrators must have seen him at the window, because they stopped hammering at the shutters and began insulting my father. He stood to the right of the window where he couldn't be seen but could keep observing the street. Some of the Nazis had gathered stones and were trying to hit our window with them, but by the time the missiles reached the third floor, they didn't have enough velocity to do much damage. This seemed to tire them out. I thought that they'd start attacking the hall door downstairs again and expected to hear the blows of the battering ram in the hallway. On the other hand, perhaps they'd refrain from invading the building. We in fact were the only Jewish tenants, but did they know that?

I was right about their either being tired or becoming circumspect about the house not being fully infested with Jews. The battering ram did not begin again. They just shouted, "Jewish garbage! You just wait! We'll be back, we'll burn down your

hovel! Vermin! Dirty Jew! Come downstairs if you have any balls! Hang all the Jews!"

Little by little, they rejoined their comrades, who were already shaking the shutters of a neighboring store. A few citizens had joined them and most of the crowd, behind, still just as curious, followed without saying a word, as before. My father closed the window and with a weary gesture wiped away the sweat from his face.

"Well, my children, it's over for today."

THE DAY AFTER these events, the Danzig government took the position that it opposed such acts of violence, even though, of course, it had not deployed police to do anything about what happened the day before.

As a matter of fact, the Nazi president of the Danzig senate assured the Jewish community that physical assaults against the Jews and the destruction of their businesses were breaches of "party discipline." Nevertheless, my father was no longer so optimistic that the anti-Semitism was just normal, periodically awakened, eastern European behavior. He and my mother now felt that it was only a matter of time before things would get much worse. They began to consider sending me away from Danzig to continue my studies once I passed my final exams at the gymnasium.

In the days that followed, the political climate indeed became more and more turbulent. Personal relationships between German Jews and other Germans began to be affected. Elisabeth, a close friend of my mother, had a brother who was now in

the SS. He admonished her not to associate with us. Elisabeth ignored him, for my mother's friendship meant more to her than her brother's party affiliation. In Germany, Jews could no longer occupy public offices, marry, or have intimate relations with Germans. They had been forced to resign professorships, and Jewish doctors were only allowed to treat Jewish patients. Anti-Semitism was becoming more and more blatant. But in Danzig all this had been nothing more than a rumor about what was happening in Germany. Now blatant anti-Semitism was more and more frequently striking home.

ELISABETH WAS TO become a person important not only to my mother but to me. In fact, if the violence I had witnessed constituted a kind of initiation into the darkest aspect of adult reality, I was soon to experience with her an initiation of a far more pleasant sort. One afternoon I arrived home from school earlier than usual and heard her and my mother talking and giggling in my parents' bedroom, trying on new dresses. The bedroom door was open, and I caught a glimpse of Elisabeth standing in front of a full-length mirror with nothing on but her bra, laced panties, and silk stockings. The sight made me yearn for something I certainly didn't imagine was possible. Elisabeth, at twenty-six, was ten years younger than my mother and ten years older than I. She caught my libidinous gaze and answered it with a flirtatious smile. My mother must have seen my glance but not Elisabeth's response and immediately ordered me to my room. From then on Elisabeth's body inhabited my dreams. My days were spent preparing for final exams at the gymnasium,

so I could not afford to be completely occupied with erotic reveries, but she was never very far from my thoughts.

One early spring Friday, home alone studying late in the afternoon, I heard a soft knock at the front door. When I opened it, before me stood the very woman who was already present to me between more studious attentions. After a moment's hesitation, she asked, "Isn't your mother home? We were supposed to go to a movie together this evening."

"Oh," I said. "She must have forgotten to tell you. She and my father have gone to Sweden for the weekend."

"Too bad," she said. "Today is the last showing of *The Blue Angel* with Emil Jannings and Marlene Dietrich." She paused and looked at me smiling. "Didn't you tell me you read Heinrich Mann's novel *Professor Unrat*—the film is based on it. How about coming to see it with me?"

"I would love to." The words were out of my mouth before I had a second to think about them.

On the way to the theater, we spoke about nothing very consequential, but I was quietly summoning personal qualities I had no inkling I possessed. At the box office, I nobly offered to pay for the tickets (actually with money my parents had left me to purchase my meals). Elisabeth didn't stop me. She was watching me closely and seemed impressed with how confidently this adolescent was dealing with the transaction, as well as with the subtle interpersonal intricacies of such an excursion. In the theater we sat close, mere inches apart, as the show began.

Short reels of comedic sketches and cartoons preceded the main feature. When the screen lit up, I let my eyes drift toward

her, just catching her profile. She had high cheekbones; the lines of her face drew to a perfect, narrow chin, ruby red lips darkly accented in the low light, bosom slightly exposed, not carefully or modestly hidden. Marlene Dietrich was amazing to behold, but I was accompanying a woman, who, in the flesh, was more amazing than any beauty on the screen. The tragic obsession of the aging professor in the film was fascinating, but far less so than the object of my awakening passion. My longing for Elisabeth could not possibly be masked, though even I was sophisticated enough to understand the advantages of coyness.

After the movie, she walked me back home. To bid me good-bye, she kissed me on my cheeks, but my lips sought hers and I briefly pressed my body against her, just long enough for her to feel the force of my excitement. She did not pull away.

"Have you ever tried?" she whispered.

"Not yet," I replied.

"Would you like to?"

I was trembling all over as we got to the couch in the living room. I fumbled to get my trousers down. To shorten the agony of excitement, Elisabeth immediately instructed me how to proceed, gently guided me into her, and fully participated, enjoying it as much as I. From then on we got together, if possible, at least twice a week, until I left for Paris six months later. The motivation driving our behavior I do not consider immoral. It never even felt socially incorrect, though it might indeed have seemed to be so, given the sexual mores of the time. My mother suspected nothing. The idea that her best friend, in the bloom of womanhood, could be turned on by a teenage boy,

never crossed her mind. Nor did Elisabeth's attitude toward my mother change; and they both were very proud of me when I passed my final exams with excellent grades.

PREPARING TO LEAVE DANZIG

Summer 1937

M Y PARENTS—WITH MY enthusiastic approval—had decided that indeed I should continue my studies outside of Danzig. I would move to Paris.

The day after I was notified that I had passed, I walked to the Consulate General of France to apply for a visa. My parents picked that country because my father had a business correspondent there (a Monsieur Berger) who would keep an eye on me; furthermore, France possessed the best educational system in Europe and the most liberal policy regarding the admission of refugees. The consulate's neighborhood was very familiar to me. I often strolled through the area to admire its patrician mansions. Some of them dated back many centuries. Affluent shipowners had commissioned Dutch architects to design beautiful and imposing, half-timbered corbeling homes. Whenever I was in that neighborhood, I took the time to saunter from one street to another to appreciate their houses with finely wrought gables and old windows made with rosettes. But today it was different. All I wanted to do was to reach the consulate

as quickly as possible. As soon as I saw the flagpole affixed to the first-floor balcony of the fifteenth-century house in which it was located, I knew I was in the right place. A large brass plaque over the entrance read "Consulate General of France." I pushed open the heavy doors. It was pleasantly cool inside and the parquet floor, covered by a large brown rug, felt soft under my shoes. I liked France already. Somewhere upstairs I could hear the noise of a typewriter, which stopped suddenly. A secretary came down, asking if he could be of assistance. "Yes, sir. I am here to apply for a visa."

"Please go upstairs to room twelve." He was very polite and articulate, gesturing to the upper floor as he spoke. "Take a seat in the anteroom until you are called into the office of the consul."

In the middle of the anteroom stood a low table laden with journals, magazines, and newspapers. I sat down on a leather armchair and picked up a fashion magazine. Leafing through it, I found models confirming my dreams of French girls. On the wall, paintings showed French landscapes, and advertising posters invited tourists to French resorts and attractions.

After about fifteen minutes, I was called into the main office. Above the mantelpiece hung the portrait of an elderly gentleman who wore a tricolor sash across his chest. The consul, a man in his thirties sporting a mustache just like the person in the portrait, asked me for my passport and told me to sit down in front of his desk. "How long do you plan to stay in France?" He spoke in accent-free German.

"For at least two years," I replied.

"What is the purpose of your visit?"

"To study French literature and history." This was only partly true. I had not fully decided upon a course of study, but a friend of mine who had already gotten a visa advised me to give that answer in order to flatter French culture.

"Who is to pay for your room and board?"

"My father has made the necessary financial arrangements with his French business associate."

"Would you please fill out these two forms in duplicate." I was to return them with identity photographs, an extract from my legal record, and a statement of permission from my parents. They would issue a visa within three days.

THE VISAS WERE provided without any further difficulties and we began making plans for my departure for France, to take place early in September 1937. In the meantime my parents thought that before immersing myself in another culture, I ought to spend some time with my paternal grandfather whom I had never met. A trip to visit him was for two reasons: out of respect for him (after all, I was his oldest grandson), but also because it would not hurt me to become acquainted with my own religious, cultural, and ethnic background before being seduced by French culture on top of the German one to which I already fully belonged. Toward the end of July in 1937 I took a train to Mlawa, Poland, the Polish shtetl where my grandfather lived as a prosperous grain merchant with his daughter, my aunt Leah, and her husband, in a large stone house at the center of town.

My grandfather was sixty-seven and a widower. His wife,

my grandmother, had died a few years before. Leah's husband, Moishe Cytryn, was in business with my grandfather. Leah was running both households, a somewhat onerous task considering the dietary requirements of Judaism.

The train ride from Danzig to Mlawa took three hours. It passed through the "Corridor"—the tract of land belonging to Poland that separated East Prussia from Germany. I arrived at my grandfather's house at 11:00 A.M. on a misty Friday morning. Aunt Leah greeted me warmly, told me my grandfather was not at home but that he would be back not too late in the afternoon. My parents had been anxious that I arrive fairly early in the day, because Orthodox Jewish families generally prepared their homes for the Sabbath, which begins at sundown on Friday evenings. Though they themselves were nonbelievers, they respected my grandfather's practices and didn't want me to show up after the Sabbath had begun. Leah was in the process of cleaning everything in the house very thoroughly "as if expecting the arrival of an especially close friend"—I learned that this was the proper attitude—not to welcome *me*, but the Sabbath itself. The mood in the house was thus one of joyous expectancy. Aunt Leah busied herself in the kitchen preparing a festive meal.

I took the opportunity to take a walk about town—one of many I would enjoy during the three weeks of my visit.

My grandfather actually arrived back in the early afternoon, greeted me, washed up, and put on fresh clothes. I was a little surprised at his appearance. I knew from my father that he was an "observant" Jew, I presumed a Chassid. I had seen Chassids in

Danzig. They all grew the same full beards and wore the same clothes. But my grandfather was dressed in ordinary business attire. He had no sidelocks though he had a luxurious beard, and his hat was not a broad-brimmed Chassid's hat. I would find out why in due course. Meanwhile, while he was preparing himself to greet the Sabbath, I resumed roaming around Mlawa. It was a small town, typical of other shtetls in Poland and elsewhere in eastern Europe. Only about half the people living there were Jews, who dwelled mostly in wooden houses (my grandfather's stone house was an exception) at the center of the town, the outskirts inhabited by Polish farmers. My aunt told me to be back half an hour before sunset. The Sabbath, she said, arrives at eighteen minutes before sundown.

At what I supposed was precisely eighteen minutes before sunset, Leah was igniting two large candles mounted in heavy silver holders while reciting a blessing over them. When she had finished lighting them, she cupped her hands around their flames and brought the heat she captured from them over her eyes. I found the gesture very striking, and it has remained with me all my life. She seemed to be drawing the blessing contained in the candles, symbolized by their warmth, into her own being. I had never been to a Friday-night service back in Danzig—we certainly never did anything like this at home. However, to avoid showing my ignorance of Jewish tradition, I refrained from asking my grandfather any questions during dinner.

As we sat down to eat, my grandfather said a prayer and asked me to participate. Before my departure for Mlawa, my

father had given me a crash course in how to read Hebrew letters and some of the basic *bruchas* (blessings) and prayers, but I'm afraid it was too little too late! There were quite a number of recitations before and over dinner, but I knew none of them. My grandfather realized this as I struggled to imitate him phonetically. From that time on, the only religious imposition he made upon me was the addition of a small cap to my outfit. He didn't seem to mind my silence, but when our feast was over, he began to explain some aspects of the tradition to me. Our conversations were in German, which was in fact his native language. He spoke it impeccably.

"I want you to know," he said, "that the Sabbath is the most important special day in Judaism, even more important than the day of Atonement (Yom Kippur) and the other High Holidays celebrated early in the autumn." He told me that the Sabbath is the only ritual observance required by the Ten Commandments—a gift from God, a day of general joy, anticipated throughout every week of the year. He said that on the next day I would see for myself how it is celebrated, and that we would spend the day talking about Jewish customs and practices.

My grandfather and I spent almost the entire Saturday together in his study, the bookcases of which were lined with large, leather-bound volumes of Hebrew texts. For my grandfather, the Sabbath, the Day of Rest, meant a day of pious study. Though I didn't read Hebrew, I knew that the books peering at me from countless bookshelves—and even in piles on chairs and other surfaces—were scripture and religious commentaries.

As we became more familiar with each other, my questions

began to flow freely. I asked my grandfather how they knew exactly when the Sabbath "arrived." He told me it wasn't about eighteen minutes—that was just an approximation. The real beginning was when the first three stars appeared on the horizon. I wanted to know about the ritual with the two candles and Leah's interesting gesture. I had my own ideas about the symbolism of light, which I knew was common to many traditions. But what was the exact meaning of the two candles? One, he said, represented *Zakler*—remembrance. The other represented *Shanor*—observance of God's Law. And what was the meaning of Leah's gesture? For some reason he was reticent to speak about this, perhaps because the gesture itself was a very intimate one, Leah drawing the symbolic enlightenment and spiritual warmth symbolized by the candle into herself, but with a meaning to be felt more in the performance of the action than through verbal explanation.

I was a nonbeliever and my parents were not "observant" of most Jewish customs, as I mentioned, so I had many more questions besides these, to each of which my grandfather responded with patience and a show of wisdom. Since he realized I knew practically nothing of Judaism, he introduced me to the meanings behind some of the holidays as well as other customs. We talked about what it actually means to be a believer, as well as what one has to do to claim true religious membership.

In one of our discussions, the subject of charity came up. "In Judaism," he said, "charity [in the sense of giving alms]— *Tzedakah*—is seen as a 'mitzvah,' a moral duty, that must be performed regardless of one's financial standing, mandatory

even to those of limited financial means." Charity, moral reflection, and pious study were the ways to God. He explained that the central Rabbinic text was the Talmud, the primary source of religious law and theology. Chassidic Judaism, in contrast, which became influential in communities in Poland in the late seventeenth century, largely due to tremendous suffering, holds that we are in touch with God through emotion and ecstatic mystical excitement, rather than through knowledge and disciplined study. Some of the leaders of the Jewish communities formed a group to resist the theological implications of Chassidic practices.

"Grandfather, I thought you *were* a Chassid," I said.

"No, no," he corrected me. "I am considered to belong to the doctrinal opponents of Chassidism, the *Misnagdim*. We apply to the Talmud a critical examination of the text and also reject all forms of mysticism, welcoming modern, secular sciences and thought. Not that we condemn mysticism entirely, but we seek to analyze and explain it with rationality."

WHEN I RETURNED home, my parents wanted to know if I had learned anything from Grandfather. "Don't worry, I am still a freethinker," I said. "But I did promise Grandfather that someday I would read, if only in translation, the Talmud and *The Guide for the Perplexed* by Maimonides."

They seemed content with that.

Though I never became an "observant" Jew, my three weeks with my grandfather did kindle an interest in Jewish history, culture, and in a certain way its theological perspectives. Years

later, in the late 1940s, when I was working on my PhD in literature and linguistics at the University of Cincinnati, I audited lectures and courses at the Jewish theological seminary there, and some years ago I began to write a novel (never completed) about the Jewish apostate and "Messiah" Sabbatai Sevi, who in the seventeenth century won followers throughout the Jewish world before, under pressure from Islamic authorities, being forced to convert to Islam.

AT THE STATION

September 1937

I RETURNED FROM MLAWA in the middle of August (1937), and the day of my departure for France was fast approaching. The whole journey would take more than a week because my travel itinerary included a stopover in Berlin to visit my father's older brother, Martin, well known in musical circles in that city. On the morning of the beginning of my journey, my family gathered at the station to see me off.

"We have fourteen minutes left," my father said as he replaced his watch in his waistcoat pocket. He turned to see if it showed the same time as the big station clock. "Yes. The train should be here soon."

As for me, I could hardly contain my impatience with what was developing into an endless farewell scene.

It was only natural that they should accompany me to the station and stay with me until the last second—my father, my mother, my sister, as well as Elisabeth. I would probably not see them again for a year or more, but I didn't feel particularly sad. Rather, I felt happy, because once the train had departed, there would be nobody but myself deciding things for me. Guilt nagged at me as I tried to mirror the sadness of my family, but I wasn't very convincing, for nothing in the world would have made me give up my journey. Still, I fell in line with the general mood and played my part.

My poor mother, with tears in her eyes, had been repeating since the previous day, "When you reach Paris . . . send us a postcard to let us know that you have arrived safely."

As for my father, he asked incessantly for me to visit his brother in Berlin on my way to Paris. My father looked at his watch again, took me by the arm, and pulled me aside. On the other platform, a locomotive surrounded by a cloud of steam came puffing by and whistled.

"Let's walk along the platform to pass the time. There are a few things I would like to tell you: how important it is to study, for no one can take away from you what you have mastered intellectually. Oh, and by the way, I am very pleased that my associate Monsieur Berger has agreed to look after you in Paris. If you listen to his advice, nothing seriously bad can happen to you."

I said, "I don't see how anything 'seriously bad' could happen to me," but my father didn't answer. He seemed lost in his own thoughts. Finally he said, "You're no longer a child, Justus, and I

want to talk to you man-to-man. If you have any *problems*, don't hesitate to confide in Monsieur Berger and take his advice."

I suppose my father's discomfort, not only about discussing things having to do with sex, but even giving any indication to his son that such things exist, was typical of upper-middle-class Jewish fathers of the time. I remember one day when I was perhaps fourteen years old, I was walking, holding hands with a girl on the jetty going out into the ocean from the suburb Zoppot. I noticed my father walking toward us, and I was prepared to greet him, but he held his head in the air and walked on by pretending that he didn't notice us at all. Back home, neither of us ever mentioned the event.

"What kind of 'problems' are you referring to?" I asked, feigning ignorance. Elisabeth, who had been walking quickly and was a bit ahead of us but was close enough to overhear, turned around and smiled. I smiled back. My father was too preoccupied to notice.

"You're going to be on your own for months," he continued. "You'll meet girls . . . and women . . . and, well . . . you might . . . *date* them." My father had turned beet red as he delivered his advice. "But don't make friends . . . with just anyone, choose wisely. For your own sake. If due to some bad luck, something happens to you . . . I mean, well! Don't be ashamed, it can happen to anyone. Don't be afraid to talk about it. But you must not wait. These things can be taken care of. There are hospitals and clinics for that. It's quite common. It happens to many. What you have to do is take care of it as soon as it shows up. Do you understand?"

By now I, too, had turned red and was looking at my feet. My attempt at a reply was equally embarrassing. "Look, Dad . . ." I was going to lie and say that girls did not yet interest me, but he didn't give me the chance to finish. He kept on talking about girls, but I was thinking about something else, someone else.

Finally, I boarded the train and waved goodbye. Nothing was further from my thoughts than the possibility that it would be fifteen years before I saw any of them again.

BERLIN

September 2–12, 1937

MY FATHER, VERY proud of his older brother, Martin, often told me about his nonconformism and achievements. My grandfather recognized Martin's intelligence and gifts when he was a boy and planned to have him educated at a highly respected yeshiva. Yeshivas are Orthodox-Jewish secondary schools that focus on the study of traditional religious texts, primarily the Torah and Talmud. But Martin had his own ideas; after his bar mitzvah, instead of going to a yeshiva he insisted on remaining in Mlawa and attending a public school. During this time he secretly became a member of the left-wing Polish Socialist Party. At the age of fifteen, on May 1, 1905, in support of the first Russian Revolution and International Labor Day, he marched through the streets of Mlawa waving a red flag.

This was an action with serious consequences. Though his family—in particular my grandfather—was embarrassed by his socialist sympathies, they had done nothing to interfere with his views. Martin avoided being arrested for his activism by fleeing first to Austria and then to Berlin where, with the support of the Jewish community to which my grandfather was well connected, he studied music and laryngology, a specialty of medicine that dealt with injuries to the voice. At some point he was a student of the composer Arnold Schoenberg. Martin's interest in music and politics led him to organize a chorus of workers that grew to over four hundred singers, mostly committed Marxists. Under the name of Rosebery d'Arguto, he'd conducted his own compositions on Radio Berlin, using the workers' chorus and their children. Under that name he'd also published scientific articles on laryngology.

That's all I knew about him before I visited him in Berlin on my way to Paris.

From the side window of his spacious living room, I could see a large courtyard where children played hopscotch and skipped rope. Opposite the window stood a grand piano, over which hung a plaster copy of Beethoven's death mask; frowning tragedy and laughing comedy masks were attached above the fireplace. Against the widest wall there was another piano, an upright one, on top of which was a framed picture of an attractive young woman.

"Isn't that Inge, your girlfriend—the ballerina—who visited us in Danzig a few years ago?" I inquired.

"Yes, it is, but we don't see each other anymore because

of the Nuremberg Laws." Enacted in 1935, these laws denied German citizenship to Jews and outlawed sex and marriage between Jews and gentiles.

"For a while we continued to live together. I even had the impression that she was more attached to me than ever, but under the Nazi regime, we could never get married. Even to be seen together was not prudent. We never went out to a café, a restaurant, or a show. All we had left was ourselves and the countryside, where eyes were not so watchful. Occasionally we met there with friends."

"She must have been very fond of you." I was thinking about Elisabeth and her Nazi brother. Things had not gotten this bad in Danzig, but of course I knew that the Nuremberg Laws could be applied at any time.

"I think the challenge of a forbidden relationship added spice to it for a while. But more and more of our friends were keeping their distance. The few that stuck with us—musicians, painters, and actors—still preferred not to be seen in our company. Inge and I met exclusively here at my place, mostly magical evenings listening to music. But even that was to end."

"Why?" I asked. "If she still cared for you—"

"Well, it was always I who would ask when I would see her again. The more insistent I became, the more distant she grew. Finally I suggested that we go abroad where we could get married."

"Did you want to force the issue or just resolve it?"

"I suppose a bit of both. Anyway, she didn't respond to this right away, but a few days later she told me that she had thought

about it and felt she would not be happy far from Berlin, because everything she loved—her friends, her career as a dancer—was here. The last time I saw her, she only stayed half an hour, and since I didn't ask her when I'd be seeing her again, I never did." He paused and was quiet for a little while. At last he said, "Let's go out and have something to eat. I know a restaurant where they don't discriminate against Jews."

We had a light supper and a bottle of wine, which loosened his tongue.

"On the third of March 1933, at 9:45 in the morning, fifteen minutes before I was to conduct on Radio Berlin the workers' children's choir I had founded in the 1920s, a private guard stopped me at the entrance.

"'I beg your pardon, Professor Rosebery d'Arguto, but earlier this morning I received an order not to allow you to enter the premises.'

"That was all the guard, whom I had known for years and who was always deferential to me, was able to tell me. I saw no point in arguing with him. Unemployment was rampant. In his place, I would have acted the same way."

"How were you able to support yourself since your radio program was forced off the air?" I asked.

"I have my practice as a laryngologist, and I am still allowed to teach singing, but only to Jewish students."

Uncle Martin seemed very sad as he told me these things. To change the subject, I asked him if he would allow me to go to a performance of Franz Lehár's operetta *Das Land des Lächelns* (*The Land of Smiles*), whose melodies I had loved since

childhood. Though it was being performed in a theater that did not admit Jews, I tried to convince Martin that it would be safe for me to go—that with my blond hair and blue eyes I could "pass" as an Aryan. This on occasion would prove useful over the course of the war and in my activities with the Resistance. It worked in public situations where my physical appearance was all of me that anyone could know about me, but where my actual identity was the issue, looking Aryan wasn't enough. The Nazis were quite adept at finding out the details of one's Jewish background.

For several days my uncle resisted my campaign but eventually gave in, provided I immediately came home after the performance.

At the ticket office I acted as if I had every right to be at the theater. I had no trouble purchasing a ticket for an orchestra seat in the sixth row, from which I had an unimpeded view of the stage and of the boxes to the left and right across from me, occupied by high government and Nazi officials. Now and then I glanced up at them with the thought, *If they only knew who was sitting below them!* The light dimmed, the overture started, the curtain opened, and I was transported away from the political reality of the situation. During the intermission, I watched some occupants of the boxes strutting around the lobby in their custom-made uniforms. *What a bargain*, I thought, *two spectacles for the price of one!*

When I got home, I couldn't wait to tell Martin how much I enjoyed the music, that of all the instruments—piano, violoncello, and others—the trained human voice is the most mag-

nificent, unparalleled in its ability to evoke emotion in the listener; but I realized that to relate my experience would be to drive home the emptiness my uncle must have been feeling, deprived as he was by the Nazis of his raison d'être.

Two days later, roaming around Berlin, I noticed everywhere posters in large type announcing that that very evening Adolf Hitler would be addressing his *Volksgenossen* (fellow citizens) at the Berlin Sportpalast, a large, indoor sports arena. The Führer had visited Danzig several times, but my father had always refused to let me see him close up. What I had known of Nazi violence on the streets of Danzig of course frightened me, but it also awakened my curiosity. What was it about this man that could inspire such hatred? One had heard that his rallies were powerful dramatic performances, and I wanted to see one for myself. Again, with my blond hair and blue eyes I would have no trouble getting into the spectacle, I was sure. The problem was providing a plausible excuse for my uncle to let me go out alone in the evening. The best I could come up with was the cinema. Of course if my uncle would want to go to the movies with me, I'd end up having to watch a film with him, but I thought I'd chance it.

In the early afternoon, I told him about a theater without a NO JEWS PERMITTED sign and that it was showing *To New Shores*, with the Swedish singer and actress Zarah Leander, a star in Nazi Germany. As fate would have it, Martin had already seen the film and allowed me to go alone.

When I got to the Sportpalast a little after seven, most of the seats were already taken. What struck me was the immensity of

the arena. The hall could seat fourteen thousand people. It took
a while for me to find an empty chair. Eventually I found one
on an aisle and not too far from one of the exits, with an un-
obstructed view of the raised platform from which Hitler was
to speak. Above it, banners and flags hung from the ceiling—
for the most part white swastikas on a red background. The
walls of the Palast were covered in posters and large banners
that bore political and nationalist, essentially racist, slogans.
There were no excoriations of Jews on these banners: only
apparently positive imprecations such as *Deutschland Erwache*
(Germans: Wake Up). People were talking, but the hall was so
full that their voices sounded like a high sea wave breaking as
it rolled toward the shore. One of the men on the platform, in
an SA uniform, took the microphone, tapped it, and said, "Our
Führer has just left the chancellor's building and should be here
in a few minutes!" The crowd erupted and thousands of heads
turned toward the main entrance, hoping to catch a glimpse of
the Führer entering the grand hall. Another SA man took the
microphone, put some sort of listening device to his ear, and
said, "Our Führer is approaching the entrance!"

The ovation was deafening as he came through the door:
"HEIL HITLER! SIEG HEIL!" six times in unison. I moved my
lips as though I, too, was shouting his name, so as not to at-
tract any attention to myself. My eyes followed the Führer and
his entourage as he advanced down the main aisle toward the
stage. On both sides of the aisle, every five or ten feet, SA men
lined the path. Each time Hitler acknowledged the crowd, rais-
ing his arm, bent at the elbow in that characteristic gesture all

his own, the response was overwhelming. He climbed the steps to the platform, went straight to the podium, and stood there for about ten seconds with his arms folded. Then he raised both hands to calm the crowd, and the noise stopped immediately. A murmur still floated through the hall, but then there was absolute silence, as in a concert before the virtuoso starts his or her performance.

He began calmly, using facts, statistics, and arguments not easily refuted. At certain points he talked about the unfairness of the 1919 Versailles peace treaty, reminding the audience that the National Socialist German Workers Party embodied the feeling of the nation, that it was ready to fight for the abolition of the fiscal and territorial restraints imposed upon Germany. He said that as chancellor he had ordered the reoccupation of a heavily industrialized territory bordering France. Even though he didn't mention it by name, everyone in the audience knew what he was talking about—the Rhineland—and stood up to sing the national anthem: *"Deutschland Über Alles"* ("Germany Above All"). The rational part of his performance was over. The rhetorical crescendo kept building. He spoke of "Love of the fatherland, readiness to fight for Germany's place in the sun, will to bring all Germans under the political umbrella of the National Socialist Third Reich." Once he got to these topics, his voice had risen to a shout. *"Deutschland erwache!"* ("Germans: wake up!") he shouted and the crowd once again came to its feet. I was paying attention to the response of the crowd now, more than I had to his earlier arguments, which, for all their logic, tended to be repetitive and tedious. In any case, the intellectual substance

was far less interesting than the performance itself. Hitler's tone and theatrics had an incredible effect on his listeners. They were clearly investing their hope, their faith, and their love in their Führer: ready to fight for him, oblivious of the rights and well-being of non-Aryan citizens. The ethos was one of religious fervor, certainty, and hatred.

Anti-Semitism wasn't the only thing that bound Hitler to the musician Richard Wagner. I think he learned from the composer something of his power to hypnotize an audience, to build themes slowly and to carry the audience along emotionally until at a pitch of transcendent fervor it would seem that there was no reality outside of the *Gesamtkunstwerk* (the total work of art)—operatic or National Socialist—that was the context of the audience's rapture. Friedrich Nietzsche had warned against the hypnotic force of Wagner's music, and surely one of its consequences was to instruct Hitler in the development of his rhetorical power to unprecedented peaks.

To my amazement, at the end of his speech, Hitler appealed to God. He asked him to extend his blessing, in the years to come, to Nationalist Socialist ideas and the Fürher's actions, and to protect him from illegitimate pride as well as any sort of cowardly psychological excuses for inaction. He prayed that the nation be allowed to find the right paths to the Providence God had assigned to the German People.

Hitler abruptly stopped at the end of his prayer, and as he left the place, the audience again sang the German anthem followed by the Nazi Party song.

On my way home, I debated with myself whether I should

tell Uncle Martin where I had been and give him my impressions of Hitler, or to perpetuate the lie. My desire to talk about it triumphed. I told him how afraid I was of the reaction of the crowd. Like my father before the pogrom in Danzig, Martin was not particularly alarmed. He had confidence in the German people. He thought that the country that had produced Beethoven, Kant, and Goethe would come to its senses, that National Socialism was an evil wind that would pass. Though Jewish artists and intellectuals of his stature were leaving Germany, he himself would not emigrate.

That was the last time I saw him. I learned after the war that he had perished in Auschwitz. After a week in September 1937 with Martin in Berlin, I departed by train for Paris.

Part II

PARIS

September 1937–September 3, 1939

THE TRAIN FROM Berlin to Paris stopped in Namur, Belgium, for an hour. As I stepped onto the platform to stretch my legs, I was captivated by a scent I had never experienced before. Something was beckoning me to its source—a food stand selling "pommes frites," thinly sliced potatoes fried in oil, covered in sea salt, and wrapped in a cornet of newspapers. This was my first taste of what everyone except the French call "french fries."

I arrived in Paris on a beautiful fall day, and walking out of the Gare de l'Est (the East Station), I fell in love with the sights and sounds of the city. I had to take a cab to a restaurant that Monsieur Berger owned and above which he lived. The ride provided a quick tour of fashionable Parisian neighborhoods: the evenly arranged buildings whose tasteful architecture seemed to glow with an aura that I immediately felt *was* Paris; and I also got a view, as the taxi made its way, of parades of gorgeous Frenchwomen that did not disappoint the expectations I had formed looking at fashion magazines at the French consulate.

I very much wanted to explore Paris in greater depth before starting school, but as it turned out, I would not have much free time to wander about. Monsieur Berger had already arranged

for my admission as a "pensionnaire" (a student residence with room and board) at the most prestigious *lycée* in Paris, known as a training ground for generations of France's political, academic, and artistic elite. My education regarding life on the streets of Paris would have to take second place to study. My classes were to begin at once.

I was immediately plunged into a heady new atmosphere. The lycée, I soon discovered, was the equivalent of the German gymnasium. Before enrolling at the Sorbonne, which was my goal, it was necessary to have a fluent command of French, and spending a year in the final class of a lycée was an excellent way to do this. I already had the rudiments and could read tolerably well. But at the Sorbonne the rudiments would not be good enough, and in Paris, it was a good idea to be able to speak French like a Parisian.

Intellectually the lycée was demanding and challenging with little time left for anything but studying. The meals—except for breakfast, the traditional croissant, brioche, and café au lait—was not what I expected from a country renowned for "haute cuisine." We were served institutional food that was unexceptional, except for the fact that every meal was accompanied by a small carafe of wine and followed by a sweet for dessert. The students had evolved a thriving barter trade, between those who preferred sweets to wine, and others who preferred the opposite. It was the first time I had experienced wine with any consistency, and you can guess which category I belonged to.

The sleeping quarters, twenty-five beds side by side in a dor-

mitory and a curfew at 10:00 P.M., left little room for privacy
or time for reading in bed. But it was possible to take a flash-
light under the covers if one was careful. Reading was already
my favorite pastime, and I quickly became addicted to classical
French novels. I was reading Balzac for the first time. I read
him during the war. I am reading him still.

We were not unsupervised in the dormitory. A live-in
proctor was stationed in a kind of island in the center of the
room—a room within the room as it were—surrounded by
curtains that he could open or close at his discretion, depend-
ing on whether he wanted to conduct surveillance or whether
he wanted privacy. There was also a night watchman who ap-
peared every so often. Several students had built and owned
crystal radio receivers that could be listened to with earphones.
They had a particular use in the dormitory: lottery numbers
were announced nightly, and the boys who had purchased
tickets would crowd around the radio, to find out if they had
winning numbers. The radios had to be connected by a wire to
an external metal object like a radiator. When the watchman
appeared, they had to be disconnected quickly and you had to
jump back into your own bed before you were caught, for these
gadgets were very strictly forbidden. Of course, I had built
one and had learned to match the wariness of the proctor and
the watchman with a foxiness of my own, an ability that served
me in good stead not too much later in the Resistance.

I must say that my main disappointment in Paris was that
the lycée had no female students. How could that be in the
République Française, whose motto since 1871 had been *Liberté,*

Égalité, Fraternité? I eventually put that question to a day stu-
dent who sat next to me in class. His name was Charles Le-
vasseur and we quickly became friends. He knew the ropes of
student life in Paris. He kept me posted about what was going
on in the outside world. He would bring three French papers,
The Paris Soir (a socialist paper), the *Humanité* (communist), and
the *Figaro* (conservative) to class every day. He seemed most
interested in the sensational news stories that they all shared;
for instance, one morning each paper told how on January 27, a
brilliant aurora borealis described by some as a curtain of fire,
by others as a huge blood-red beam of light, had streaked across
Europe and startled its people; that the German war minister
Field Marshal von Blomberg, married two weeks ago, had re-
signed today when the Nazi press revealed that his wife had
previously posed for pornographic pictures. To Charles such
news was fascinating, but I wanted to hear about the absence of
girls at the lycée. He laughed and gave me the reason.

The name of the lycée itself, Janson de Sailly, tells it all. It was
so named for a wealthy Parisian lawyer who, a few years before
the 1789 Revolution, had caught his young wife in flagrante de-
licto (in the act), disinherited her, and left his entire fortune to
the French government on this condition: that they build a lycée
that would not admit women. Where was the égalité?

DURING MY FIRST three months in Paris, I corresponded with
my parents weekly. I was naturally very concerned about events
back home. They had sent me to Paris to escape the circum-
stances that still posed a real danger to them. They indeed re-

ported how anti-Semitic policies were being enforced more and more seriously, and that discussions were under way in the Jewish community to see if everyone somehow might leave Danzig en masse. There was little I could do to help the situation, so I became more and more engrossed in my studies and in my new life in France. As time went by, we corresponded less frequently, letters from home merely telling essential bits of news.

I spent much of the time when I wasn't studying with Charles Levasseur. He knew all there was to do in Paris for young men our age—both appropriate and inappropriate. With his help, I became steeped in French culture, attending performances of plays at the Comédie-Française we had just read in class—at half price for students. But we did remain aware of the general political situation in Europe.

I stayed at the lycée from September 1937 to the summer of 1938. During that time Hitler advanced his program for putting Germany "before everything" by two fateful steps. He annexed Austria and he annexed Czechoslovakia. How far beyond those regions would he go? How would the old allies, England and France, react? Hitler's main desire was to bring territories with large German populations under the Reich. Would Danzig, whose population was 70 percent German, be next? Would the anti-Semitic policies of the Nuremberg Laws be forced upon the annexed nations? Would anti-Semitism and the rising intensity of anti-Jewish feeling catch fire even beyond the countries controlled by the Germans?

Charles and I were of course horrified by these developments and we were beginning to think about how the Nazi movement

could be resisted if it continued to expand. We had no particular plans, but the seed for active resistance was planted in our minds at that time. We, however, did not always see eye to eye. I was already beginning to think like a Marxist, while he was something of a Social Democrat. But we were both beginning to orient ourselves toward the possibility of political action.

A SUBTLE IF not aggressive form of anti-Semitism was evident at the lycée. My French classmates in general were very helpful and friendly, yet none ever asked me over to their home except for Charles Levasseur—but only once! He invited me to his parents' apartment for lunch one Saturday. From the address and the building itself, it was clear that his family belonged to the upper middle class. Charles's father, because of my first name, a common one in Scandinavia and Germany, was not sure whether I was Jewish. "Rosenberg" was not necessarily a Jewish name. The most influential ideologue and theorist of the Nazi Party was named Alfred Ernest Rosenberg! Charles's father engaged me in small talk until he found out. Though Charles and I remained good friends, his parents never invited me again. Charles was very well aware that his father was a supporter of a French ultra-conservative, xenophobic, anti-Semitic party whose members still believed Captain Dreyfus was a traitor. In a conversation with Charles, his father had complimented me on my assimilation of French culture but remarked that I was still a Jew.

Charles was deeply disturbed by his father's racist views. He told me of many heated and even acrimonious conversations between them. Their conflict in fact exemplified what was oc-

curring in many French families. The conservative part of the French population had harbored anti-Semitic sentiments for decades if not centuries, while those inspired by the French tradition of *Liberté, Égalité, Fraternité* did all they could to resist it. And the conflict often divided families. I knew very well where Charles stood emotionally and politically, and his father's attitude in no way came between us.

BESIDES EXCURSIONS WITH Charles into Parisian culture, I did some explorations on my own. Indeed, I became something of a *flaneur*—one who wanders the streets experiencing its rhythms and spontaneous phenomena, making observations and recording impressions. Baudelaire, whom we studied at the lycée, wrote poems and prose pieces about *flânerie*—in fact he invented the term. I am today very fond of these texts, which so suggestively mirror my own experience as I meandered through the streets of Paris. To be a flaneur involves more than merely roaming around aimlessly (though it requires a bit of that too!). One becomes one with the crowd and probes the metropolis inch by inch, prying into its hidden corners and best-kept secrets. For me it was a revelry in freedom and a kind of salutary aimlessness. I felt the poetry of my own special gait as it counterpointed the visible pulse of history, reflected in Parisian architecture and orchestrated (to some degree) by the famed Parisian city planning that surrounded me. Evenings (depending on the balance of my monthly allowance), I spent a few francs on a play at the Odéon, or any boulevard theater. The Bobino, a popular vaudeville venue, was one of my favorite

haunts, because it was cheap and always surprising—you never knew who or what would be on the program: acrobats, tap dancers, jugglers, humorists, clowns, singers such as Charles Trenet and Edith Piaf, at the beginning of their careers. I once even attempted to enter the Folies Bergères to see whether they really staged what their pictures at the entrance promised, and, to my surprise, they let me in. (The Folies Bergères was and still is a highly sophisticated vaudeville-like performance venue, featuring what today would be considered "soft-porn" numbers with a distinctively Parisian flavor.)

On rainy or cold days, I visited the Louvre, where room by room I would experience the difference between impressionism and expressionism, for instance. The galleries of contemporary art flourished in the Paris of the late 1930s and were the home and meeting places of some of the world's most prominent painters, musicians, writers, and sculptors—most poignantly from Germany, where contemporary art was being denounced as "degenerate" by the Nazis. This period was the heyday of modernist, surrealist, abstract, and other forms of experimental art. Paris was famously its center and all of it was anathema to Hitler, who had been an art student in his youth, not sympathetic to these movements.

Before it closed, I visited the 1937 Exposition Internationale des Arts et Techniques dans la Vie Moderne (International Exposition of Art and Technology in Modern Life), held at the Champ-de-Mars and the Colline Maillot. Countries from all over the world were represented here, each putting its unique cultural identity on display, not particularly for political pur-

poses, but I could not help noticing political implications when they were present. As the exposition was in the process of clos- ing, only a few vestiges of it remained. The Palais de Chaillot still stood with its water cannons and the fountain at its base, its large terrace and spectacular view of the Eiffel Tower. In the center of the exhibition, two particular pavilions faced each other as if ominously holding their ground—that of the Soviet Union, topped by hammer and sickle, and that of Germany, headed by an eagle and a swastika. The Stalin-Hitler nonag- gression pact was two years away; the appeasement of Munich one year. All of Europe knew that another war was coming, but for the present, when, where, and how it would erupt were in the balance. From my experience, both in Danzig and Ber- lin, I knew that peace would not be maintained. But as long as Germany and the Soviet Union were willing to confront each other in this symbolic fashion, I felt secure. This feeling was reinforced by a 280-mile-long defensive wall the French built along their border with Germany, the Maginot Line—at least as far as a fear of a German invasion of France was concerned. The French assumed that if Germany were to attack France, it would be by crossing this border. The line seemed strong enough to discourage the Germans.

The Spanish Civil War (1936–1938), meanwhile, was in full swing, and Picasso's *Guernica*, memorializing the bombing of a small Spanish town by the German Luftwaffe, had its first showing at the Spanish pavilion. Its vivid evocation of the hor- rors of war made me appreciate the peace that still held, in most of Europe.

When school was over in June 1938, Charles asked if I would join him and his friends in Carantec, Brittany, a small village on the Channel across from England. Without parents or teachers or supervisors of any kind, he promised great fun and plenty of girls for us to go out with. I wasn't sure if my parents expected me to return to Danzig for the summer, but as it turned out, they were pleased with the idea of my remaining in France.

THE SITUATION IN Danzig itself was becoming more and more critical. For all my flânerie and excitement about Paris life, I was very much preoccupied with the way Hitler referred to Danzig in his speeches.

On March 12, 1938, Hitler had annexed Austria. Though of course Austria was a German-speaking country and there had been public sentiment for the union of the two nations going back to the nineteenth century, the Versailles treaty had forbidden this, with the express purpose of preventing the rise of a Third Reich; that is, Austria, Germany, and other German-speaking peoples, under a single government. The treaty also allocated to Czechoslovakia the German-speaking Sudetenland for similar reasons; but the Nazi program to create a Third Reich was now in the process of being achieved. It was clear that Hitler was not going to stop with Austria. He was implicitly demanding among other things the return of Danzig. No one knew what this would mean if it occurred. Would there be restrictions on emigration and travel, particularly for the Jewish populations? It seemed best for me to remain in France.

With plenty of time at Carantec, I had finally sent my parents details about my life at the lycée and my vacation, and they were informing me of how things stood in Danzig. For the time being nothing interfered with my plan to begin studies at the Sorbonne. Before leaving for Carantec, I had rented a room in the apartment of a young French couple close to the university, so for the time being political developments at home or in Europe more generally would not interfere with my formal education.

There *were* ominous developments in Europe, however. The very week that I returned to Paris from Carantec in September of 1938 and attended my first lecture at the Sorbonne, the Prague cabinet received an ultimatum from Hitler that it surrender the Sudetenland along with all the Czech-border fortifications. The Anglo-French response led to the meeting at Munich between Hitler, Mussolini, Britain's Neville Chamberlain, and French prime minister Édouard Daladier. The Czech prime minister, Edvard Beneš, was not invited. On September 30, they agreed that in exchange for the Sudetenland, Hitler would refrain from demanding any further annexations. The weekly news showed Chamberlain waving a piece of paper and pronouncing the now infamous words, "I have brought peace in our time." The French crowd—I was among them—hailed Daladier returning from Munich along the Champs-Elysées for having avoided war.

THE EUPHORIA OF Munich was not to last long. On November 9–10, 1938, something far more consequential and destructive than the mob violence I saw in Danzig occurred in cities

throughout Germany. The parents of a Polish boy living in Paris—a boy in a situation not unlike my own—had been mistreated and stranded in a refugee camp between Poland and Germany after being expelled from Germany. Outraged, the boy entered the German embassy in Paris and shot and killed a high German official named Ernst vom Rath. In retaliation, the Nazis went on a rampage, setting fire to synagogues and destroying Jewish stores and businesses. The event became known as *Kristallnacht*—or in English "The Night of Broken Glass"—because of the enormous number of smashed storefront windows. It was a turning point in relations between Germans and Jews. Before that night, German anti-Semitism had something like the face of legality: the Nuremberg Laws were still "laws." Now, violence against Jews required no such sanctions. The Kristallnacht events of November 9–10 soon spread beyond Germany. A few days later it happened in Danzig.

As soon as I heard this, I fired off a telegram to my parents. The telegram remained unanswered. I thought of going to Danzig at once and spent several days trying to find out how that might be possible. It was not. Several anxious weeks later my landlady handed me an express letter on whose envelope I recognized my father's handwriting. I raced over its eight pages to find out if everyone was okay. They were.

The letter reported that all the Jews in Danzig, including my parents, now regarded emigration as a matter of highest priority. My father wrote:

"[T]he Danzig government is ready to collaborate with representatives of the Jewish community for an orderly exo-

dus. They have come up with the following plan to generate funds and find places to which 7,500 of us living in Danzig can migrate.

"Of course, the 2,500 Polish Jews willing to return to Poland could do so; others who can get visas to other countries will be allowed to travel there. Your mother and I have certainly decided not to return to Poland. Like the majority, we would prefer, although not Zionists, to go on an illegal transport to Palestine.

"The money to implement this plan is to come from two sources: the Jewish community has agreed to sell all of the real estate it owns—synagogues, cemeteries, orphanages, old-age retirement homes—to the Danzig government at derisory prices. A second source of funds is JOINT, a Jewish relief organization based in New York, which is willing to buy all the ritual objects belonging to the Jewish community—Torahs, menorahs, and so forth. We shipped the crates of those things to New York on December 20th (1938), the day your mother, Lily, and I left for Bratislava in Czechoslovakia. From there we are scheduled to go by Danube river-boat to Romania.

"Since I don't know what is coming next, I have arranged that, should we lose touch with each other, we can use the address of a cousin of your mother's living in Philadelphia as a point of contact."

In addition to this really devastating news, my father said that he had transferred a considerable sum of money to Monsieur Berger for my use—enough to last more or less a year. This letter in fact was the last I heard from my family until after

the war. After a month or so, when no further news had come from my father, I wrote to the cousin in Philadelphia but got no reply. I never found out why.

IN SEPTEMBER, CHARLES and I had begun our studies, and in spite of these events, we continued with them. The Sorbonne has no strict entrance requirements. One just signs up for courses. Instead of eliminating inappropriate candidates before enrollment as in America, the weeding-out process is performed by the final exams. Generally, only about half the enrollees pass. The exams—first a written one, and then, if one passes, an oral—were the sole means of evaluating a student's performance. Attending classes and lectures was optional. One did so according to one's interest or felt need. Provided you did the readings, you could get by with sporadic attendance. The exams were administered when the courses were completed, and I first sat for them in June 1939.

One of my courses was "The French Novel of the 19th Century." We were asked to read Balzac and Stendhal as well as Flaubert. No one knew in advance which novel or author we would be tested on. The written part comprised an essay to be composed in a huge room with all the other students, on a topic you selected from among choices given at the exam. It lasted for as long as three hours, depending on your speed, thoroughness, and how much you had to say. At the exam I picked the topic "Explain Why Balzac Is the Father of Modern French Realism," thinking it would be easier than other topics presented. I used all three hours and wrote a long essay. If you

passed the written exam, your name appeared a few days later on a publicly posted list, and you advanced to the oral portion. The order of names ranked our performances. I read down it—a long way—before I came to my name, practically at the bottom. I had just barely passed.

Because of the enthusiasm with which I had written my answer and my familiarity with the subject, I thought I'd be higher on the list. It was hard to shake my doubt about my own preparedness as I approached the door to the room where the oral phase of the exam was to be administered. When I entered the forbidding chamber, I could tell at once that things did not bode well for me. There were three grim professors seated there. They got right to business. The first one said, "Your essay was well-written, but your analytical acuity leaves something to be desired. Who are you to copy-edit Balzac?"

In my essay, I had explained that while Balzac was indeed one of the fathers of modern French realism, he had overdone it somewhat. I had expressed this view in a brief remark without giving my argument. They wanted to know what I meant. I told them that in the novel *Père Goriot*, his description of material "reality" involved too much detail in the opening chapters. There were descriptions that did not contribute to the movement of the story or really enhance the atmosphere. I didn't belabor the point, however. I was willing to concede that this did not significantly diminish the value of the work. I wanted to pass. Through the rest of the examination, I managed to tell the committee what they needed to hear. I was vindicated in my criticism twenty years later, although no doubt these

professors were dead by then. A biography of Balzac revealed that the author, always broke despite (or because of) his extravagant lifestyle, was paid by the word!

Outside of the university, I continued my flânerie, attending all the plays I had not caught before, and with my rapidly expanding culinary knowledge, trying out all the best restaurants I could afford. Though my preference was for French cuisine, I tested restaurants with food from other countries. I came to be of the opinion that eating is culture on a plate!

There were secondhand stores to visit as well as cheap bars, places with a very different milieu from the new department stores just coming into fashion. Flânerie involved an attitude of curiosity and open-mindedness—not taking anything for granted. After a while, I realized that though this openness was necessary, flânerie was not at all about detached observation, for when I lost touch with my own feelings, there was a real danger of losing myself. Nor was it about being idle or doing nothing, but rather it was an active search for the essence of things. I thought the idea of it was deeply human. Its philosophy became important in France in the nineteenth century during what was in fact an intellectual revolution—a "resistance"—a movement looking for a way to keep our humanity and poetic sensibility in a world that was becoming increasingly dominated by rational calculation. Directionless wandering signaled an acceptance of the unexpected and a challenge or corrective to the opposite human impulse: the desire to control everything. I thought, and still think, that some of the best things in life happen by chance. I was, un-

beknownst, being exposed to the realm of surrealism—that sometimes, somehow, the mere presence of an object can activate the subconscious.

I HAD BEEN studying at the Sorbonne since September 1938. A year later, as my second year there was about to begin, in September 1939, events leading to the Second World War came to a head. Everyone knew it was coming. In March 1939, gas masks had been issued to the civilian population. On August 23, the Soviet Union and the Nazi government signed a nonaggression pact (known as the Molotov-Ribbentrop Pact, also the Hitler-Stalin Pact).

Generally, as political events transpired and news of them became available from newspapers, I was in the habit of working out my own interpretation of what was happening. At first the neutrality agreement was very confusing. If you were a leftist and in sympathy with the Soviet Union, you felt that the pact between Stalin and Hitler was a terrible betrayal. If you were a liberal, you were terrified that this union of the two dictatorships would easily conquer Europe. I had neither of these reactions and eventually came to think the following:

For Hitler, the pact was a step on the way to the conquest of Europe without having to fight a war on two fronts. For Russia, it was a way of buying time. Hitler thought that he would conquer France quickly and reach an accommodation with England. A new European order under German supremacy would be established very soon. The Soviets, on the other hand, imagined that the imminent German invasion of France

would simply reinaugurate the trench warfare of the First World War and therefore go on indefinitely. Hopefully, from its point of view, this would lead to revolutions sympathetic to the Soviet Union. Meanwhile, it won time to develop its defenses. If Germany invaded Poland—which it seemed to be preparing to do—far from appearing to Russia as an act of aggression threatening her, it looked like it would establish a buffer zone between her and Germany, for the Poles were ferociously anti-Russian.

The Communists in France were happy with the pact, while the liberal authorities, of course, opposed it. On August 25, the French government seized Communist newspapers for supporting the Hitler-Stalin Pact.

On September 1, 1939, Hitler, through diplomatic channels, let it be known that if France and England agreed to his annexation of Danzig and "the Corridor," he would stay out of Poland. His concern was primarily with places with a large German population. If they refused, it would be these nations and not Germany that had broken the agreement at Munich. England and France refused. The first place to fall into German hands was Danzig, and simultaneously the invasion of Poland began. On the third of September, France and England declared war on Germany, marking the official beginning of World War II.

My parents, though I had heard nothing from them, were, I hoped, safe in Romania. I was concerned about my grandfather in Mlawa. And if the Germans took Paris, would the Sorbonne close? What would I do?

"THE PHONY WAR"

—————

Paris, September 1939–June 1940

T HE FIRST BATTLE of World War II took place on September 1 when a German battleship opened fire on a Polish garrison in Danzig; this happened as Hitler invaded Poland. His armies subdued the country in a three-week-long lightning campaign (*Blitzkrieg*). Despite England and France's pact with Poland to assist in its defense, nothing happened on the Western Front. For the next eight months, the French army and the British Expeditionary Corps stayed behind the Maginot Line, in a war without combat referred to by many Western military pundits as *une drôle de guerre* (a phony war). Even the Germans sarcastically called it the *Sitzkrieg* (the sitting war). The Maginot Line comprised French fortifications along the French-German border from Luxembourg to Switzerland. The Germans did not seem to be preparing to invade from behind that line, so there was, at the very beginning of the conflict, what seemed to be a stalemate.

For all practical purposes, life in Paris, except for the blackout rule, did not change much. People were still attending concerts, going to the theater, visiting one another. I continued to study at the Sorbonne, but my life had drastically changed. Up until about this time, the money my father had transferred to Monsieur Berger held out, but it was rapidly diminishing to nothing. Very soon I would have to provide for myself. I had no choice but to give up my apartment and move into a cheap hotel in

the Latin Quarter on Sommerard Street, close to the Sorbonne and the Cluny Museum.

To complicate matters, though to alleviate them somewhat, during this time I found myself in a relationship with a financially comfortable young woman named Denise whom I met at the Sorbonne. We often studied together in the Jardin du Luxembourg—a pleasant park with an artificial pond where children played with toy sailboats. We spent nights in my hotel room or at other more pleasant hotels for which she provided the funds. Denise was a very intelligent woman, and I must say she had an almost technical interest in exploring her (and my) sexuality. We were quite close in our way, but we never formed an emotionally compelling attachment. Like my relationship with Elisabeth, our fling came to an early end—when the German invasion of France finally came.

At the hotel, there were many foreign students in a financial situation similar to mine. We got to know one another, bonded together, pooled our resources to buy foodstuffs to save money. Four baguettes for ten people went much further than one baguette for a single person, half of which would go stale before it could be consumed.

Our repast consisted mostly of saussiçons, paté, cheese, and hard-boiled eggs cooked by the woman who owned the hotel. Our main staple was the baguette.

In one of my courses at the Sorbonne, I sat next to a Tunisian student named Ismail who, like me, was interested in literature. He supported himself by selling fresh vegetables at a local open market three times a week and was in need of someone to do

it with him. He wanted to know if I would be interested. With my funds nearly all gone and no prospect of a job, I jumped at the offer.

My first exposure to his "business" was at Les Halles, a large wholesale market of fruits and vegetables located in the center of Paris, housed in an iron-and-glass pavilion that reminded me of similar end-of-the-century buildings I'd seen during my flânerie. A great percentage of Paris's fresh fruit, vegetables, and fish arrived by truck at Les Halles during the night. The food was then neatly sorted into categories and separated by quality. The "cream of the crop" was sold to buyers from exclusive retail markets and to chefs of fancy restaurants. Ismail's idea was to arrive at Les Halles with a small pushcart at closing time—just before three in the afternoon—when we could acquire leftover produce at centimes to the franc. The next morning we would push our loaded carts to a local market and sell carrots, leeks, onions, and other vegetables at a good profit.

We had to get up at dawn and push the cart up the steep avenue, but we were done by 9:00 A.M. and able to make it to our classes on time. It all worked very well during August, September, and October, but in November, it was too cold for an outdoor job.

Early that month, Benno Epstein, a Romanian student living in the hotel with us, learned that the Théâtre du Châtelet was looking for extras. I went to check it out.

At the theater, the head of the extras department wanted to know if I had ever read the novel *Around the World in Eighty Days* by Jules Verne.

"Of course—actually several times."

He didn't look like he particularly believed me. I continued, "It's about Phileas Fogg of London and his attempts to circumnavigate the globe in a mere eighty days to win a wager of twenty thousand pounds."

He raised his eyebrows, persuaded by the summary. "Very well. The Châtelet has been putting on a play based on that novel for sixty-four years without a break—over two thousand performances. Extras come and go and are often as in demand as they are now. You won't have to say a word, but you need to change costumes five or six times. The pay is twelve francs and fifty centimes for an evening performance, double pay for Wednesday and Saturday matinees. Are you interested?"

"Yes," I answered, with a mixture of excitement and relief. The pay would be enough to furnish our needs, though as a matter of fact it was a step backward financially. We earned a bit more carting vegetables. But at least I'd be indoors. I *was* interested.

"By the way—perhaps you have some friends who also might be interested."

"As a matter of fact, I do," I responded.

"Good. Send them to me."

I told the others about this opportunity. Ismail, as I knew he would, would prefer being a warm extra to being a frozen businessman.

For the next seven months, my hotel-mates and I appeared in the play. When not onstage, we pursued our studies in the dressing rooms. After the show, we'd go out with the girls of the corps de ballet.

One day, before a matinee performance, the man in charge of the extras wanted to know whether I was familiar with the last act.

"Of course. I am one of the ship's crew."

"Do you think you could play the captain?"

"Certainly. I even know the line: *'Et le cap sur Liverpool'* ['Course straight ahead to Liverpool']. He points his right arm straight forward."

"Very well, you are the captain from now on—with double pay."

After my first week as this character, during one performance, there was a chorus of bravos and clapping after I delivered my line. It came from the highest balcony at the back of the theater, where Charles and other friends of mine had bought the cheapest tickets to play a joke on me. To go along with it, I looked up at the third balcony and bowed.

My career as an actor came to an end in May 1940.

Early in the month the Germans found a way to circumvent the Maginot Line. They invaded on May 10 and easily brought to their knees first Holland and then Belgium. Denise and I had left Paris for the weekend, in spite of this dire news, and were staying in a small hotel in a beautiful town along the Seine, very popular, by the way, with the artistic community. It was early in the morning. Suddenly the menacing rattle of unfamiliar motor vehicles grabbed our attention. We went to the window and saw a line of tanks on the street in front of the hotel proceeding, as we learned, to meet the Germans, who were already in Belgium and advancing toward France.

We hadn't spoken about what we would do if the war

actually came to Paris. We spoke about it now. Denise said she wanted to visit relatives in the country and would decide there what to do next. I had no clear plans, but Charles and I had discussed joining the French army. Denise and I parted that day, and I never saw her again.

I returned to Paris and was with Charles in a café on May 12. I was talking to him about Denise, feeling a little blue about our parting, though I must say not excessively so. It always made Charles a little nervous when I talked about my relations with women and in particular my sexual adventures. He was a year older than I; he was a tall good-looking Frenchman and I a somewhat diminutive foreign Jew, but somehow he had never been able to attract women with the ease that I did. Charles was trying to belittle Denise's sexual freedom, a bit prudishly, it seemed to me. Suddenly we heard over the café radio a voice representing the French High Command announcing that the German enemy had initiated a massive offensive in the north of Sedan. Charles and I looked at each other. It seemed to both of us that it would be impossible for the French and their English allies to stop the Nazis now. The announcement was followed however by an optimistic declaration to the effect that we were putting up an admirable resistance, that our elastic defense was working wonders, and that our troops were repelling the German attack and inflicting huge losses on the enemy. Any apparent retreat was dubbed "strategic withdrawal."

Every day for the next few weeks there came, day by day, less and less credible announcements of tactical victory, but by May 21 we were in fact fighting in Laon, forty-five miles inside

of France. Five days later Abbeville and Amiens had been taken by Hitler's army. Since the French reports were silent about this, it was from Swiss radio that we learned that the Germans had reached the Channel and had split our forces in two. After that, it was more difficult to hide the truth.

Our troops were in fact retreating hastily, and no one was calling it "strategic withdrawal" anymore. The entire British Expeditionary Corps as well as the French First Army, encircled in the pocket of Dunkirk, was unrelentingly pushed back to the seashore. On May 28, Calais fell, Belgium capitulated, and the French were glad they had somebody else to blame for their losses.

ONE AFTERNOON DURING the first week of June, Charles and I, sitting on a bench in the Jardin du Luxembourg, were talking about the war. While I had been away with Denise, Charles's conflict with his family had at least for the time being relaxed. The imminence of a German invasion tended to bring patriotic Frenchmen together—even those who were anti-Semitic and deeply conservative. Charles's father had been an "appeaser," wanting peace with Germany at all costs, but he was not happy about the actual German invasion. Charles's patriotism was growing almost to a fury. He wanted to join the French army right away. For my part, I wanted to think more about it. I loved France, but it was not actually my homeland. My real home was already under Nazi occupation. Would it even be possible for a foreigner to join the French army? I would soon find out that it was not.

A few feet from where Charles and I were sitting, a well-dressed, elderly man wearing a ribbon in his lapel denoting distinguished army service seemed to be listening to our conversation. "Don't worry," he said. "Nothing is lost. In 1914 it was exactly the same, but we stopped them at Verdun!" He said this with a complacent smile. "France has not said her last words. Verdun is still holding out. We are going to turn them back soon, you'll see. We will end up stopping them, for God's sake! We will do something about it, no doubt!"

Every morning as I got up, I hoped to read the headline "A Successful Counteroffensive," but it never appeared. Every morning Swiss radio on the other hand told us how many square miles of territory and how many towns had been lost. In the evening, during the news hour, Charles and I, walking down the street, could follow the news on radios blaring from window to window. People were listening to the Swiss station, or sometimes to news coming from Stuttgart. It was rare to hear any French reporting about the calamity.

Paris was never more beautiful than during the week in June before the arrival of the German army. Late-spring flowers were in bloom, the trees in their greenest finery, people on the boulevards in fashionable garb all abustle. But dark questions loomed beneath these happy appearances. Would I have to leave and never see Paris again? What would the Germans do? Would they bombard this jewel of a metropolis, demolishing its magnificent and superbly tasteful architecture? Would the spirit of Paris itself be ravaged and destroyed?

Refugees from the north of France were streaming through

Paris on foot and on anything with wheels. Rumors had it that German paratroopers would be dropped soon, and that fifth columns were everywhere. Like many others, I could not believe that the French would capitulate so easily and surrender Paris, but preparations for armed resistance were nowhere in view.

THE DEBACLE

Paris and Bayonne, June 1940

EARLY ON JUNE 13, the Germans were not yet in Paris. Charles and I were walking along the avenue called de la Grande Armée—ironically as it now seemed. Charles looked at me, visibly upset, and blurted out something I had also been thinking.

"I can't take this anymore. I have to do something about it. I am going to enlist, even before they call me."

"I am with you. Why don't we go to the recruitment office at the Invalides tomorrow?" I suggested.

"Why not right away?" Charles insisted.

In the metro, I was a bit nervous—my own nature is to reflect before taking action.

I was not accustomed to being swept away by feeling, but Charles's solemn and determined expression overcame my hesitation. I simply followed him. The rattling of subway cars made me close my eyes, and in my mind, I could hear the

stirring lines of "La Marseillaise": "The day of glory has arrived / to fight against the merciless enemy."

Once off the metro and walking on our way to the recruitment office, I took a deep breath and tried to reflect on the practice of violence and war. I couldn't get my mind around the inevitability of taking up arms.

At the entrance at the Invalides, a sergeant directed us: "Office fourteen, first floor, on the left, C building—over there." He pointed across an empty courtyard. There was no one there save two trucks that had been parked in the center. As we walked across, we noticed a man carrying files headed in the direction of the vehicles, and soldiers dumping the contents of drawers into a small fire. What were they doing? No doubt, getting rid of delicate documents in anticipation of the arrival of the Germans.

In room 14, a tough-looking sergeant sat at a large wooden desk.

"Why are you here?" His tone of voice made us come to attention.

"Well, sir, we'd like to volunteer," Charles said.

"I need your identification papers."

We both slid our carte d'identité across the table. He glanced at them briefly before starting with Charles.

"All right, Levasseur, report to the main Paris armory tomorrow morning. That's all now, soldier."

Charles looked at me. "I'll wait for you outside," he said as he was leaving.

"How do you know each other?" the sergeant inquired.

"Well, we were classmates at the lycée and are attending the Sorbonne together."

He looked again at my carte d'identité. "You're French, no?"

All identity cards in France look the same except for one's place of birth.

"No, sir, I was born in the Free City of Danzig."

"So. You're German, then."

I thought it unwise to reveal my German upbringing. "No, sir, I am a Pole, my parents are Polish."

"Justus. Is that a Polish name?"

"No, sir, it is a Latin one. The Romans used it. It means the Righteous."

"Well, whatever. You are Polish. You cannot join the French army. If you want to enlist in the Polish army, you have to go to their recruitment and training camp at Coëtquidan, Brittany."

He signed a paper and handed it to me.

"How do I get to Coëtquidan?" I asked.

"On your own. Buses and trains are no longer moving that way."

Charles knew about Coëtquidan, located about 215 miles southwest of Paris. The fastest way to get there was to take the metro as far as Sceaux more or less in the right direction.

You might think that I would have been frightened, disoriented, filled with anger or confusion. As a matter of fact I was excited. Just as when I left for Paris two years before, I was ready for whatever would befall me. If I had any apprehension, it had to do with the Poles. In fact I had known very few of them in Danzig, and what I had heard was not favorable. Poles

themselves harbored many anti-Semites: their university segregated Jews, forcing them to sit in separate seats in classes; there were quotas for admission, and so forth. But what was most on my mind was the practical matter of how to get to Coëtquidan.

After Charles and I said goodbye, I went to my hotel, packed a few things in a rucksack, and was on my way.

Once off the metro I started to walk together with the thousands of individuals, cars, and horses that stretched in a line all the way to the horizon. I didn't know where they were going, but I thought it made sense to follow. We crawled along for what seemed hours with very little progress. Finally things sped up a bit for me when, at one of the crossroads, I showed my papers to a gendarme who was trying to direct traffic. He stopped a military truck going to Tours and put me on it. I didn't remember that Tours was south of Paris. In my confusion I must have considered anything away from Paris would be more or less on the way to Coëtquidan. The movement of the truck and my exhaustion put me to sleep, though I would frequently wake up with a start, disoriented by what must have been a long convoluted dream. I dreamt I was on the train leaving my family at Danzig. Then there were images from the week I spent with my uncle—his stories from *his* youth repeating themselves in my mind—how he would go to political meetings, sneaking out of the windows in his home—or how he would slip political pamphlets under doors in town. I promised myself that when peace returned, I would live with my rebellious uncle that I so admired.

I also experienced a nightmare—swarms of people trying

to get into the truck or to set fire to it, planes descending upon us with machine-gun fire, leaving my shirt soaked in blood. I woke up agitated and sweating and saw that the line of people fleeing Paris had not come to an end. The line and we ourselves were on a road that French tanks were traveling on in the opposite direction to approach the city. German planes were flying really low overhead harassing the military vehicles, and there were civilian casualties. I don't think the planes were intentionally targeting civilians—but I was in a military vehicle!

We drove for about two hours, during which time I fell asleep on a sack in the back of the truck while other soldiers around me—seven or eight of them—also slept on sacks or among crates. At one moment I crawled my way to the back of the truck to look outside, careful not to disturb the sleeping soldiers. I saw an endless caravan of people, stretching for miles and miles. It surely reached all the way to Tours, or even farther. At one point, the truck stopped, and I thought we had arrived, but there were no houses.

A gendarme approached us and asked for assistance. Ours was the only military vehicle going in the same direction as the refugees and he needed help directing traffic. After a few minutes, we hadn't started again, so I twisted my neck to see what was going on. The driver was standing on the side of the road, talking to two men. Another soldier in the truck with me who was also observing this conversation called out to the driver, "Are we sleeping here or what?"

"Tours was bombed twice this morning," replied the driver. "Dead people all over the place."

"Those German bastards," said a soldier in the truck looking at me. "Nothing to stop them anymore." The driver came back and started the truck going again.

When we finally arrived in Tours that evening, I saw what the driver had been talking about: there were bodies and injured people all over the place. We got off the truck. No one seemed to pay any attention to me, so I went up to a gendarme and told him I had come to enlist with the Poles at Coëtquidan and asked him how to get there.

"Well, young man, you are really coming at the wrong time. Everyone is trying to get out of here. And I don't even know if there *are* any Polish troops left at Coëtquidan. The bombing certainly hasn't improved communications with what's happening beyond Tours." He thought for a moment and added, "Go to the armory just around the corner, anyway, and see if they want to take you on. If nothing else, they may give you a place to sleep. It's possible they may have trucks going down to Niort or Bordeaux and can first leave you off at Coëtquidan."

I found my way to the armory, but there was practically no one there. I did learn that there was a truck leaving at noon the next day that might take me to Coëtquidan. All I needed to do was wait in the armory courtyard and not wander too far off—no one was going to come and fetch me! I settled by the wall of a great white building and tried to get a bit more sleep.

I was awakened by the frightening sound of alarm sirens. What was going on? I had never been violently startled that way before. The sirens themselves must have been very close to the armory. On the street behind the armory gate, I saw sol-

diers rushing out of the buildings across the courtyard heading for the street. An officer, or an adjutant, called to me, "Hey, you! Don't just stand there—follow the others!" At that moment I heard the planes and started to run.

I asked the adjutant, who was running beside me, "Where are we going?"

"To the building across the street. It has a shelter. There's none in the armory."

"Shelter for eighty people." It was an inscription over a doorframe. I ran inside and descended a dark staircase smelling of sour wine and mold, while the earth above me shook. A cobweb caught my face. The ground and walls began to move as the bombs fell like hail on the town and kept falling for some time. I didn't feel much like talking, nor did anyone else. The air seemed to be shaking as much as the ground. The thunderous sound of the bombs came in waves and could indeed have been mistaken for thunder, but we all knew it was not a storm of that nature. When it finally stopped, we just stood there, looking at one another wordlessly, wondering if it was really over.

"I think it's stopped," someone said.

We looked at one another again, and I took a breath. I felt better for an instant, but then the ground began shaking once more, but this time it seemed farther away. There was a new lull, broken only by someone screaming. It seemed to be coming from the stairs or from the corridor of the shelter. Another wave of bombs fell. The screaming, more like a wail now, continued.

"There's somebody up there," someone near me said. Two of us went to take a look. Suddenly light from outside flashed

across our faces, and I could see a man who had just opened the door. He was cradling something in his arms. He leaned against the wall, seemingly unable to come down, moaning feebly. We went up to him. He took a few steps toward us and then let out a horrible scream—the thing in his arms were his intestines, slick with blood. He collapsed, dead, before anyone could do anything.

It could have been me. I could have been there, at the feet of two soldiers, a mess of entrails and torn clothes, nothing but lifelessness forevermore. There was no more meaning behind this mass of bloody flesh beyond its capacity to awaken horror in others. What was all this talk of dignity and beauty in war? Where was this dignity and beauty postmortem? Where had the meaning gone? The scene reminded me of the one war novel I had read—the novel by Remarque whose English title is *All Quiet on the Western Front*. There is no beauty in death, only in life. Beauty is what lives. Death is the end, I saw, and any talk of the soul paled before this image, this heap of bloody death at the feet of two soldiers. I thought that I myself was nothing more than an animal of flesh and blood. Where was the soul? I never felt it in life, why would I feel it in death? What else could this man have done with his life? What future had war taken from him? He was stopped, frozen, at the end.

Of course there are some who would say that life itself is a dirty trick and this poor chap was out of harm's way and that nothing would ever come again to torment him. But did he want to die? I don't think so. Even if his whole life had been a failure, tortured by remorse or fear, did he want to die? The

way he grasped at the wall, how he was trying to stuff himself back together, his cries to us, his final moments of real agony—surely that was the pain that existed in the gulf between the will of his mind and his failing body. Perhaps he was someone who wanted, like me, to go on hoping, perhaps stupidly, that he could change the world. He had returned now to that place from which he had been pulled at birth, the outside of life. In any case, he would surely "live on," remembered by a plaque in gold, "Victim of the June 16th bombardment," but he could no longer change the world, at least not in the way he might have once intended. He was dead.

We laid his corpse against the wall at the bottom of the stairs. I covered it with an old bag I found lying around. I looked at him and was filled with a strange pity, as one might look at one's own reflection.

The sounds of planes had vanished, but it was still safer downstairs, as the all-clear siren had not yet sounded. I sat on the wet floor of this basement shelter while soldiers told us what they had seen. When my hands touched the cellar floor again, I saw myself as if in another nightmare, lying facedown as planes roared overhead. The feeling overtook me and I was convinced, if only for an instant, that the bombs were upon us once more, that the earth was trembling, and that I was up there lying with my stomach split open. A bomb could crush us and end it all, I realized—the barrier between life and death was so very thin. I thought of dying like this, before I had even lived my life, because up until this moment, I had known only education and adolescence, had not yet achieved anything significant. My

whole life seemed a void, an enormous and grotesque comedy, a lonely desert of a life few would remember.

I must have shouted something, for someone shook me out of my reverie, and others were looking at me puzzled. "Excuse me," I said, "I must have drifted off." I thought to myself that I must not die, so that I might live and experience every second of every minute. I wanted to eat, drink, make love, to lie in the hot sand with the waves of the sea gently reaching me.

The all-clear siren sounded.

I was told by some soldiers that the truck that was supposed to pick me up had been crushed under the rubble. They did not know where to find another vehicle, and besides, for the moment, there were other things they had to attend to. Later in the afternoon I did find another one on the other side of town, and soon I was off to Coëtquidan. Who knew what I would find when I got there.

Through back roads this time, the truck took me to the Polish camp. The sun was setting as we arrived, and as I jumped off, I felt a cold breeze. There weren't many people in the camp or in the barracks, and I started to wonder if I was in the right place. Perhaps it had already been evacuated? The truck I'd ridden in was already on its way out, leaving a small cloud of dust in its wake. I heard the sound of voices from one of the windows in the camp and walked toward them. I saw a light go on and I knocked on the door.

A man of about forty opened it. I explained to him that I was looking for the Polish recruitment office. He took me to another building where there were more lights on.

"Here it is," he said.

"Thank you."

"Come on in," said another man, in French with a Polish accent. He was decked out in full uniform with medals, ribbons, and epaulets. An officer. The Poles were as uniform-fastidious as the Germans. He tried to hold himself at formal attention while seated at a small table much like the one at the recruitment office in Paris. He took my papers immediately but didn't look at them.

"I enlisted in Paris and they sent me here."

"You are too late, young man; we are evacuating the camp. There's only about thirty men left. You said you came from Paris? How long did that take you?"

"Three days."

"Did you walk?"

"For some of the way . . ."

"Well, that's pretty good!"

While we were talking, he was fiddling in a stern and absent-minded manner with the forms I had been given in Paris. He saw the note, "Authorized to report at the camp at Coëtquidan on June 16, 1940," and his demeanor changed.

"Well, you're even early! Where are you from?" He flipped through his documents, and I saw him read and wince simultaneously. "Hmm . . . what to do with you? Since this morning we've been evacuating all the Polish soldiers to England. France is a joke. The whole French army is in disarray. They keep writing deployment orders that they never follow through with."

"What should I do?" I asked.

"What should *I* do?" he said with emphasis. "What do you think I should do with all these people I'm landed with? Most of them enlist just to escape, so I'm here to ask if you're really willing to fight?"

I had the strong urge to fight *him* instead of the Germans in that moment, but I let him go on. He said they had plenty of "people like me," by which he meant Polish Jews, and they did not know what to do with them. When he took a moment to catch his breath, I asked him calmly, "So I'll be on my way then? Could I have my papers back?"

"Don't be fresh with me! I could lock you up!"

"What, I can't leave?" He didn't reply to that but instead took out a big logbook and began to leaf through it. With his left hand he held my papers and looked between the documents muttering, "Rosenberg."

". . . it figures . . . here you are!" He was pointing to my name in the register. "Your name arrived from Paris three days ago." Then, as if he were talking to himself again, "I suppose I have to accept you. Here are my orders. I have to send you toward Bayonne, but the thing is, I have no means of transportation, so tomorrow morning you'll be on your way with the others, if you like, whatever way you can. If you want to go over to England from Saint-Jean-de-Luz near Bayonne, you have to get there by your own means. All right. You'll sleep here tonight. Just go into the first barrack with the lights on. Here are your papers back."

I went around the camp. It was almost night now. There were in fact several barracks with lights on. I chose one with no one else in it. I had to think things over and I preferred to

be alone to do it. Besides, the somewhat churlish officer, whose anti-Semitism was evident to me, had for the moment taken away my desire to be with the rest of the men. Just a bed would be good enough.

I realized that, first, I had to have a map to see exactly where Bayonne was. (It is just north of the Spanish border on the Mediterranean and Saint-Jean-de-Luz, a port very near it.) Then I needed to eat. Finally I would have to find a way of getting there. The officer had said "by any means" with all his decorations and arrogance. I would *show* him by getting to Bayonne, even if they did not want me with the rest of the company. I would manage on my own, without anyone's help. In any case, it was better that way. Every man for himself. I was getting fed up with what I was seeing of the army and its helpless direction at this point.

AFTER A SHORT nap, I thought once again of my three problems: I had to find some food, I had to find out how to get to Bayonne, and I had to find out how to get there *fast*.

Where might I find a map? Most likely in the commander's office. I thought I remembered seeing a map on the wall. The commander didn't sleep there—the office was tiny and there was no cot or even a comfortable chair—which meant I could access it, now that it was late at night, without much difficulty. Quietly I snuck into his office, turned on the light, and could see from the map how to find my way to Bayonne, about 290 miles to the south, on the various French roads. I took it off the wall and folded it to fit inside one of my pockets.

Then I raided the pantry, which I had noticed was located in a room adjacent to the office. The door (on the outside of the armory) was locked, but there was a window that, as luck would have it, was a bit ajar. I climbed in, and once inside, I found an old loaf of bread on a lower shelf, and up on the highest one, a box of sugar and three pieces of hard, moldy cheese. Better than nothing.

There was a garage to the armory and its door was open. No cars inside. Actually, even if there'd been a motor vehicle of some sort, I had no real idea of how to drive one. There *was* a motorcycle, but its tires were flat. I was really hoping for a bicycle. Unable to find a vehicle, it occurred to me that the next best thing was to acquire some fuel, in the hopes that I could find someone willing to take me along in exchange for it. In a small shack next to the garage, there was a pile of rather small empty cans, but under a workbench I found a few that still contained gasoline. There was an old canvas bag in the corner, big enough to hold a few of the cans. I stuffed as many as I could into them and set out on foot lugging the bag over my shoulder.

Technically, this was an act of theft, but the commander had told me to reach Bayonne "by whatever means" I deemed necessary. Furthermore, since I was in the army, and these were army goods, my conscience wasn't troubled. Still, fearing a night sentry, I hauled my cargo and myself over the fences at the back of the camp rather than go through the main gate. My journey had begun.

After about an hour, my load was too heavy to carry con-

tinuously, so I had to take a break every few miles. I read the map by moonlight—the night was clear—and I was able to recognize a few road signs pointing in the right direction. Beneath me—I was on a high road through the hills—I could see other refugees beginning to awaken from resting in the fields and thin trails of smoke coming from a town on the horizon.

The road led toward the town. When I reached it, I found a fountain in the town square—not a decorative fountain but one with a pump—from which I was finally able to have a drink of water. I saw a motorcycle propped up against a tree, and across from it a young man, apparently its owner, just shaking off the vestiges of slumber.

"Is that your bike?" I asked.

Still half asleep, he muttered, "What? Oh, yes, it's mine."

"Have you run out of gas?"

"No, but I'm close."

"I have some to spare, if you'd be willing to let me ride with you. I have to get to Bayonne."

The road to Bayonne passed through Bordeaux, at which we arrived in the afternoon, and the motorcycle owner would go no farther because his grandparents lived there. "Why don't you come with me?" he offered. "Come and have a bite with us." We hadn't spoken much, so this invitation was unexpected. I was worried about getting to Bayonne quickly, but I was hungry, and I put my apprehension aside.

"I would love to," I said, "but I don't have much time. And I have to figure out how to get to my destination."

"My grandfather knows many people here. Someone might be able to help you."

"Pardon me, but I don't know your name."

"My name is Francois, and yours?"

"Justus."

"What? That's not French! You're not French?"

"No, I was born in Danzig, but it seems now that I am Polish."

"Huh, Danzig. I don't know much geography . . . where exactly is that?"

"Northwest of Poland, on the Baltic Sea."

"At my grandparents', don't mention that—don't mention that name. They don't like foreigners. Go with 'Justin.'" This was my first experience under a false identity! There would be many more in the years to come.

We soon arrived at Francois's grandparents' home and were served a hearty meal. They insisted that it was too late for me to get back on the road and let me use a spare bed. I was anxious to get to Bayonne, but I was also quite exhausted, so I did not refuse their generous offer. Before falling asleep, I heard Pétain's speech on the radio announcing that he was asking for an armistice, that France had been defeated. They would now accept an "honorable peace."

I didn't know much about Pétain. I knew he had been a hero of Verdun in World War I and had been an important figure more or less on the political right since that time. I was not happy that France had capitulated so easily. I had wanted to join the French army, and, since that proved impossible, I was on my way to join the Poles. There were at that time many Poles liv-

ing in France. They had been brought in because, for one thing, they were needed for their skill as mine workers. But more generally there was a connection between French and Polish high culture. Think only of Henri Chopin. I assumed the Polish army would be fighting alongside the French against Hitler, but what would happen now? Pétain's right-wing leanings no doubt made him a likely person to head up a French nation under German rule, but what would he be forced to agree to in this armistice? Once again, I was worried that anti-Semitic regulations would be instituted in France. I had nowhere else to go, so I thought I might just as well go to England and join the Poles.

The next day, a truck driver, who had worked for Francois's grandfather, agreed to take me to Bayonne. There was bus service from Bayonne to Saint-Jean-de-Luz, and I learned from the truck driver that the British had sent ships there to pick up Poles who had begun to form an army. The bus was late, however. Arriving, I noticed that there were no ships in the harbor, and so I found a nearby police station. Inside an officer told me, "If you'd gotten here a little while ago, you could have boarded a boat with the soldiers, but they're gone, and don't ask me when there'll be another one. Until Pétain signs the armistice and we know what the Nazis intend to do, everything at this harbor is on hold."

"You say the boats left a few hours ago?"

"Oh, not even that long. From the promontory at the end of town, you may still see them."

"That's too bad! I am an experienced sailor. As a matter

of fact I've just returned from traveling around the world in eighty days!"

I walked away, leaving the gendarme with a quizzical look in his eye and ran up the hill to the promontory. The ocean did not look nearly as glamorous as on the sets at the Châtelet, where stagehands crawled like caterpillars underneath the painted canvas to suggest the rolling of the waves. I shielded my eyes from the sun. I could see a tiny flotilla, under thin ribbons of smoke, floating away over the horizon. I wouldn't, it seemed, be joining the Polish army in England.

TOULOUSE
———

June and July 1940

*"Things don't happen . . . it just
depends on who comes along!"*

A FTER THE DEBACLE at Bayonne, I needed to find a Polish consulate. No one knew when the armistice would be signed or what its stipulations would be. At this point it seemed to me safest to maintain that I was from Danzig but of Polish nationality. The nearest Polish consulate that might be of help in legitimizing my situation was in Toulouse, 150 miles away. At Saint-Jean-de-Luz, I found other Poles wanting to join the Polish forces and who had also missed the boat. They were in

the process of hiring a truck driver to take them to Toulouse and they let me join them.

We drove to Toulouse. The situation at the consulate turned out to be more chaotic than any of us anticipated. When we finally got the attention of an official there, and it was my turn to be dealt with, the official said to me, "Leave your name with us and come back in a few days to pick up your 'Ordre de mission' for Casablanca, which might help you to get out of France." (This was an order sending me to Casablanca, the capital of Morocco, a French colony that remained relatively open throughout the war.)

"Where do I stay in the meantime?"

"Wherever you can find a place."

After the German invasion of France, the population of Toulouse was to quadruple in a fortnight to about a million. It was already teeming with refugees. All the hotels except for the most luxurious ones were so full that people were sleeping on and under dining room and pool tables, on the floor of hotel lobbies, and outside in abandoned automobiles. I spent my first night in Toulouse on a bench in a public park sharing it with an experienced refugee who gave me two useful tips. "Try one of the most expensive and luxurious hotels, dressed in your best clothes, and sit down in one of those well-upholstered chairs in the lobby. If they ask you what you are doing there, tell them that you're waiting for your parents who have a reservation and will be arriving shortly. That might work for one night. After that, go to the Cinema Pax, which is owned by the Toulouse Socialist Party and whose seats have been replaced by

bags filled with straw to serve as beds for refugees. They'll let you in if you tell them that in Paris you belonged to the Young German Socialist League."

I found such a hotel and it *did* work for one night (in spite of the fact that I had no traveling wardrobe). On the next evening, I went to the Cinema Pax, which was packed with radical and progressive refugees—the full leftist political spectrum—socialists, anarchists, Trotskyites, Stalinists, Spanish Republicans—which made for heated debates in the Cinema and in nearby cafés.

For several nights I slept in close proximity to a small, brown-haired woman in her midthirties who told me that she and her husband had joined the International Brigade and fought on the side of the Republic during the Spanish Civil War (1936–1938). Her name was Katia Landau. Prior to meeting her I knew that the war had pitted rightist Nationalists led by General Franco, against left-leaning Republicans led by Juan Negrín. The Nationalists were backed by Nazi Germany and Fascist Italy, while the Republicans drew most of their support from Mexico, the Soviet Union, and international volunteers. I confessed to Katia that after my arrival in France, I had been toying with the idea of joining an International Brigade myself, but by that time, the war was almost over. It had been a bloody conflict, killing nearly half a million Spaniards. By the time the victorious Nationalists took over the government in April 1939, more than another half-million had fled Spain across the Pyrenees to southern France. I told her my story, then she told me more of hers.

Her husband, Kurt, was an Austrian communist, a Trotsky-ite, who wanted to make peace with the Stalinists and thereby stop dividing the proletariat, so that they could all fight together against fascism. In November of 1936, Katia accompanied Kurt to Barcelona. They were members of the Partido Obrero de Unificación Marxista (POUM) (The Workers' Party of Marxist Unification). Recently, in May (1939), POUM had been outlawed by the Republican government, which said that *the Communists* were dividing the working class and, by doing so, helping the German and Spanish Fascists. Her husband was a member of the Executive Committee of POUM and went into hiding. Katia learned that he had been arrested and she had heard nothing of him since. Some friends of hers helped her leave Spain and settle in Paris. When the Nazis invaded France, she came to Toulouse hoping to get a visa to Mexico, which was more hospitable to leftists.

I wondered why the unification of the Marxists would have been a problem for the Republican government. Katia explained that the real tragedy of the Spanish Civil War was that the anarchists and other non-Communist Republicans, who, in coalition, were in the majority, could never develop a strategy together with the Marxists. The unification of the Stalinists and the Trotskyites would have strengthened the hand of the Marxists, weakened the others, and intensified their conflict since the Communists would no longer be divided.

ONE AFTERNOON, AS we were talking, Katia was visited by a young woman named Miriam Davenport. Katia and Miriam

had become friends in Paris while they were living at a small Latin Quarter hotel. Miriam invited us out for a bite to eat. She was a rather small, slender young woman, given to the giggles. She wore her ash-blond hair parted in the middle from her forehead right down to the nape of her neck, the two parts braided and somehow folded on the top of her head, giving her an unmistakable if rather prim look.

Miriam introduced herself, saying she was a graduate of an American college and had received a fellowship to pursue a doctorate in art history at the University of Paris, the Sorbonne. Once it was clear that the German army would be threatening Paris, the Sorbonne had decided to hold its end-of-term exams at the University of Toulouse.

"I'd be taking exams here myself if I weren't looking to get out of France!" I told Miriam.

"I'm not staying here either," she responded. "I'll be going to Marseille to revalidate my passport at the American embassy. I need to inquire about a Yugoslavian visa and apply for an Italian transit visa. My fiancé is a Slovenian—he lives in Ljubljana—and I want to marry him and take him back to the States. You know," she continued, "I think you yourself would have a better chance of leaving France from Marseille. Let me give you the address of the hotel where I'll be staying, in case you need some help."

We talked a bit more, and Miriam started joking about my name. "What should I call you? I can't call you 'Justus.' Are you 'Judge Rosenberg'? Maybe I'll call you 'Juss.' Hmm. What about 'Gus'?"

"No no no," said Katia. "Too German. Too much like 'Gustav.' How about 'Gussie'?"

"Terrific," said Miriam. "We'll call you 'Gussie'!" Somehow it stuck. I became "Gussie," and later on she introduced me to her friends in Marseille as such.

At this point Miriam said she had an engagement somewhere else, so she bid us goodbye and left the restaurant.

After Miriam was gone, I asked Katia, "She hardly knows me, why is she being so nice to me?"

"Oh, I don't know. But maybe you remind her of her younger brother. She had to take care of him after their parents died. He's about fifteen now. You do look young for your age, and no doubt she would have come to his rescue if she found him in circumstances like yours."

"Do you think she's right—that I should go to Marseille?"

"I think she might know."

ON JUNE 20, 1940, in the middle of the day, I was standing in the city square waiting to hear the latest news, which was generally broadcast over a public-address system. The speakers came on and proclaimed, "France and Germany have agreed to end current hostilities."

On the twenty-second of June, and on Hitler's insistence, the signing of an armistice agreement was to take place in the Compiègne Forest, the very site where the Allies and Germany had signed the armistice that ended World War I. France was now a divided land: German troops would occupy all ports north and west and the key railway hubs, as well as approximately 55

percent of French territory. The area south of the Loire to the Mediterranean remained an "unoccupied zone" ruled by the government in Vichy.

The powerful French navy remained permanently anchored at Toulon, a large town about thirty miles east of Marseilles. The French army would henceforth be highly restricted numerically. I'm not sure exactly what the agreed-upon maximum number of troops was. According to "Article 19" of the armistice, the now officially recognized Vichy government would be required to surrender "on demand" any German requested by Nazis. In response to protests by the French Armistice Delegation and public outcry, the German representatives let it be known that they would restrict extraditions to very few individuals. As a matter of fact, they adhered to their promise for the first two years of the accord, at least regarding extradition from the unoccupied zone. But *Liberté, Égalité, Fraternité* (Liberty, Equality, Fraternity), the famous motto of the now defunct Third French Republic (and really the rallying cry of France since the first French Revolution), would be replaced by *Travail, Famille, Patrie* (Work, Family, Nation).

I continued to stay at the Cinema Pax, trying to decide whether to go to Marseille.

Marseille, the second-largest city in France, would now be the unofficial capital of the unoccupied zone. It was still unclear to me what I should do under the new political conditions, but it was the most convenient place to go to acquire visas, if I decided to leave. Marseille indeed was the best bet for finding a way out of France.

TO MARSEILLE, IN MARSEILLE

August–September 1940

THE TRAINS FROM Toulouse to Marseille were so packed that it took the dexterity of an acrobat to get on one. Some people climbed through the windows, others forced open the emergency back door of the train's last car. Unable to get through the dense crowds on the trains, conductors gave up collecting tickets. Space was so tight that some people sat on the reinforced netting above the seats.

I managed to board by abandoning my suitcase on the platform, so at least I wasn't burdened with my bag when I arrived at Marseille past midnight. It only held a few necessities—nothing that I would regret parting with. I had put all my important papers in a pouch that I kept on my person. I wandered for an hour through dark streets trying to find Miriam's hotel. When I finally arrived at the address she gave me, I wasn't sure it was the right place. The building looked more like an upgraded army barrack than a hotel, despite the large, pretentious golden letters above its entrance: "Hôtel Paradis Bel-Air," really rather inaptly named. It should rather have been called "Purgatory," if not "Inferno." Its inhabitants, hopefully, were just passing through!

In the lobby, dimly lit due to the lateness of the hour, there were no chairs or sofas. The concierge was asleep at his desk. How was I to get to Miriam's room without knowing its number? I had to wake him. Obviously annoyed, he thundered, "Didn't you see the sign at the door? No vacancies."

Time for some quick thinking. "I did, sir, but I'm not looking for a room. I'm here to deliver an urgent message to my cousin who is staying with you."

"And who might that be?" he inquired, raising his eyebrows.

"Her name is Miriam Davenport."

He looked me over from head to toe. "You mean the American girl with the funny hairdo?"

"That's her, sir." I nodded. "May I take the message to her room?"

"Leave it with me."

More quick thinking: "I'm sorry, but I cannot do that, sir. It's very . . . personal!"

Thinking that he was witnessing a tryst between a modern-day Romeo and his Juliet, he said, "Room 607 on the last floor under the rafters. The elevator's busted. You'll have to walk up."

Though exhausted by the train ride and wandering about the streets, I managed to climb the stairs and discreetly knocked on the door marked 607. No answer. I knocked again.

"Who's there?"

"Gussie, from the Cinema Pax in Toulouse."

She opened the door, drew me into the room, and whispered, "Shh! Come in." We talked very briefly. I told her I had no place to stay in Marseille. She nodded okay. "We can dismantle my bed." We put the mattress on the floor and I lay down on it. Miriam dropped onto the box spring. We were both asleep without even saying good night.

WHEN I WOKE up next morning, Miriam was gone, but she returned an hour later to tell me she'd moved into more spacious accommodations downstairs, and that I could stay in her room where I was. How had she managed that? Did she bribe the concierge? I have no idea.

We put what would now be *my* bed back together and walked across the street to a bistro for breakfast—café au lait and a croissant—Miriam's treat. After breakfast we went our separate ways and agreed to meet at the bistro again to tell each other what we had seen, heard, and done. That evening, Miriam reported she had spent a good part of the day trying to get her visas.

"It seems it's going to take much longer than I hoped," she said.

Late in the afternoon, she had left the consulates and gone to the US embassy to have her own passport revalidated, where she met a very attractive and handsomely dressed American girl who was also trying to get out of France. They hit it off and when they were done at the embassy, they went for a drink at an outdoor café overlooking the old harbor.

"Her name is Mary Jayne Gold," Miriam said. "In spite of her Jewish surname, she's not Jewish, she insisted on informing me! Her family lives in Chicago."

They talked for a little while, but then three fellows surrounded Mary Jayne and asked if they could take the three empty seats at their table. Two of them were British soldiers stranded in Marseille waiting to be evacuated to Gibraltar. The third, a Canadian, had signed up for five years with the French Foreign Legion and was waiting to be sent to Algiers.

"I don't know what his real name is," Miriam pondered, "but his friends call him 'Killer'—no doubt because his conversation assassinates the English language, and incidentally because he looks a bit like a tough guy."

Miriam giggled and continued, "Mary Jayne and Killer very quickly became cozy with each other and arranged a rendezvous for the next day. But how was *your* day, Gussie?"

"I roamed all over town. While walking past St. Charles Station, I saw an elderly man struggling with his baggage and realized how difficult it is to navigate the stone steps leading to and from the station. I helped the old fellow. I didn't ask him for a tip, but he gave me a generous one anyway. It occurred to me I could earn some money helping people up those steps to the station."

These evening meetings with Miriam became a custom. I became a regular presence on the St. Charles Station steps, and Miriam continued to explore the city while the process of acquiring her visas dragged on.

One evening a few weeks later, she told me something particularly interesting.

"This morning," she said, "I received a message from Walter Mehring—you must have heard of him."

I nodded. "He was one of the most wittily sarcastic poets of the Weimar Republic."

In fact I knew all about him, and he was already something of a hero for me. In the 1920s, Mehring had been a prominent author with a caustic and expressionistic style reflected in poems, plays, and songs performed in the best Berlin cabarets. He

was an anarchist, a dadaist, and a proponent of revolutionary pacifism, and he was still considered one of the leading authors in the German language. The Nazis of course hated him. When they came to power they burned his books and revoked his citizenship. Though Mehring was thoroughly Aryan by birth, Goebbels called him a "subversive Jew" and a "cultural Bolshevik" because of his contempt for anti-Semitism and his anti-militarism. He fled the country. I was fascinated that Miriam knew him and I wondered if I could be introduced to him.

"Well, I met him a few months ago in Paris. He had published a highly derogatory poem about Hitler that got Goebbels's goat. Walter was sure the Nazis were after him in Germany, so he fled to Paris. We were living at the same hotel in the Latin Quarter, and now he's here. He asked me to pay him a visit, and I did it this afternoon. I found him cowering in a small hotel in Pointe Rouge, on the outskirts of Marseille. He's afraid to come into town."

"Is he so recognizable that appearing even in an urban crowd would put him in jeopardy?" I asked.

"Unfortunately, yes. Mehring is a very conspicuous fellow. Wherever he goes he stands out like a sore thumb. Even when things are going well for him, his appearance is on the rumpled side of shabby. He always looks like a *clochard*, the kind of tramp or bum the police love to pick up for loitering or being 'drunk and disorderly.' Walter is no drunk, but that's beside the point. If he were to be picked up, his identity would be discovered. Naturally he fears being turned over to the Nazis. He rarely ventures out and spends most of the day with a fellow

exile in the bar Mistral next to his hotel. Once he *did* venture into Marseille, but someone recognized him and greeted him demonstrably. He panicked and took off back to his lodgings.

"When I saw him this afternoon, Walter told me of an American who has come to Marseille with pockets full of dollars and a list of two hundred artists, writers, and intellectuals. He is commissioned by something called the Emergency Rescue Committee to help them get visas. Walter said that the man is staying at the Hôtel Splendide. He wants me to go and see him to find out if his name is on that list."

THE NEXT EVENING Miriam told me about her encounter with this American. She had gone to the Hôtel Splendide and found him looking like a banker or businessman rather than someone entrusted with a delicate rescue mission.

"The man's name is Varian Fry. I told him my name and that I had come to see him on behalf of Walter Mehring. I said, 'He's afraid to come to see you in person, but he needs to know whether he's on your list.' Fry shuffled his files and said, 'Yes, he is on my list. But it's a rather complicated case. He has no passport, and you need one on which to stamp your visa. Give me his address, and I will get in touch with him directly from now on.' As he was talking, he seemed to be studying me. He said, 'Miss Davenport, tell me something about yourself.'

"I told him how I had been a student at the Sorbonne and that I was here to get visas for myself.

"'It seems like you may be here for a little while.' He paused. 'Can you type?'

"'Yes,' I said, 'why do you ask?'

"'Since word has gotten around that I am here, not only people on my list come to see if I can help them. I myself need help—someone to interview them and type up reports to me about them. Would you be willing to work with me?'

"Without hesitation I said that I would.

"'Very good,' he said. 'By the way, we won't be conducting the interviews here. As of September first, we will be at 60 rue Grignan—a more appropriate facility than a room in the Hôtel Splendide, and the name of our committee will be Le Centre Americain de Secours. We will refer to it in English as the American Emergency Rescue Committee, or ERC for short.'"

One evening she knocked on my door and said enthusiastically, "Gussie, I think I may have found a real job for you. There are six interviewers working for the Rescue Committee. This afternoon Fry asked us if we knew someone to be a courier ferrying documents between him and the people he was helping. I said, 'I know just the man.' I took the liberty of giving him your name and telling him that you are fluent in German and French, know some English, and that, though Jewish, you could pass as a gentile with your blue eyes and blond hair; that you are familiar with the contemporary political situation; and, most importantly, that you can be trusted."

Miriam giggled and continued, "Fry said, 'Sounds too good to be true! But send him to me tomorrow morning.' Gussie, are you up for it?"

"Yes, of course. Sounds exciting!"

Though I was managing to put together a little change

on the steps of the station, it wasn't a very productive way of spending my time. I was thinking more and more about how to do something to oppose the Nazis. This sounded like it might be my opportunity. And Miriam told me everyone working for Fry was provided with a living allowance.

She gave me the rue Grignan address and told me to be there at nine the next morning.

The next morning, the streets on the way to the office were bustling with life. Rue Grignan was close to the harbor. On the large square where the main avenue known as "the Canebiere" goes down to the water, produce sellers hawked their wares, one louder than the next. On fishing boats attached to the wharf poles, the wives of fishermen offered the catch of the night in the most imaginative terms. In the back of the harbor, the masts of hundreds of little yachts quivered above the blue water as they swayed restlessly, tied to their moving moorings.

I arrived at nine sharp. To me Fry looked more like a British public school "don" than Miriam's "businessman." He examined me up and down, asked a few questions in French, but, as soon as he realized that my French was much more fluent than his, switched to English and explained what was expected of me.

FOR THE FIRST few days I ushered people into the office for their interviews. Within a week, I began to be given more significant and potentially hazardous assignments pertinent to the situation of refugees in Marseille.

Beginning in 1933, with Hitler's ascension to power in Germany, refugees including politicians, intellectuals, artists, Jews,

and members of other non-Aryan groups were flowing into France not only from Germany but from Poland and many Balkan states where democracy was being suppressed. The flow increased markedly after 1936, when Léon Blum and the leftist Front Populaire (Popular Front) assumed power in France and did not restrict such immigration. When war broke out with Germany's invasion of Poland in 1939, at first the refugees felt safe, largely because of the Maginot Line. But in the spring of 1940, when Germany circumvented the line by invading France through the Netherlands and Belgium, all hell broke loose. Everyone was on the run. To where? Marseille and the Spanish border.

The armistice of June 1940 stabilized the situation but not by much. It divided France into occupied and unoccupied zones. Refugees flowed into the south of France, but even there, they lived under constant fear of the infamous Article 19—whether or not it was being applied. This article in the armistice agreement was intended to ensure that Germans taken prisoner by the French during the three weeks of combat would be returned to Germany, but it was worded ambiguously, suggesting that the Vichy government would be required to surrender any refugees fleeing to the unoccupied zone whom the Germans deemed inimical to the Reich. In fact, during the period of the Vichy regime, the Germans only acted upon the prerogative twice, but thousands of political leaders, journalists, educators, and scientists, in addition to artists, intellectuals, and people of non-Aryan ethnicity felt threatened.

In the same month as the armistice, a group of intellectuals calling themselves American Friends of German Freedom had

met in New York City and formed the American Emergency Rescue Committee. Its purpose was to help intellectuals whom they thought were in particular danger get out of France. They raised $3,000, made a list of some two hundred people, and looked for someone to go to France and secure visas for them. Several people they approached declined for one reason or another. Varian Fry was by no means their first choice, but he was willing to go—for what they imagined would be a mission lasting not more than a few weeks. Nothing in Fry's background had prepared him to deal with refugee work—legally or outside of the law.

When he arrived in Marseille on August 15, 1940, with the money and the list, by his own admission he really had no idea of how to go about accomplishing what he had to do. How was he to get in touch with these people and what could he do for them when he found them?

Fortunately he had been given two or three names of Americans who were already in Marseille and possibly could provide him with information and names of people willing to be of assistance. One of these was Dr. Frank Bohn, who had been sent by the American Federation of Labor to help threatened European labor leaders get out of France. Bohn was able to provide Fry with some useful contacts and tips.

The first task was to assemble a staff to handle the influx of people and to examine their political views, credentials, and the merits of their work. By the beginning of September, some fifteen people were part of the operation. They included my two American friends (Miriam Davenport and Mary Jayne Gold),

two Frenchmen (Daniel Bénédite and Jean Gemähling), an assortment of Germans, Romanians, Austrians, and now myself.

OVER THE PYRENEES

———

September 11–13, 1940

"Il n'y a pas de grand homme pour son valet de chambre" (*No one is a great man to his manservant*)

—Napoleon Bonaparte's personal valet

During my first week as a courier, I was constantly on the run between the ERC's office and Marseille's central post office sending coded telegrams to New York. I went from one *tabac* (government-licensed tobacco store) to the next buying blank identity cards and taking them to a person staying at the Hôtel de l'Espérance (Hotel of Hope!) under the pseudonym Bill Freier. The blanks were official forms for the identity cards everyone in unoccupied France had to carry. One filled them out and took them to the police to be stamped. Of course, many of the refugees under the Vichy regime had no official status, so the stamp had to be forged. Freier was a master forger.

I remember having seen him before I joined the ERC, sitting in front of a fancy restaurant on the old harbor drawing caricatures of people for ten francs a picture. They were so artfully and skillfully done that I would have had him draw one

of me had I had the money. Freier was using his skills to forge documents for Fry: Vichy identification cards complete with a police stamp and the signature of the "Commissaire de Police" flawlessly executed.

The first time I was on this mission, realizing that I carried a bunch of fakes with me, I kept looking over my shoulder to make sure I wasn't being followed. Just to be on the safe side, before going back to the ERC office, I darted into a big department store with many entrances and exits, ran out again, and jumped onto a bus just as it drove off, a maneuver I'd seen in spy movies.

My first *truly* dangerous mission was undertaken in the second week of September 1940 when Fry asked me to meet him and one of his trusted assistants, Leon Ball, at 4:30 A.M. inside St. Charles Station. When I arrived, he and Leon were talking to two elderly couples surrounded by a mountain of suitcases. Fry was in a state of great agitation, gesticulating and walking back and forth in front of the people he was talking to. His behavior struck me as rather odd and very much in contrast to the subdued manner of the circumspect person I knew in the office.

While Fry went to the ticket window, Ball took me aside and told me that all of us would be boarding the train to Cerbère, a French town close to the Spanish border, and that I would be in charge of the baggage. From identification tags on the valises, I could tell that eight of them belonged to a Mr. and Mrs. Mahler/Werfel. Could it be, I wondered, Franz Werfel, the author of *The Forty Days of Musa Dagh*, a novel that dealt with the genocide of the Armenians by the Turks during World

War I and that had brought him world fame? The lady next to him must have been his wife, Alma, a celebrity in her own right, the widow of the composer Gustav Mahler and later of Walter Gropius.

The other suitcases belonged to Mr. and Mrs. Heinrich Mann, another name familiar to me as Heinrich was the author of several novels, in particular *Professor Unrat*, whose film adaptation known as *The Blue Angel* I saw that night with Elisabeth.

Our task on this adventure would be to get all these people across the Spanish border. Though the Fascists had won their civil war with the help of the Germans and were more or less their allies, they were not obstructing French refugees from entering Spain as they attempted to leave Europe. Generally the French required one to have an exit visa to depart from France, but if you could get across the border without one, the Spanish as a rule would not send you back, though this was not always the case and what would actually happen varied from day to day. But the main obstacle in our adventure was that, except for Fry himself, none of us had exit visas.

By the time Fry returned with the train tickets, Golo Mann, Heinrich's nephew (and Thomas Mann's son) had joined us. Fry pointed to the mountain of valises and said, "Make sure that these bags get on and off the train with no problems."

At precisely 5:30 A.M., the locomotive pulled out of the station into the panorama of Provence, still under the blackness of predawn. Two hours later at Nîmes two gendarmes came aboard to check the passengers' papers. Traveling to the border without a special permit or French exit visa could lead to arrest.

They walked right past our first-class compartment. They must have thought that such distinguished-looking elderly people and their relatives would not be traveling without proper permits.

With the gendarmes gone, the Manns, the Werfels, and Golo, who had Spanish, Portuguese, and US visas but no French ones, were still anxious. Fry calmed their apprehension, saying that his plan would enable them to travel directly from France to Spain without impediments. "Upon reaching Cerbère," he said, "we have to get off the train to catch a connection to Portbou on another platform. To do this, you must go through a restaurant that exists *between* the platforms, to avoid having to pass through Passport Control."

At the station at Cerbère, we all sat down in the restaurant, while Fry and Ball went out the other door to try out the stratagem, but they were stopped by customs officials. Only Fry was *en regle* (had proper papers) and could get to the train. They wouldn't let Ball through. They came back to the restaurant.

Ball now took charge of the situation, gathering everybody's passports and disappearing into the office where the officer in charge was sitting, but he soon came out again, looking rather glum. The border guard had strict orders: no exit visa, no boarding the Portbou train. Ball persuaded the officers to keep the passports—to ensure that we weren't going anywhere—and allow us to find a hotel and stay overnight while the matter of our papers was straightened out.

Fry placed three possibilities before us: we could return as far as Perpignan (a large town about thirty miles away) and try to secure exit visas; Fry could do that while we waited in

Cerbère; or we could cross the Pyrenees on foot and land in Spain.

I must say the whole operation seemed a little strange to me and still does so. What was Fry's actual concern in getting these important people out of France? Why did he give them so much priority that he himself was accompanying them? I think it was because he wanted to show the people in New York his competence and that he was willing to take the risk. He was anxious, but also invigorated. If things misfired, he would be responsible for the arrest and internment of the people depending upon him, but as a matter of fact, the risk wasn't actually his! The US still had diplomatic relations with both Vichy and the Germans. But if he pulled it off, it would be by the grace of his decisiveness and daring.

There was an irony in these particular exiles' situation, for they were people, it turned out, who had made their living by what they wrote on pieces of paper. They were famous authors and their wives. Now suddenly their lives depended on what others wrote: Fry's "list"; false names and fake passports; a primitive border map; the blue writing on visas; and instructions communicated by brief and enigmatic telegrams.

We agreed that the refugees should trek over the mountains. The distance to Portbou was about five miles as the crow flies, but it involved a very difficult climb over rough terrain up the Pyrenees and down. It was especially difficult for the elderly people in our party. Ball and I would go along to assist them, and Fry would travel with the luggage to Spain and meet them at Portbou. Now I had to make sure that the luggage went along

with *him*. Fry downplayed the difficulty of the passage across the mountains, though it should have been clear that the aging couples would have no easy time of it. Werfel was a short, plump man with a pear-shaped body and bottle-bottomed glasses, and soon had trouble keeping up with the purposeful stride of the imperious woman—Alma Mahler—at his side. Eventually she and Ball had to prop him up to get him over the mountains. Heinrich's wife and I, in turn, helped Heinrich.

During our long forced march—a hike that would normally take two hours took us six—I got to know Nelly Mann pretty well. She was a relaxed and jovial woman, even under these trying circumstances, and was very happy to have someone with whom to talk German. Every so often she discreetly pulled out a small flask of brandy, took a swig, and offered it to me. She told me her maiden name was Kröger and that she had married Heinrich—who was now seventy years old—only ten years before, though they had been together since the '20s when as a young cabaret dancer she met him. She was now just forty-one.

From the mountaintop we could see Portbou below, directly adjacent to the Spanish border. As soon as they arrived at the border and made it across, they would have to register and show their Spanish transit visas. Once their passports were stamped, they would be free to take the first train to Barcelona, and from there to Madrid and Lisbon. All this happened without any further difficulties. Fry went with them, Ball and I boarded a train, I to Marseille, Ball to other projects.

On the ride back I gave some thought to what I was doing at the American Emergency Rescue Committee. There were

many practical matters involved in getting people safely out of France. It required a lot of money, a lot of planning, and a lot of people to carry out the tasks that made rescue possible. I think of these people as the spear-carriers in an army. It seems I was to be a spear-carrier in the struggle for freedom.

WALTER BENJAMIN

Late September 1940

WHEN I GOT back to the ERC office on September 13, since I was the first returning from what was in fact a test run across the Pyrenees, everyone in the office was relieved to see me and wanted me to tell them of my experience. Two weeks later the place was abuzz with the story of another attempt to get refugees across the Pyrenees, this one not quite as successful as ours. The ERC, it turned out, was not the only group involved in this line of work. Hans and Lisa Fittko, as private individuals, had established themselves in a pension at Port-Vendres near Portbou and were helping refugees, intellectuals, artists, and anti-Nazi organizers without proper exit visas leave France. Walter Benjamin had approached the Fittkos and he was part of a party on their way into Spain.

I knew nothing about this Walter Benjamin, who in fact was one of the most insightful, original, and eccentric intellectuals of the twentieth century, though he struggled all his life for

academic and other recognition. There had been a period when he was known as a leftist thinker among German intellectuals—a close associate of Theodor Adorno, Gersholm Scholem, Hannah Arendt, and many other important thinkers. Though his scholarship was impeccable, his views, his habits, and the sheer inventiveness of his literary manner made an academic career very difficult.

At forty-eight, in frail health when he attempted to leave France, Benjamin was not on Fry's famous "list" and he had not sought our help. I have often asked myself why that was so. I had once taken a peek at that list, and what I noticed was that though prominent artists and intellectuals, many of them "radical" in various senses, were on it, known left-wing political ideologues and activists were conspicuously absent. Be that as it may, he had come to Marseille seeking to leave France, where he was fairly well connected to other important intellectuals, including the novelist Arthur Koestler. His friends had succeeded in getting him visas to cross Spain, enter Portugal, and to enter the United States, where a position at the New School for Social Research awaited him. The only thing lacking was the French exit visa, which, as we have seen, was only necessary some of the time.

On the journey across the mountains, Benjamin, according to everyone who accompanied him, remained stoical and gracious in spite of the fact the man was suffering from a heart condition, depression, and general nervous fatigue. He followed a regular procedure, walking steadily for exactly ten minutes, then resting. He kept that rhythm for the whole journey.

Though he and his group made it across the border, they were stopped right in the village at Portbou where the local *Spanish*—not the *French*—authorities would not let them proceed through Spain without the French exit visa. They would be allowed to spend the night in Portbou but would then have to return to France, unless of course the rules changed. The next day the rules did change. The refugees were allowed to go on, but Benjamin had been too distraught to wait out the night and try again. A long-term drug user, he was carrying a supply of fourteen morphine capsules, swallowed them all, and was found dead in the morning. It was no accidental overdose. He left a suicide note for Theodor Adorno in the hotel room.

I felt that Benjamin's tragic death confirmed an observation I had made while trekking across the Pyrenees; namely, that especially gifted persons—what the French academy dubs "*les Immortels*"—have their weaknesses, temptations, fears, and doubts, just like any of us mortals. We idolize those whose innate capacity, ambition, sometimes public-mindedness, sometimes necessity, sometimes rank desire—have propelled them toward achievement. There are no geniuses, really, only what people make with what they are given—that, and a confluence of circumstances. I myself have had an interesting life and a successful academic career. This is certainly partly due to my ability to learn languages with ease, but just as much to the people I met, the historical events I happened to be a part of, narrow escapes in dangerous situations, and the habit I formed of thinking seriously about what was happening along the way.

VILLA AIR-BEL

November 1940–February 1941

B Y THE TIME I returned from the Pyrenees, Miriam Davenport had moved out of the Hôtel Paradis Bel-Air and into a large villa—called coincidentally the Villa Air-Bel—that she and Mary Jayne Gold had found on the outskirts of the city.

Mary Jayne was a very wealthy young American adventuress, well connected in American society. She kept an apartment in Paris, hobnobbed with the European upper classes, and had donated her private airplane to the French government when war broke out. She decided to stay in Marseille to be with Killer, who now was her lover, and to become involved with the American Emergency Rescue Committee, to which Miriam had introduced her, by making generous financial contributions.

Miriam and I were so busy at the ERC that we no longer met regularly at the bistro. In mid-November, she finally was able to leave Marseille and rejoin her fiancé in Slovenia. With Mary Jayne's support, she convinced her friends that it would be in everyone's best interest to let me join them at the villa. There was no telephone installed there, and messages between its occupants and the ERC had to be delivered by courier. I was already an ERC courier. If I lived there, I could easily serve as their contact with the outside world.

It could not have come at a better time, for a few weeks after I moved in, Marseille's coldest winter in half a century began with a fury. Furthermore, food was being rationed throughout

unoccupied France. There was now a good chance that I would have a warm meal every day.

In November 1940, two days before Miriam left for Slovenia, she invited me to join her and her friends, the Bénédites, Jean Gemähling, and Mary Jayne Gold, for dinner at the Villa Air-Bel. This would give me the opportunity to become acquainted with other people living there. As it happened, I would be working with them for a long time to come. Among them was André Breton, leader of the surrealist movement, and the villa had become something of an outpost for surrealists seeking to leave France. Miriam and Fry wanted to see how I would react to such an unconventional group of people. They thought it would be useful for me to be installed there, but they wanted me to experience the scene before I committed myself to taking up residence.

The ERC's villa, three stories high and bordered on both sides by plane trees, whose great girth was remarkable, reflected the eclectic taste of the early-nineteenth-century nouveau riche family that had built it: solidity coupled with romantic and classic elements. I didn't realize it at the time, but the slight incongruity between the staid setting and the outlandish population that was staying there had something "surrealistic" about it, something slightly out of place and anxiety-provoking, something slightly in contradiction to an ordinary sense of reality. The sober terrace on both sides of the Villa Air-Bel, however, looked a bit less so due to patches of grass and flowers—zinnias, marigolds, and geraniums that must have vied for attention when in bloom.

I arrived for dinner half an hour late and was shown into the dining room where everybody was seated at a huge table. At the head of it sat an impressive-looking man who was introduced to me as André Breton. I had only a vague idea who he was. Next to him, a young woman exuding sex appeal was introduced as Jacqueline Lamba. Her accoutrements—innumerable clinking bracelets, a necklace of tiger teeth, pieces of colored glass fastened to her hair—had a startling effect on me.

All evening long they talked about their favorite topic, surrealism. What I remember most was Jacqueline's spirited defense of that movement as an artistic practice and general philosophy. Breton himself spoke about how surrealism opposed the present political situation in France. I found the meal itself very interesting. The Villa Air-Bel supported a housekeeper and main cook—one Madame Nouguet—assisted by three maids. No doubt because shortages engulfed more and more foods, Madame Nouguet's dishes were creative and innovative. Furthermore, the surrealists' presence must have stimulated her imagination. She had become, whether she realized it or not, a true surrealist *artiste*, her mode of expression, gastronomy; her medium, food. Her dishes comprised unusual combinations; for instance, she sculpted the few vegetables that were available to look like a roast and served them in an antique tureen.

Another person at the dinner table was Victor Serge—not himself a surrealist—in fact his objections to some of Breton's pronouncements had inspired Jacqueline's speeches. After I left, I learned that Victor Serge was an author who had actually been a Soviet delegate to the Communist International. Think-

ing about it today, I realize that Serge, a member of the first
Stalin cabinet dismissed because of his Trotskyite sympathies,
had actually been in greater danger than any of the surrealists.
He was susceptible to reprisals from the Stalinists, from Hitler,
who particularly hated Trotskyites, and from the ultraconser-
vative members of the Vichy government. He was living in a
room in the villa with his thirty-year-old mistress, Laurette Sé-
journé.

The others living in the Villa Air-Bel besides Victor Serge,
his mistress, and the surrealists were Miriam, Mary Jayne, Jean
Gemähling, and Daniel Bénédite and his wife. Before the war
Daniel had been working at a desk job for the Paris police
(though he, too, was a closet Trotskyite). He was drafted into
the army when the war broke out, was discharged after the ar-
mistice, and through the association of his family with Mary
Jayne, was living with his wife at the Air-Bel.

Jean Gemähling was living at the villa and working at the
ERC as a cover while in fact helping to organize the Resistance.

Because of the lateness of the hour at the end of the dinner,
the trolley car had stopped running, and I was invited to spend
the night in a room that would become my home until Novem-
ber 1941. It consisted of an old-fashioned double bed and a ma-
hogany armoire and chest. Behind a screen in a corner stood a
marble-topped washstand with a white basin. The hand-carved
bed was a particular luxury. I hadn't slept under clean sheets
and blankets in almost two years.

The next morning I ran into Laurette Séjourné in the vil-
la's library. She had actually never been introduced to me and

I mistakenly took her for Victor Serge's daughter. When I attempted to engage her in conversation, I was met with a stern and contemptuous look—a facial expression that seemed to say, *Who do you think you are?*

A few days later I moved in. Life at the villa was relatively quiet. Most of us were gone during the day, except for Victor Serge and André Breton. When I would return to the villa from performing my various missions as a courier, I would head straight for the library, which was the only room whose fireplace was in use and where Serge or Breton—always on different days—sat writing.

Classical authors stocked the library, which was on the second floor and had a special ladder to reach volumes on the top shelves. The walls not supporting bookshelves were covered with wallpaper depicting scenes from Greco-Roman mythology, among them Aeneas's flight from Troy.

At first, the only other social contact I had with Breton and Serge was at the communal dinner, which all the people living at the villa shared every evening at 7:00 P.M. But as soon as Breton and I got to know each other a little, he trusted me to be his courier and occasionally even talked and listened to me. I did not know much about the surrealists other than that they made paintings from dreams and considered themselves political radicals with Marxist sympathies. One day I made bold to ask Breton if he didn't think that the transformation of society required a realistic understanding of the conditions of economic life and not just the indulgence of wild fantasies. Breton responded with something like the following:

"Capitalist culture will never be overcome without a liberation of the imagination from the shackles of bourgeois consciousness. The revolution requires not only new economics but a whole new way of seeing the world."

WORD HAD GOTTEN around that André Breton was living at the Air-Bel, and surrealist poets and painters living in and around Marseille were showing up unannounced to pay homage to their "pope." As this interfered with Breton's writing and private life, he sent me to their hangout in Marseille, a café called Le bruleur des Loup adjoining the old port, to let it be known that he would hold open house for them on Sundays at the villa from noon to 7:00 P.M. At other times they were to stay away.

At the Sunday gatherings, besides the surrealists, only Jean Gemähling, Mary Jayne Gold, I myself, and occasionally Varian Fry (whom they seemed to tolerate out of necessity) were allowed to sit in—as passive observers.

They met in the large dining room with its mahogany table surrounded by enough chairs to accommodate all who showed up to argue, carry on, and entertain themselves. Breton provided the wine, and everyone drank to their heart's content. There was a food shortage but not a wine shortage during those years. You could buy barrels of local vintage very cheaply.

The first time they met, I placed myself in a corner of the room, for I was anxious not to disturb the proceedings, though I really had no idea what to expect. There was an air of ceremony about the occasion that interested me and made me not a little apprehensive. I did know that the *sur*-realists practiced

some sort of intentional violation of conventional reality, but what could that mean in terms of their own social gatherings and arrangements?

At that meeting there must have been forty or fifty people. To start the proceedings, Benjamin Peret read a scatological poem of his own, a genre for which he was famous. I couldn't believe my ears! The crowd applauded, whistled, and cheered. Some of them moved into the small salon next to the dining room, while others sat down at the table to take part in the surrealists' games, which could only accommodate eight or so players. These were the main surrealist devotees, not the dozens of fellow travelers curious to see what was going on. They included, particularly, Oscar Domínguez, Victor Brauner, Wifredo Lam, Max Ernst, and André Masson.

At the head of the table sat Breton, the master of ceremonies and "high priest," facing a piece of paper folded horizontally into as many parts as there were people participating. Within easy reach on the table lay pencils, drawing pens, crayons of many colors, scissors, other sheets of paper, and dated magazines. Once everyone was seated with plenty of elbow room between them, Breton opened the folded paper, drew something on the first section of it, refolded it, and handed it to the next participant. The paper went around the room in this fashion, so that in the end there would be many drawings juxtaposed on the same sheet, each having been made without knowledge of what the others were.

The game was called "Exquisite Cadaver" or "Exquisite Corpse." I didn't know at the time why they called it that, ex-

cept perhaps that the phrase itself violated conventional verbal associations and piqued conventional sensibilities. It was originally a word game. Instead of drawings, each participant would write a word, phrase, or sentence on his folded section, and the final result would be a poem composed of non sequiturs for lines. I later learned that the game title was the first line of the first poem they composed in this manner: "The exquisite corpse loved the new wine."

They had a variation of the verbal version where they wrote their utterances on separate pieces of paper. There would be a hat standing in front of Breton and a blank sheet and everybody would put what they wrote in the hat. Breton would shake it up and draw out a word or phrase or sentence, look at it, and write it down. Then he would draw another utterance, examine it, write it down in turn. He'd repeat the procedure until all the writings were transcribed. Breton now declared that a surrealist poem had become manifest and read it aloud. Each had contributed to the creation of the poem. Surrealism in this sense could be a "collective" process, not only the revelation of an individual's fantasy.

Obviously the juxtaposition of apparently random sentences could give rise to innumerable interpretations (or none at all!). After the "exquisite corpse" had been assembled, it "came to life" in a manner of speaking. Some of the participants would retire to a salon adjacent to the dining room and discuss, sometimes with great excitement, the significance of the poem they had created, as well as the general significance of the game. Though the combination of the lines of the poem was random, the utterances themselves were often filled with high serious-

ness, so in a sense their juxtaposition represented the random confluence of the expressions of several minds. The game itself had first been played years before by the surrealists in Paris, and it was repeated as a kind of surrealist ritual. The ritual was performed each Sunday, and we guests just sat there without opening our mouths. Even Fry was silent, for I think he realized he was in the company of his intellectual betters.

On one occasion when I was with Breton, not at a Sunday gathering, I remember I dared to tell him that the Exquisite Corpse game reminded me of something like it we used to play in grade school. Breton pronounced, "The mind which plunges into surrealism relives with burning excitement the best part of childhood."

While staying in Marseille, the surrealists wanted to amuse themselves with the Marseille Tarot deck and sent me to town to see if I could purchase one. I could not, so they proceeded to devise one of their own. Their deck consisted of miniatures painted by the artists and representing various figures of cultural importance to the surrealists, together with their own interpretation of the traditional tarot suits. The deck was eventually published under the name Le Jeu de Marseille. I still have a copy of that deck in my possession.

In general, the surrealists at the villa retained a haughty attitude toward us, but in town and at the office of the American Emergency Rescue Committee, it was quite the opposite. The surrealists depended on us and assumed a more humble, egalitarian stance and tone.

★ ★ ★

A FEW DAYS after the first of the Sunday meetings, I was asked by Fry to deliver urgent messages to each of the artists whom I had witnessed producing their Exquisite Corpse drawings. The messages were in sealed envelopes, and I wasn't aware of their content, but I assumed they had to do with plans for their impending departure from France. Be that as it may, I had hoped that delivering them might give me an opportunity to ask some questions about what the surrealists were up to, since I wasn't allowed to do so at our Sunday gatherings, and I wasn't completely satisfied by Breton's response to my question about the purpose of surrealist fantasy painting. For one thing, I didn't understand the strange images in their collective drawings, though I was busy trying to work out my sense of them. The ones I had seen seemed well executed to me and perhaps psychologically significant as dreams or indeed as fantasies. Still, some of them hinted at more explicit meanings. All in all, I wasn't sure I could accept so much downright weirdness as "art." I was too much of a "real" realist, not a "sur" realist at heart. Be that as it may, I had to deliver these messages.

One of the artists was Victor Brauner. When I entered his quarters, he read his message and told me to wait for an answer. He returned with a sealed envelope. We talked for a little while, and his friendly attitude emboldened me to ask for an explanation of the Sunday drawings. In response he showed me a drawing he had just finished. Unlike the "Corpses," it gave me no difficulty to unravel. Its simple lines showed a male and a female facing each other. The male was represented by a dog standing on his hind legs with an erect penis. He was trying

to kiss the female who was nude and had a very large head and whose thighs and feet were made of tree trunks. The dog had a forked tongue and was stretching toward the woman's lips while she was trying to hold his head away from her. The thematic content was clear: the sexual power struggle between man and woman. The tree trunks suggested the necessity of a woman's turning herself into a kind of fortress. The man wanted to have sex with her, but she wanted something more. She needed to barricade herself behind heavy tree limbs, as if to say "no sex without love."

When I asked Brauner to explain the difference between the kind of collective surrealism involved in the games, and this individual expressive art, Brauner said it was self-evident and bid me goodbye.

I never did get to push any further on that point with a surrealist, since I still was required to keep silent at the Sunday ceremonies, and in any case they were soon to come to an end.

I do remember one conversation with Victor Serge about Breton. I don't think they generally saw things eye to eye. I asked Serge what he thought of Breton's poetry, to which he responded, "Ah, well, Breton, you know, is flirting with the 'Au déla' [the beyond]." I think that is true. Breton wanted surrealist practice actually to make contact with another world.

ON DECEMBER 4, 1940, an event very much of *this* world took place in Marseille. Marshal Pétain was to pay a state visit and ride in parade through the streets. To prevent any demonstra-

tions against the Vichy government, the police had rounded up all suspected dissidents and put them in preventive custody for the duration of Pétain's visit. They detained surrealists and in particular the inhabitants of the Air-Bel, including me. We were not charged with any crimes, but it meant that I now had "a record."

As I mentioned before, the winter of 1940–41 in Marseille was the most severe in some forty years. This made it particularly difficult for us to get refugees over the Pyrenees and out of France. The journey over the mountains was one of the main paths for such an exodus and was arduous even in good weather. It was now impossible. A new tactic however became available in early February 1941. The Vichy government was not equipped to extend the surveillance of refugees into the French colonies, so it was possible for them to go there without exit visas. Once in the colonies they could continue on their journey to wherever they wished to travel. The problem was that up until now there were no ships to take them, but beginning in February, steamships bound for Martinique began leaving Marseille regularly. The surrealists and others at the Villa Air-Bel were among the first to benefit from this possibility, among them Breton; Jacqueline Lamba; their six-year-old daughter, Aube; Victor Serge; André Masson; and several others.

A total of about eighty of the ERC's clients were packed on such boats leaving France by way of Casablanca to Fort-de-France, the capital of Martinique. Those with valid visas to Mexico, Santo Domingo, the US, and other countries could

continue on their voyages provided that they had money to pay for it.

One of my assignments was to accompany the Breton family to the wharf and help them with their luggage. I had the momentary thought that I myself might make my escape from France by getting on board, but of course I knew that this was quite impossible, as the passenger list was tightly controlled by the Vichy police, and I didn't think I could make it as a stow-away.

Not all of the surrealists left on this journey. Once the Bretons had vacated their room at the villa, it was taken over by Max Ernst and the American heiress Peggy Guggenheim. Peggy was a friend of Mary Jayne, and I learned from Mary Jayne more about her as a collector of modern art and men than about Max Ernst as a surrealist painter. Sometimes I wondered why Ernst had gotten involved with her. Well, I know why. She was the one who got him out.

MAFIA

February–June 1941

NOT LONG AFTER Fry had set up the ERC in Marseille, the organization was swamped with refugee artists, writers, intellectuals, and their families—not limited to the persons on Fry's list—who wanted to get out of France, as I mentioned

before. The money that Fry had been given in New York be-
fore leaving the States and the funds made available in francs
by contributors like Mary Jayne Gold were far from sufficient
for financing the escape of the refugees. Funds were needed
to acquire—sometimes to forge—passports and visas, and to
pay transportation costs from France to Spain, across Spain,
to Portugal or other ports, and from these to the US. Now
that transportation was possible directly from France to the
colonies, the need was even greater. There was one, perhaps
surprising, source from which to acquire the needed monies:
the black market in currency exchange operated by the Corsi-
can Mafia.

Fry had been introduced to the head of the local "mob" by
Killer—Mary Jayne's Foreign Legionnaire lover. This mafioso
owned all the houses of prostitution and many other illegal
sources of income in Marseille and needed a way to get his ac-
cumulated fortune out of the country. In particular, he needed a
way to convert his francs to dollars at a rate more advantageous
than the inflationary rates offered by aboveboard exchanges.
Fry, on the other hand, was in need of francs—a million francs
to take care of expenses for March, April, and May. The going
rate of exchange was something like fifty francs per dollar, but
the Mafia was able to give many times that amount under the
proper circumstances. The idea was that people wishing to help
refugees emigrate from France with funds in dollars in the US
would deposit them in the Mafia's New York City bank account,
in exchange for francs provided to Fry in Marseille, in this way
multiplying the value of the New York monies many times

over. Over a period of about four months, probably as much as several million dollars—in any case a sizable portion of Fry's budget—was now being obtained in this way. By 1941, the black market rate varied from 250 to 350 francs per dollar. The Mafia would supply the francs in Marseille, and a coded message would be sent by telegram to New York saying the money had been received. One of my jobs was to send those telegrams.

The mafioso conducted his business from a small office in the back of the first-class restaurant in Marseille known as the Dorade, which he owned. Information regarding the exact rate at a given time was (of course!) negotiated in code. The arrangement was for Fry to send a courier, me, to the Dorade, where I would ascertain the present black market rate from the mafioso.

The first time I was sent there was in early March '41. I was supposed to say that I had come to make dinner reservations for Mr. Fry and five of his guests and that I needed to know the prix fixe per person. As a matter of fact, Fry had not told me the nature of this operation. I arrived in my ordinary attire, expecting to be given the price and then to return to the ERC office at once.

When I arrived at the restaurant, I was conducted to a "back room." It seemed a little strange, but when I got there, I put my question to a distinguished-looking, middle-aged and well-mannered businessman. He answered "350 francs" and made an offhand remark about my rather shabby appearance. I returned to the ERC office none the wiser.

By the second time I visited the Dorade—in April of '41—I

knew the score. In the interim, I had been on a mission taking a message to a particularly endangered client of ours who was hiding away in one of the don's bordellos—these were actually the safest places to hide in Marseille. Why? Because the Mafia had already paid off the police to stay away. The mafioso was effusively friendly when he saw me. He had apparently been made aware of that earlier mission, because he alluded to it implicitly when he asked me, "And have you yourself ever frequented a 'maison de joie'?"

"No," I said, "I've read all about them but never been inside except to bring that message."

"Nice, *n'est-ce pas*? Listen, *mon jeune, si tu veux tirer un petit coup, c'est à l'oeil* . . . [in effect, 'if you ever want to frequent our establishment, it will be on the house']," he said and roared with laughter.

I was tempted, thinking of the luxuriously appointed salon and its scantily clad, gorgeous young women. But my response to his offer was just to smile. Before I left, though, he sent me to his tailor with instructions to make me a nice suit and have the bill sent to him.

The third visit to the Dorade lasted almost no time at all. Soon after I had conducted my business in the restaurant, I was accosted by a police detective. He identified himself and asked me to follow him to the Marseille police headquarters—a place with which I was quite familiar because of my detention there during Pétain's visit. This time they wanted to know why I was at the Dorade, a high-class establishment with suspected connections to the underworld. I acquitted myself satisfactorily

saying I was making dinner reservations for Varian Fry and his guests and was released, but, since I was briefly arrested, now my name was on the record twice.

IN EARLY MAY of 1941, Peggy Guggenheim invited the surrealists still living in and around Marseille to observe Max Ernst apply fixative to his latest works, exhibited for that purpose in the villa's garden. I helped her pin his prints, canvases, and engravings to tree trunks, hang them from low branches, and place the frailest ones against the protected walls of the garden shed. As I had frequently done in the museums of Paris, I eased my way up to exhibit viewers who seemed to be in the know about the work, hoping to hear their critical or descriptive comments. In particular I lurked behind Wifredo Lam and Oscar Domínguez, but in vain, for they stood before the Ernst works in total silence, a *contemplative* silence no doubt.

LOOKING BACK OVER the many refugees that I came in contact with while working at the ERC, I must say that the more famous they were, the more difficult they were to help or just to deal with. There was a certain elitism, a certain intellectual arrogance among not only the intellectuals but the artists. They seemed to feel that because of their fame and their great contributions to art and literature, they deserved more attention, more concern than other people. They tended to associate exclusively with one another and not connect fraternally with the common people who were working, and

sometimes at great risk to themselves, on their behalf. However, for some reason they tended to like me, so I am not speaking out of personal pique. By and large they humored us and patronized us. Perhaps they needed to talk down to the people who were deciding their fate and contributing essentially to their well-being, in order to maintain their own self-esteem in the face of possibly intolerable vulnerability and danger. They were incapable of feeling an appropriate relation to those with whom only that vulnerability and danger was pertinent.

The surrealists' engagement with "sur-reality" was no arrogant pose, however. The First World War, the rise of fascism, the dislocation of ordinary life and ordinary reality that many sensitive men and women had experienced thus far in the twentieth century really did seem to challenge reality itself. These genuinely extraordinary people, who had dedicated their talents to imagining in visual and literary terms the implications of all the disruptions, can hardly have been expected to live and think in conventional ways. Their strangeness was a consequence of their inner commitment, and the hauteur they adopted to negotiate association with people whom they assumed were not aware of what they had allowed themselves to experience was perhaps not always amiable, but certainly understandable and to an extent honorable.

Be that as it may, they had little respect for and paid no deference to Fry, whom I think they treated with intellectual, not simply elitist, contempt. This is borne out by the fact that almost none of those whom Fry helped stayed in

contact with him after they no longer needed his aid, the only exceptions being Jacques Lipchitz, the sculptor, and André Masson.

CHAGALL

———

Spring 1941

IN THE SPRING of 1941, Marc Chagall and his wife escaped to America. Chagall had two strikes against him: he was Jewish (his true name was Moishe Segal), and he was considered by the Nazis a "decadent" artist. Still, he refused to leave his beloved France, until in the spring of 1941 the Vichy government's increased enforcement of anti-Jewish laws compelled him to emigrate. Fry sent me with a message to his villa in Gordes north of Marseille, offering him help, since he was on Fry's list. I of course had heard of the great Jewish modernist and was looking forward to meeting him. I was ushered into a stately room, where Chagall was standing with his back to me, and we were introduced. He turned around. We didn't shake hands. Chagall took the envelope with the message, opened it, looked at it, read it, looked at me quickly, and said, "Merci." As a matter of fact the ERC was not arranging for Chagall's passage out of France, though it did pay for his passage to America. The American vice consul, Hiram Bingham, an admirer of Chagall's, had him and his wife driven in a diplomatic limou-

sine (providing a cover of diplomatic immunity) all the way to Lisbon—with only a US visa.

MAX AND PEGGY DEPART

———

July 1941

A COUPLE OF MONTHS after Max's exhibit at Villa Air-Bel, Peggy Guggenheim and Max Ernst departed from France, without any difficulty at all, because of Peggy's ample financial means. My understanding is that they flew directly from Lisbon on Lufthansa, the only airline flying from Portugal to the States at that time. Before leaving, Ernst asked me to check on his studio in Saint-Martin-d'Ardèche. He had left the studio to come to the Air-Bel and had brought with him works that would be exhibited in the Air-Bel garden—so there was nothing left at his studio. Though he was about to depart for America, in the back of his mind he hoped he would eventually be able to return to it after the war, and he wanted to know what condition it was in. I found the studio in good shape. The only art pieces left were two sculpted columns that were embedded outside of the studio in a wall near the doors: two strange semiabstract, hand-carved figures. A few of his neighbors standing around his studio were curious to see what I was up to, and we got to talking about Ernst. They said that they had liked *him* and the fact that his presence brought tourists to the village, but they

didn't know what to make of his art. Actually, they didn't like it at all. When I told this to the artist, he said, "Art has nothing to do with taste!" Ernst was actually a personable fellow, and he was grateful for my report about his studio. He knew that I was living on the small stipend I had from the ERC, and, before departing for America, Peggy gave me $500 in American currency, and Max himself handed me five gold coins. He said that they were "Louis d'Or" gold pieces—coins minted by Louis XVI and very valuable to collectors. He said I should only use them in an emergency. An emergency, as we shall see, did arise, and I got a few hundred dollars. I understand that today the group of them might sell for as much as $25,000.

THE EXPULSION OF FRY; MY MOUNTAIN CLIMBING ADVENTURE

August–December 1941

AFTER MARY JAYNE Gold and Peggy Guggenheim returned to the US in 1941, there was a crisis at the American Emergency Rescue Committee: a general lack of support for its activities and a lack of funds. For three weeks in August of 1941, Fry disappeared from Marseille. The only person who knew how to contact him was Danny Bénédite. The rumor had it that he was vacationing at the Hôtel Majestic in Cannes, luxuriating in its haute cuisine, its fine champagne, and Scotch whisky.

He reappeared on Wednesday, August 27. Two days later (it was a Friday, with only three of us at the office—Fry; his secretary, Anna Gruss; and myself), two plainclothes detectives showed up at the office and, by order of the chief of police, de Rodelec du Porzic, asked Fry to come with them to the Evéché (the main police headquarters in Marseille). At the Evéché they told him that though he was not under arrest, he would be taken under escort to the border of Spain and expelled from France.

He was driven to his hotel and given two hours to pack. The police brought along his "office boy" (me) to assist him. Varian was tight-lipped as usual. The only thing he said to me was that I should tell the Bénédites, Jean Gemähling, Anna Gruss, and any other staff members I could find to meet him at the Dorade for a farewell dinner, to be held that evening in the presence of the police commissioner who, after the meal, would escort him to the Spanish border. That was the last time I saw him or delivered a message for him.

The mood of this farewell dinner was rather strange. None of us knew why Fry was being forced to leave. He was never very forthcoming about his situation with either the French or the US government. He tended to be inexplicably exuberant or equally inexplicably morose. I think that today he would be considered to be bipolar. At the dinner he was pensive and formal. He said that he was leaving France and that the ERC had served its purpose and would be dissolved. After coffee he bid us goodbye and off he went, accompanied by the police commissioner.

★ ★ ★

AFTER FRY'S EXPULSION, Daniel Bénédite tried to find out what was behind it. Danny had worked before the war for the police in Paris and had contacts at the Marseille police department of intelligence. He was able to examine a copy of a letter sent by the governor of the Department Bouches-du-Rhône (the district where Marseilles is located) to the Vichy Ministry of the Interior. It was dated December 30, 1940, barely four months after the commencement of Fry's activities in Marseille, and headed "Regarding the activities of the American Rescue Center and its president, Varian Fry." Translated, it said, roughly:

"This organization claims to help intellectuals, artists, and writers who want to leave France obtain their necessary visas and provide them some financial support. The fact, though, is that this Center has rapidly expanded its activity and does not seem to be a purely charitable organization. There is plenty of evidence that its president does not always respect the legal formalities to achieve his goals. The U.S. government feels that actions taken by the Center could harm the good relations it wants to maintain with France and has asked Fry to return immediately to the States. Fry has decided to stay in Marseille. He is being closely observed by the secret police."

I'm not sure how much Fry knew about his being under surveillance. He certainly was aware that he no longer enjoyed the support of the US government. It was in accord with the bravado of his character simply to ignore the order to return.

Once Fry was gone and the ERC had disbanded, I was afraid that my two arrests would put me in jeopardy, since if for some reason the authorities took notice of me, I no longer had a po-

sition with a recognized organization to identify me. I didn't want to end up in jail, so I decided that it was high time to leave France and join the Free French Forces in England. It seemed to me that the easiest way was to trek over the Pyrenees into Spain, an itinerary with which I was already familiar. With Fry gone, however, I no longer had connections with people on the border and inside of Spain, and there was no funding from the Rescue Committee. I would have to depend on my own devices.

I had the $500 I received from Peggy. I was able to sell the gold coins on the black market for 175,000 francs, another $500 as I mentioned. There was also some additional funds from Mary Jayne Gold. I would carry the cash in $5, $10, $20, and $50 denominations, tightly rolled up and stuffed inside my underwear.

I knew from my experience at the ERC that money could get you through most situations. The French, the Italians, the Spanish, and the Americans were all easily corruptible. The only people you couldn't corrupt were in fact the Germans, but I probably would not have to deal with any of them in my flight from France. My funds were more than enough to establish new contacts and to pay or bribe my way through Spain to Lisbon, which I might have to do, since I had no visas.

The only document I carried with me was my French identity card. The safest way to enter Spain was through Andorra, which bordered both countries. Its citizens had trafficked in everything from tobacco to weapons during the Spanish Civil War and were now smuggling British pilots (saved by the French Underground after parachuting from shot-down planes) to Gibraltar—for a price. My plan was to take a train from

Marseille to Ax-les-Thermes and walk from there across the border.

The only person to whom I confided my plan was Jean Gemähling. Jean was nine years my senior, born in 1912; his father was a law professor and his mother a teacher of literature in a lycée. Jean himself was educated as a chemist and, drafted into the French army in 1939, fought against the Germans, acted in Belgium as a liaison officer with the British forces, and managed to get to England in May by way of Dunkirk. Upon returning to France, he joined the American Emergency Rescue Committee, and while the committee was in operation, he used it as a cover while developing the segment of the Resistance known as "Combat" in the south of France.

Combat was one of eight movements that in August 1940 became the National Council of the Resistance with headquarters in still unoccupied Lyon. The eight movements were organized regionally and actually originated within the various French political parties and groups—Communists, Socialists, Social Democrats, and so forth—that were strongest in each region. Though stemming from very different ideologies, they were united only in their dedication to the defeat of Germany. Each movement operated with a considerable degree of autonomy and had its own organizational personnel and leadership. Jean Gemähling was a leader of Combat, one of the Resistance organizations in the south, but he was to become the general head of the Resistance intelligence network that, by circuitous conduits, delivered information about German military installations and troop movements to de Gaulle in London.

Jean did not think much of my plan to leave France and tried to convince me to work with him instead of going to England. I thought that it made more sense to join the official French army under de Gaulle, protected by the Geneva Convention, than risk being tortured if captured as a terrorist. I was by this time committed to resisting the Germans, but how much I was willing to risk personally was still unclear to me. Jean didn't argue with me about what I intended to do but said he would be very interested to hear from me if and how I managed to carry it out.

The first part of my plan, the train ride to Ax-les-Thermes, went without a hitch. I set off marching confidently toward the border in my mountain boots with a rucksack, to which I had attached grappling hooks, spikes, a pickax, and other paraphernalia that made me look like a mountain climber. For a final touch, to make it look legitimate, I wrapped a rope around my belly. My thinking was, once inside Andorra, I would shed all these accoutrements and hitch a ride to the railroad station in Manresa, Spain, and continue on to Barcelona.

About a mile before the border, outside the village of Hospitalet, I was walking in full mountain-climbing regalia on the main road when two French gendarmes accosted me. I thought I was well prepared for such an eventuality.

"What are you doing here?" snapped the older of the two in a deliberately accusatory manner.

"I've come to do some mountain climbing."

They weren't buying it. It seemed that I wasn't the first "mountain climber" they'd run into walking on the main road straight for the Spanish border.

"Where's your permit?"

"What permit?"

"Your permit to wander about this frontier region."

My ability to feign innocence was beginning to wear out.

"I didn't know that."

"Oh, didn't you. You will come with us."

They took me to their car, drove to their nearby station, and put me into a tiny whitewashed cell whose walls were covered with initials and dates, scratched on them by other "mountain climbers" jailed for the same crime as I.

The next day they drove me to Foix, a town twenty miles north of Ax-le-Thermes, to appear before a prosecuting attorney. He had me put in jail to await trial for my infraction. I was stripped, put in a prison cell, given a number. My clothes were thrown in a box. Goodbye to my stash of dollars. This was to be my home for the next two weeks. The conditions were particularly dreadful. By 1941, there was a severe food shortage all over France and nowhere was the food shortage felt more keenly than in prison. In the morning, I got some soup—a few cabbage leaves floating in hot water—and one piece of stale bread. In the afternoon, the same soup but no bread. At first I could barely stomach a spoonful of this pitiful broth. After two days, my hunger took over and I learned how to choke the concoction down. I only got to leave the cell for twenty minutes a day—a walk in the courtyard—during which I wasn't permitted to talk to the guards or the other prisoners.

As a resident of France I was entitled to a consultation with a lawyer free of charge, but after talking to him, I decided to con-

duct my own defense at the trial, which occurred on November 28, 1941. The prosecutor presented the charge—that I had entered a prohibited zone without a permit. He made his case and sat down. The judge wanted to know why I had come to France. This was the moment I was waiting for as it allowed me to show off my French and my admiration for French culture. I had come to France because of its reputation for high educational standards and its liberal spirit to study French literature. When the Sorbonne was closed, I traveled to Marseilles to continue my studies. I didn't know that a permit was required for hiking in this area. All in all I gave a finely expressed, respectful, and modest performance. I didn't deny the charges, placing my hopes in the understanding of the judge. I could tell from his amused and kindly regard that he knew what I had really been up to. My tactic seemed to work well. The judge exchanged some looks with the prosecutor and sentenced me to a minimal fine (which I didn't have to pay at once) with two years' probation. He ordered the gendarmes to have me released from jail immediately and suggested I return to Marseille at once.

The reason for the unusually lenient sentence became obvious to me when he summoned me to his chambers. On his desk was the day's newspaper with the headlines "General Rommel Close to the Suez Canal" and "German Panzers Outside Moscow." I hadn't seen a paper since leaving Marseille three weeks before. The judge saw me straining to read the articles, handed the newspaper to me, and said I could take it. He commented, "Bad news for France. But there was also some good news. The Americans have extended the 'lend-lease' policy to the French

army in England." (The US had already been supplying England with arms [on the assumption that Britain would pay for them after victory, hence "Lend-Lease Policy"] and were now going to do the same for the French army under de Gaulle.)

Good Lord! I thought. *This judge must be a Gaullist.* That there were such persons in official governmental positions was really not surprising. The Vichy government had no time or means to investigate the allegiance of every official of the Free French Zone.

On my way out of his chambers, the judge gave me a final piece of advice: *"Jeune homme, la prochaine fois vous faites de la montagnes, tachez de vous y prendre mieux!"* ("Young man, the next time you go mountain climbing, try to be more circumspect about it!")

"Thank you, Judge. I certainly will."

I was taken back to the jailhouse and given the box with my clothes and was astonished to find, in the band of my underwear, my hidden treasure undiscovered and all there. I cannot describe the feeling of freedom that came over me when the wrought-iron gate of the prison closed behind me and I was let out. The expanse of nature that greeted me outside appeared in finer detail and more brilliance than I had ever seen before. On the train back to Marseille, as I looked out the window at the well-kept fields and flourishing forests of France, everything I saw seemed a miracle just meant for my eyes.

I also read the newspaper the judge gave me. The articles under the headlines and others in the paper indicated a tension within the German High Command regarding general strat-

egy for conducting the war. Hitler had broken the pact with Stalin in June 1941 and invaded Russia, anticipating easy conquest there, allowing German forces to head through Russia into Azerbaijan west of the Caspian Sea to access the oil fields. But surrender did not come with anything like the ease with which the Netherlands, Belgium, France, and Poland had succumbed. As it turned out it was not forthcoming at all.

General Rommel was sent with a German army to North Africa and was heading east with the intent of taking the Suez Canal and passing north through Syria, Iraq, and Iran where he expected no resistance from friendly Arab governments. The ultimate goal was the same as the goal in Russia: the oil fields of Central Asia. But the British under Field Marshal Montgomery had committed themselves to defending their imperial interests in the Near East, so the African campaign itself was meeting resistance. The Germans had a protracted war on two fronts, and the tension in Berlin had to do with how to manage this situation.

As I read I began to think about the difference between "tactics" and "strategy," and an interest was born in me of following in detail the course of the war. Agreement about strategy might nevertheless give rise to conflict over tactics. Strategy is an overall campaign plan, in this case, on the largest scale, to win the war, but specifically to gain access to the Central Asian oil fields. Tactics are the actual means for gaining such a strategic objective: passage through Russia or the Near East. (The distinction is relevant beyond actual military contexts, in chess for instance, or in sports generally.)

GRENOBLE

—————

December 1941–August 26, 1942

S AFELY BACK IN Marseille, I headed directly to Air-Bel in
hopes of finding Jean. He was there. After I told him of my
peregrinations, at which he was amused, he said, "Well, I am
glad to see you back."

"I'm glad to *be* back, and I think I'm ready to join you."

We spent an entire afternoon going over the whole state of
the war. I had been eager to share with him what I had put to-
gether for myself reading those articles. He was glad to support
my growing interest and showed me a map so that I could visu-
alize in detail the present arrangement of troops in Europe and
Africa and follow the course that the war was likely to take. In
fact he gave me those maps and I kept them with me and con-
sulted them often as the war wore on.

Jean said that it was only a matter of time before the Ameri-
cans entered the war. (In hindsight one must remark that it was
only a matter of days before Pearl Harbor, December 7, 1941.)
He said that once this occurred, the role of the French Under-
ground army in providing information and disrupting as far as
possible German operations would become extremely impor-
tant. He also spoke of how the Vichy government was growing
more and more collaborationist and pro-Nazi.

"Prime Minister Laval," he said, "thinks that Germany
is going to win the war and wants France to become part of
Hitler's 'New Europe.' Our work is to make this impossible.

The Resistance needs to grow and in fact is growing. There are young men and women throughout France right now who are inspired to participate, and we need to find them. We need a man in Grenoble to help with recruitment. Grenoble is a city about 130 miles north of Marseille and one hundred southwest of Lyon. I think, Gussie, you are the perfect person for this."

"I'm all ears! Will I be given a new identity?"

"No. I would like you to move to Grenoble and register at the university there as a regular student under your own name and identify young people who are sympathetic to our cause. Nobody will suspect a refugee to be an operative in disguise. We could provide you with a false identity, but I think it best to let you be who you are. We already have rented a room at a widow's house on the outskirts of Grenoble, which you can occupy. All you have to do is to move to Grenoble and enroll at the university. Will you do it?"

"I will be glad to. I presume you have a procedure for my remaining in touch with you."

"Yes, of course. We have mailboxes in several apartment buildings in the town that serve as drop-off sites. I will give you the addresses of them to memorize. You simply place your suggestions in one of them. They will be brought to me and I will evaluate them."

I moved to Grenoble and enrolled at the university at the beginning of January 1942. For the next several months I led, to all appearances, a normal student's life, not very different from the way I lived in Paris before the war; but under my conventional appearance, I was actually brimming with excitement to

be participating actively in the Resistance. It was essential that I learn how not to show it. My natural gregariousness might prove to be a problem, though another side of my nature—my own deliberative coolness—would serve me in good stead.

The French Underground was not only interested in building up a body of personnel to throw bombs and disrupt German operations. It needed educated men and women to observe and understand what they were observing, so I was basically serving as a talent scout. I made friends easily as always, but I, of course, could tell no one what I was really up to. I had to remain detached, and so the emotional edge of my connections to the people with whom I was in daily contact was dulled. In fact, before long, I felt isolated and alone.

I was a properly documented university student and in a way my work was a full-time job. The "targets" of my attention were not limited to students. There were cafés and bars located around the university, and when students emerged from their lectures and seminars, they would head for these places, and when my classes were over I went there too. Political discussions erupted in these venues with some regularity. There were basically three positions: those who justified collaboration with the Germans, those who advocated resistance, and those who declared "a plague on both houses." Rather than enter into the pros and cons of collaboration, I listened.

On one occasion I sat in on a conversation with a group of students, two of whom were involved in a very heated argument. One was the son of a winegrower from Saumur, the other a young woman who had been brought up under the prin-

ciples of the Third Republic and passionately opposed the Vichy regime. The young man was telling his peers that for him, the armistice of 1940 meant that he wouldn't be killed in battle. He would be able to return to his father's farm and vineyards and help him "make a killing"—which was already happening at this point because of the food shortage. I was aware that town dwellers came to the countryside on train or bicycle—often with no cash but offering their jewelry to barter for food with farmers, who charged them inflated prices. The armistice also meant, the young man said, that a million and a half prisoners of war in Germany—caught during the brief period after Germany had invaded but before France had capitulated utterly—could return to their homes, their families, and their jobs.

"As long as we don't take up arms, the Germans will leave us alone," he said. Obviously he was not a viable candidate for the Underground. The young woman, however, was different. She simply didn't want to participate in any "New Europe." She wanted the old values back. She wanted *Liberté, Égalité, Fraternité* not the *Travail, Famille, Patrie* prescribed by Pétain. As a matter of fact I was personally attracted to this woman but had to forgo developing any sort of relationship with her. I dropped her name in the "box."

At the university and at cafés and bars, these themes with endless variations were expressed over and over again, argued with different levels of sophistication and rhetorical power, but the basic positions were always the same: collaborate, resist, or try to get out of the way.

It was quite difficult not to be drawn into these arguments.

On the one hand, I had to gain the trust of these people so they would reveal their views before me, particularly the trust of people opposed to the Vichy regime. It was necessary for me not to appear utterly cold and indifferent. On the other hand, if I acted on my impulse to enter into those discussions on the side of the Resistance, I put myself in real danger of attracting the attention of the authorities. The Resistance was not the only group with "observers" at the university and the cafés. So I cultivated the more reticent side of my personality and, without much intensity, let it be known where I actually stood.

The house that Jean had arranged for my lodgings was pleasant and clean. I didn't know if Jean had informed Madame Damour, the widow who maintained it, of my involvement with the Underground. She never asked me any questions. Her cooking was good. So good, in fact, that it could only have been achieved with the assistance of ingredients like butter, sugar, and meat bought on the black market. There must have been a side to her life that I knew nothing about. She was very kind to me, but she may have been secretly a collaborator for economic rather than political reasons. As the occupation wore on, everyone was "underground" in one way or another.

Part III

INTERNMENT

August 27–29, 1942

WHILE I WAS finding students to participate in the French Underground army, the Germans for the first time had begun to encounter serious military resistance in the Soviet Union. In June of 1941, they had broken their nonaggression pact with Stalin and initiated an invasion that would prove to be the largest military operation in the history of warfare. Its failure to achieve its objectives and the devastation of German forces that ensued would be a major factor in Hitler's ultimate defeat.

Initially the Germans moved easily into the Ukraine and expected to defeat the Soviet army outright in a few months and control the western Soviet Union. Their aim was to enslave the Slavs and replace them with Germans, gain access to sufficient agricultural resources to supply the war effort, and to advance to Baku in Azerbaijan to secure the oil fields of the Caucasus. None of this occurred. The Red Army proved more capable of resistance than anticipated; combat continued through the summer and fall of 1941. The Germans failed to enter Moscow in December, and the continuation of the campaign through the winter of 1941–42 proved disastrous. In June of 1942 a renewed offensive sought to secure the oil fields and the city of Stalingrad on the river Volga to protect the forces advancing

into the Caucasus, but they never captured Stalingrad, remained stalled through the fall, and would face another winter that all but spelled defeat for the Reich.

While the fate of Nazi Germany was reaching a turning point at the end of August 1942, my own "fate" was about to take an alarming turn.

FOR SEVEN MONTHS my life as a student and undercover talent scout proceeded smoothly, but then it came to an abrupt end. On August 27, 1942, very early in the morning, someone was knocking repeatedly on the door of the house. Though still half asleep, I heard Madame Damour's footsteps on the floor above me. I had been dreaming about my childhood in Danzig—on a vacation in Zoppot with my family. I was swimming with other children just a few yards from the shore. My mother and father standing on the beach called out to me, but the currents interfered with my efforts to swim to them. The knocking on the door came again. I was awake now. I pulled back the covers, got out of bed, and heard Madame Damour scuffling down the stairs. She opened the front door to two gendarmes. I came up behind her. They glared at me.

"Justus Rosenberg?" one of them inquired, glancing at a clipboard.

"Yes?" I responded.

"You have five minutes to get dressed, pack your things, and meet us outside."

"Where are you taking him?" Madame Damour shouted anxiously.

"He is being transported to a detention camp," the officer sternly replied.

Someone must have denounced me, I thought. *I've been found out. Or are they just rounding up German and Polish Jews?*

The three of them argued briefly, before Madame Damour became too exasperated to continue effectively. There was nothing to be done.

My eyes were still gauzy with sleep and I couldn't think clearly. Not that it would have mattered. There was no practical means of escape or resistance I might have put into action. One of the gendarmes was thin and tall, the other shorter and apparently a subordinate. The tall one did the talking. They both wore fresh uniforms. I was in fact known to the authorities from my past activities with Fry and the American Emergency Rescue Committee, as well as from my three arrests, but up until now, this had not caused any concern—for the authorities or for me. If they wanted to detain me for my connection with Fry, surely they'd have done that a long time ago. Varian had been expelled, but he himself hadn't been subjected to any violence or intimidation, and no one else from Fry's group had been arrested. Except for the three innocuous arrests in Marseille and in Foix, I had never felt myself to have been in any particular peril. Had I been discovered as an Underground agent? *Was I being interred for being a Jew?* I was not aware that this was happening anywhere in the unoccupied portion of France. It seemed unimaginable that France would take such a dark turn.

I was taken to a bus standing on a side street, its engine idling. It was a chilly late-summer morning, everything slick

with moisture, the sky a blank slate of gray. Inside the bus were three men, sitting near windows with blinds drawn. A strange silence pervaded the whole affair. A few minutes passed. Two more people were put on board. We headed off.

I felt alone even among these fellow detainees. It was as though up until this moment I had been ensconced in a cloak of invulnerability, but now the truth had suddenly been laid bare. Throughout the course of the day, into the late afternoon, the bus was apparently traveling from village to village, for it was stopping fairly frequently and rounding people up, sometimes one at a time, sometimes a small family, sometimes a large one. With blinds drawn, I couldn't see where we were traveling. I tried to sleep, but the rigid bus seats weren't built for comfort, and as the day wore on and the sun grew stronger, and the vehicle filled up beyond capacity, the bus became a rolling oven. Toward evening it began to get dark. Finally we stopped at what turned out to be a former military camp. We got off the bus and walked through a gate over which a sign said VENISSIEUX. We were somewhere outside of Lyon. There were city lights visible in the distance. They marched us up to a table that had been set on the asphalt of what were apparently parade grounds. The sun had set behind a line of trees at the horizon, but residual heat radiated from the asphalt. Guards milled around smoking cigarettes, while tired and confused people—from my bus and from other buses—approached one by one the implacable officers sitting behind the table.

After checking our names and crossing them off a list, the officers assigned us each a barrack to sleep in and gave us each a

coarse woolen blanket for bedding. Mealtime and curfew were explained. You could walk around the camp freely, but by 9:00 P.M. everyone had to be in their barrack. From start to finish, once we were off the bus, the process proceeded with maximum efficiency.

My barrack was packed. It wasn't a large space, and the fifty or so people assigned to it—men and women of all ages—filled it completely. It was very hot. Already warmed by the relentless sun during the day, though it was now after nightfall, so many bodies in so small a space made it even hotter. They were all Jews, from Chassids in their traditional garb to fully assimilated citizens in ordinary European dress. They were Polish, German, or other foreign Jews living in France who had come south thinking to evade anti-Semitic regulations. The suffocating atmosphere was rendered even more miserable and full of dread by the sounds of desperate people talking, young and old people crying. In the background I could hear the groaning of bus motors stopping and starting in the distance just outside the camp, delivering more people to an uncertain doom.

Though exhausted, I couldn't sleep. I decided to take my blanket and lie down outside. I crooked my arm below my head for a pillow between me and the trampled down fringe of grass that surrounded the barrack. The blanket was thin, coarse, and smaller than a beach towel. Outside the barrack it was cold and humid. It would have been nice to be covered by something. All in all, though, it was better than the inferno inside of my quarters.

But the heat wasn't the only thing that had been keeping me

awake. As I lay outside the barrack, anxious questions continued to churn in me. Why were we here? What was going to happen to us? Should I be trying to escape? If the city I had a glimpse of was Lyon, could I somehow get there and meet up with Jean, who in the meanwhile had relocated there? I also thought of my family. Had they reached Palestine? Had they even reached Romania? Were they, too, God knows where, hovering anxiously in an internment camp? Eventually my exhaustion overcame my pondering. I fell asleep, I don't know for how long. I woke to someone prodding me with the tip of his boot and shining a flashlight in my face. I sat up. It was a camp guard silhouetted against the lights that marked the camp's perimeter.

"What are you doing here? Past curfew," the guard said.

"I'm very sorry," I responded. "There are so many of us in there I could hardly breathe. I thought I could get some sleep out here."

"Well, you *can't* sleep out here," he said thoughtfully. He lit up a cigarette and offered me one as well.

The man was not particularly authoritarian or hostile. He had a rather laid-back manner—none of the emphatic fascist bearing of the gendarmes who had taken me from Grenoble or of those who sat impassive behind the registry table. We began to talk. He wanted to know what I was doing in France, so I told him a version of my story, up until the point where I had been awakened in my room and taken there.

His sympathetic attitude emboldened me to ask, "Do you happen to know why we have been brought here and what is going to happen to us?"

"Well," he said, "this is a detention camp. Once it fills up, you will be sent on a train to a labor camp in Poland."

The man sat down beside me, and it seemed as though the barrier between prisoner and guard had almost dissolved somewhat. We were just two people sharing a smoke in the damp night air.

Though we were talking casually, what he was saying was alarming indeed. I knew that Poland was rife with anti-Semitism and that this had been increasingly so even before the war. I didn't like the sound of "Polish labor camp" at all. If the conditions in the detention camp where I was interned presently were anything to go on, what things would be like in a labor camp beggared the imagination. I didn't panic, however. At least now I had something like a time frame. I made a rough calculation. It would take two or three days at the most to fill a train of, say, twelve hundred people. I was imagining that many people in the camp judging from the number of barracks, the number of people that filled each one, and the number of people that came in on each bus. I hazarded a request. "How about letting me jump the fence?"

"I suppose I could turn my back." He took a long drag on his cigarette. "These camps are very disorganized at this point. I don't think they really know how many inmates they have." He took another drag and added in a whisper, "I'm not myself a Nazi sympathizer. I'm only a guard because of the war. The Germans captured my unit ten days after they circumvented the Maginot Line and I became a POW. They offered to free me if I volunteered to join the Vichy police. In any case, I advise you not to try to escape here, but to wait."

"Why's that?"

"The troops patrolling outside and manning the guard tow-
ers are elite Senegalese fighters from the French colony. They'd
shoot at their own mothers if ordered to do so. You'll have a
better chance of escaping on the way to Poland."

He thought for a moment and then said, "This war is not
like any other war." He looked as if he were going to elaborate,
but he just sat there, letting the sentence linger in the air with
the trails of tobacco smoke. The stars overhead were crystal-
line, and I can never remember seeing a sky so full of them.

"Now get back inside your barrack," he said.

I SPENT A restless night thinking alternately about how to
escape and what the meaning of rounding up Jews must por-
tend. If Jews were being corralled like this in France, what
about elsewhere in Europe where the Nazis had control? I kept
thinking about my family. I didn't know where my sister and
parents were, or what had happened to my grandfather who
was already in Poland or my uncle Martin in Berlin. Had they
been rounded up too? Were they right now in a labor camp? I
fell asleep growing more and more determined that somehow
I myself would get away.

The next morning, I awoke early and walked to the mess
hall for breakfast. I noticed that it was run almost exclusively
by Indo-Chinese persons: captured soldiers from the French
army who must have been offered the same deal as my guard
friend. They had been soldiers conscripted by the French colo-
nial empire, and now they were cafeteria workers, efficient and

emotionless. These people had served so many masters over the centuries that it was no great philosophical leap for them now to work for the Vichy government as proxy for the Germans during the occupation. When speaking about "collaborators," one must make distinctions. The alternative for these people was no doubt beyond unthinkable, and it seemed to me that compromise had been ingrained in their nature by years of colonialism. The guard was another degree on this spectrum of collaboration, with actual Nazi sympathizers at one pole and people basically forced into obedience at the other.

I stood in line with the rest of the people and ate my breakfast—a bowl of watery barley with bits of carrot floating in it, and a small hunk of stale bread. As I ate, I was trying to contrive how to escape. After breakfast, I started to wander about the camp, looking nonchalantly for a weak point in the fence or a blind spot from the point of view of the guard posts. It didn't seem like there were any, but I had to keep looking. I was in fact quietly seething with the desire—even the will—to get out of there, but it is not in my nature to be a worrier. In the face of danger, I make plans to act.

As I was to learn again and again, survival is often a matter of luck, but being able to take advantage of good fortune depends upon alertness, preparedness, and constancy of intent. My intent was to find a way out of there, to prevent my being shipped to Poland. It seemed like surveying the camp was the best use of my mental faculties at this time. What happens to one is in general a confluence of circumstances; and one of the tributaries to that confluence is one's own attitude and effort.

As I walked about the camp, I came upon a group of young men who looked about my age. They were no more aware than I had been that we were in fact on our way to what might very well be a concentration camp in Poland. I told them what I had learned was in store for us and, as I was talking, I had the idea that perhaps collective action might be the answer.

"There are an awful lot of us," I said. "If we all rushed the gate together, I bet we could get through."

"Are you crazy?" one of them said. "If we try that, many of us will get shot. I'll take my chances with Poland." And his response was typical. I was disappointed, certainly, not so much that they didn't want to act on my plan, but that they didn't even seem to be trying to come up with one of their own. I continued to generate ideas, thinking that it was possible for me to get lucky. Anything man-made is bound to have a flaw in its construction, I reasoned with myself, though I had to admit the perimeter of the camp seemed to be an exception. Without a massive collective effort, storming the main gate was impossible. And climbing over the fence would alert the guards, as my friend warned. If I knew I were going to be there for a few years, I probably would have tried to dig my way out, but there was no time for that. The guard said there'd be a better chance escaping from the train on its way to Poland. One would wait for a stretch of territory without evidence of police presence, and jump without worrying about being injured or killed in the attempt, or about what one would do if one landed safely.

That morning a new group of detainees had been bused in—sleepy-eyed, bewildered, despairing people—not many

with the fire in their belly to plot an escape. More would arrive as the day wore on. The camp was filling up rapidly, and that meant that we soon would be on our way to Poland.

I was still taking inventory of conditions and seeking options. The camp had only recently been converted from conventional military use. The infrastructure of a military camp was still there—rows of single-story barracks, wooden walled with roofs of aluminum. Asphalt covered the parade ground, as I observed when we arrived. A train depot was outside the main gate. The compound was clearly designed as temporary barracks for troops waiting to be shipped off to other venues by rail. Now it was serving as an assembly point for shipping off "undesirables"—either young men to labor camps, indeed to provide forced labor for the war effort, or women, children, the infirm, and the elderly, to who knows what kind of a place.

As circumstance would have it, I noticed a long line of people stretching in front of one of the barracks. This, I learned, was the infirmary. It was now about 11:00 A.M., the sun was hot, and I stood for a while in the shade of a barrack wall. For no particular reason, I joined the line—perhaps out of boredom and plain exasperation. I gathered from what I heard people saying in the queue that they were there to get medical attention—stomachaches, back problems, you name it. I wasn't sick, of course, but the hot air was hard to breathe, there was a surfeit of pollen in it, and I was certainly generally uncomfortable. I suddenly remembered something Jean Gemähling once told me but to which I hadn't given much thought at the time. He said that if one was captured, one could always fake insanity or severe

illness, if every other way to escape seemed unfeasible, because it was easier to escape from a hospital than from a prison.

Insanity would be very difficult. What I needed was a serious illness. Trouble was, I had no real knowledge of diseases or how to fake them. I realized it had to be dramatic, though. I did, after all, have experience in the theater. I left the infirmary line and paced around the camp thinking about how I'd go about it, and ran by chance into the sister of a friend of mine from my days at the lycée, four years before. She was now—or had been until being detained—a medical student at the University of Lyon.

"Sarah!" I exclaimed. "My god, what are you doing here?"

"Justus! The same as everyone else, I suppose . . ."

"Yours is the first face I recognize." There was a simple, indescribable joy in seeing a familiar person, and in the coincidence that she was in medical school.

I must have already entered the mind-set of my fake illness, for she asked me concernedly, "Are you all right?"

"Yes," I laughed and, in a whisper, "I'm perfectly fine, but I'm trying to pretend otherwise. I have the notion of faking being really sick—to get into the infirmary and hatch an escape from the hospital, but I'm having a little difficulty imagining proper symptoms." I paused, then: "Sarah, I think you can help me. Could you describe to me the symptoms of some serious malady that I might plausibly imitate?"

"Oh my god, you're serious?"

I scowled.

"I guess you are. Let me see. Appendicitis? No, that's not severe enough. Peritonitis should do the trick."

"I have no idea what that means. What kind of an ailment is it, what are the symptoms?"

"It is a perforation caused by the rupture of an intra-abdominal organ that can only be repaired by immediate surgery. It is similar to appendicitis but actually far more serious. In either case you would have to be operated on before sepsis set in."

"Okay. I'll go for peritonitis. What are the symptoms and how do I fake them?"

"Excruciating abdominal pain. Chills alternating with feeling very hot. Vomiting. Difficulty urinating. You would be bending over trying to protect your abdominal area from touch, and not be inclined to speak. Just groaning piteously."

Sarah laughed as she poked her fingers below my ribs.

"Ooo—oh oh!" I moaned. "I can do all that. I'll collapse in the grass right here and get to it. You run into the infirmary and tell them there is someone dying behind barrack 33, right? I'll put on a good show."

"You were always a little crazy, Justus. I'll be right back." She ran off and I dropped to the ground. We had been standing alone at that place, but now my moans and groans attracted several fellow prisoners. One of them put something under my head and asked me what was hurting me. I made my body seem to quake and introduced two fingers into the back of my mouth, careful to make it look like I was trying to hold down my gorge. Tears came to my eyes. I gagged violently. In minutes Sarah returned with an orderly carrying a stretcher. I groaned ever more miserably. The orderly took one look at me and asked for a male bystander to help carry me off. Since Sarah was not

a relative of mine, as a woman she would not be allowed with me into the infirmary.

I was put on a primitive bed in a small private cubicle. A male nurse came in and stuck a thermometer in my mouth and left me there. Problem. How to fake a fever? Think fast. My history as a childhood malingerer came to my aid.

The school year in Danzig lasted well into the summer but if it got too hot, we were sent home. Each classroom had a thermometer, and being smart kids as we were, we knew that if we could make the thermometer go up, we could get "heat" vacations. I remember once we put matches to it, but the reading went too high. We turned to rubbing it furiously, and this did push it up a bit, the friction making the reading inch up but not too far above 98.6 Fahrenheit. At this moment, I was very thankful for my knowledge of thermometer manipulation. I withdrew the instrument and rubbed the hell out of it while the nurse attended to some other problem for a minute or two. 107 Fahrenheit. Too high. I shook it down the way one does to reset the mercury after a fever reading but just enough to reach a reasonable if still severe temperature. 104. The nurse came back with a doctor, took out the thermometer, and nodded. The doctor proceeded to examine me, poking my belly, and I emitted an appropriate howl.

If we were in fact on the way to being worked to death in a "labor camp" in Poland, why this concern to attend to our ailments now? I wondered. I eventually learned that, according to the Geneva Conventions, which the Germans were officially respecting, an ailing inmate had to be brought back to health

before being placed in incarceration once again. Apparently only healthy people could be exterminated. I doubt that such anxiety existed at Auschwitz, though I understand there was an infirmary there too. In any case, fifteen minutes later an ambulance pulled up and I was off to a hospital in Lyon, La Grange Blanche.

ESCAPE

September 6, 1942

A S WE DROVE off, I realized that as successful as my fakery had been so far, I had no idea how I would get out of the hospital once I was admitted. The tip Jean had given me was useful as far as it went, but it was in a sense "theoretical." The difference between theory and actual tactics and the relationship of both to reality is very fluid and unpredictable. What works in one situation might prove fatal in a slightly different one. How was I to get out of the hospital?

I had no idea how well guarded the hospital was or how much officials there would be concerned to make sure that patients from the camp went back to the camp after treatment. Were they keeping close watch, or did they even know who I was? I saw only medical personnel—no military or police types, no one checking paperwork. Still, I didn't suppose I'd be able just to climb out of bed and leave the place.

As soon as we arrived, I was taken on a stretcher to the operating room. As I was being reeled through the hospital hallways, I took note of the layout: where there were stairways, bathrooms, windows, exit doors. At 9:00 P.M. I was on the table, three physicians hovering over me. One of them put a cloth soaked with ether to my face.

"Breathe. Count. The deeper your breath, the less you will feel. Start counting."

I got to seven, saw a sky full of stars, then absolute darkness. Actually, nothing at all. I woke up six hours later as if nothing had happened in between. I never found out what went through the minds of those physicians once they saw that I didn't have anything wrong inside my gut. Were they sympathetic people, willing to ignore my fakery and perhaps even help me get away? In any case, they actually did take my appendix out! It was about 3:00 A.M. when I came to, and now I was really sick and really in pain, no fakery whatsoever. The sickness was the residual effect of the ether. The pain, when I moved, was from the surgical wound. I could feel the stitches and staples and gauze and bandages. I moaned. Someone stuck a needle in my thigh, morphine, no doubt, and I faded into blackness once again.

I woke up at 7:00 in the morning and found myself physically tied down to the bed, ankles and wrists in leather shackles. On a chair at my bedside was a young female French nurse. Even in my rather dire state I couldn't help noticing how attractive she was, but this was no time to initiate a romance. I turned to her and asked, "Why am I tied to the bed?"

She laughed. "Don't you remember? In the middle of the

night you tried to get up and run away. We had to strap you down to keep you from hurting yourself." I can only imagine what my unconscious had been up to during the night. For the first time since I left my parents at the Danzig station—even after my adventures gathering information about students in Grenoble and my encounter with the judge at Foix—I felt truly alone and vulnerable. All illusions of youth were gone. I alone was responsible for what would happen to me.

I must have looked a bit despondent. She gave me a sympathetic glance and said, "By the way, who are you?"

Apparently, no paperwork had accompanied me to the hospital. "I'm from the camp," I said and immediately wondered if I had made a mistake, or perhaps they did have on file somewhere who I was, and the nurse just hadn't seen it.

"Oh," she said. Now *she* looked troubled.

"What's going to happen to me when I recover?" I asked, realizing that I perhaps had blown a chance for freedom.

She hesitated. "I . . . I don't know. I'll have to ask the head nurse." She paused thoughtfully. "But I don't think I should do that. I imagine they'll send you back to the camp." Did this mean she knew what would happen and might be willing to help?

I didn't say anything, but turned my thoughts back to the problem of escaping. I was in a wing of the hospital for people with serious illnesses, some of them former detainees like me. It certainly would be easier to escape from here than from the camp, as it was much less heavily guarded, just as Jean had said. But I had no clothes, no shoes, only a hospital gown. I would need help. By now, Lyon had become the very center of

the French Underground. Jean had moved there under a pseudonym. If I could get a message to him somehow, he might have a way to get me out of there.

Over the next few days, I got to know the French nurse, telling her my story, trying to garner as much sympathy as I could. Her name was Marianne. She was one of those people who has a calling to be a nurse. She simply wished to take care of people in pain. She was intelligent and had received a general education at the University of Lyon in addition to her nurse's training. It turned out coincidentally that she had been in an anatomy class with my friend Sarah. She was shocked to hear that Sarah was in the camp. For the first time she put two and two together and realized what the camp was for. Like the judge in Foix, she was no supporter of the Vichy government. After just a few conversations, I felt I could trust her and asked her if she would help me. She agreed.

"What can I do?" she asked.

"First, I need you to bring me a piece of paper, something to write with, and an envelope. There is a certain mailbox in an office building in Lyon where I would like you to place a message."

Jean had told me about this mailbox in case I ever needed to get in touch with him personally. It was a fortunate circumstance that the internment camp was near and the hospital actually in Lyon. I gave the nurse the address to memorize and told her that a mailbox located at the left end of a row of boxes in the lobby of the building at that address was the one into which she should deposit my message. All I asked her to do was to place it. It simply stated that I was in La Grange Blanche.

Marianne nodded and asked no questions, and the next day she told me she had done what I requested. During the night I developed a new fear—not only for myself but for many others. I had done something I most definitely should not have done. She could easily have reported me to the Vichy authorities. Klaus Barbie had been appointed to the head of the Gestapo in Lyon in January of 1942—a most dangerous man. Knowledge of the mailboxes would have compromised all the Underground agents who used them. I was only thinking of my own escape—my own self-preservation had blinded me to the potential for disaster. Fortunately, however, Marianne was trustworthy and didn't report me and the mailboxes. On the fourth day in the hospital I was visited by a young priest.

The priest belonged to an organization called the Christian Friendship (Amitié Chrétienne) which was cooperating with the Resistance. Jean had received my message. He knew that priests were allowed to enter hospitals without question, and that this group was therefore the best suited to assist me. The priest whispered, "Sunday is visitors' day. People come and go without being checked. At precisely 2:59 P.M. this Sunday by the clock on that wall, the day after tomorrow, I will leave a package of clothing behind the large laundry pail in the corner to the right of the entrance to the bathroom on this floor. At precisely 3.00 P.M. you will pick it up, go into one of the stalls, change clothes, and leave your hospital garb in the laundry pail. I will come on a bicycle and will leave it by the entrance to this wing. You must simply walk out the main entrance, mount the bicycle, and pedal to this address in Lyon." He made me memorize it and walked away.

There was a problem. Because of the stitches, I was still not supposed to get out of bed. I was provided with bag and bedpan to relieve myself. It would be a bit tricky to get to the bathroom. I came up with a plan. I must get the staff used to seeing me get out of bed and go to the toilet so they'd not be surprised by my doing so on Sunday, when precision of timing would be essential. Leaving only a one-minute gap between the placing of the package and my picking it up was the best way of ensuring that it not be noticed.

I called for the nurse. She came. "I have to go to the toilet," I said.

"Okay, I'll get the bag."

"No! I have to move my bowels."

"I'll bring the pan."

"I'm sorry, I don't think I can do it. I'm really constipated, and I don't want to lie here straining. It's too embarrassing."

"I'm sorry. I can't allow you out of bed. I'll have to ask the doctor."

The cranky and impatient doctor snapped at her, "The hell with him. If he wants to get up, let him get up. It's *his* stitches."

During the course of that day and the next I made several trips to the bathroom to get everybody accustomed to my walking about. I was conscious of the stitches as I walked, and I realized that even if I succeeded getting to the bicycle, riding it might prove to be a problem.

Then Sunday came. At precisely 3:00 P.M. I arrived at the appointed laundry pail, found the package, put on the clothes, and downstairs I went. There was a gendarme standing casually in

the lobby in front of the door. When he saw me approaching, he just stepped aside. Now I was out of the hospital. A number of people were milling around and at first I didn't see the bicycle. It was supposed to be leaning against the back of a bench just to the left of the entrance, but the back of the bench was taller than I expected. After a moment's doubt I saw it. I got on it gingerly and pedaled away from the hospital grounds. I stood up most of the way with my left hand over the incision, afraid that if I sat down any jolt would reopen it. (An image flashed in my mind of the poor fellow in the air-raid shelter during the bombing at Tours who was trying to put his guts back into his body before he died.)

The matter of the incision seemed to be the most difficult aspect of the escape, but as I was pedaling not far from the hospital grounds, I suddenly heard an ambulance behind me. *They've found me out and are coming after me!* I panicked and started to pedal harder, not doing my incision any good in the effort. The ambulance passed, and moments later there was another one. No, they weren't after me. I was on the main artery to and from the hospital, so of course there'd be ambulances.

The address I was pedaling toward was a gym the Underground army used as a safe house. It still functioned as a gym and evaded suspicion by the police because there was naturally a constant stream of people coming and going. Inside, mats on which people passing through slept were strewn amid various pieces of exercise equipment. I was taken to a small side room, examined by a physician who was waiting to receive me, and my stitches were taken out.

For two days I lay there recuperating from my fake peritonitis and my real appendectomy. I learned that what had happened to me was happening to foreign Jews throughout France, occupied and unoccupied zones alike. French-born Jews, while subject to restrictions in the occupied region, were by and large left alone. But foreign Jews—from Germany, Poland, and other countries—were being interned and sent to camps in Poland and other places. Rumors were that they were not being treated well at all. Property was being seized, and any attempts at resistance to internment were being dealt with with absolute severity. If you resisted arrest, you were shot on the spot. My escape was a small miracle. My commitment to continue working for the French Underground army solidified and deepened.

I was brought up-to-date about the situation in the Resistance movement and plans were made for what my role would be once I was back in good shape.

UNDERGROUND INTELLIGENCE AT MONTMEYRAN

———

Autumn 1942–March 1943

AFTER TWO DAYS at the safe house in Lyon, a woman from the Amitié Chrétienne picked me up in a beat-up Citroën and drove me to Montmeyran in the Drome Department, fifteen miles east of Valence. (Drome was one of the ninety-six "de-

partments," geopolitically defined regions, into which France and its colonies were divided.) I was taken to a farm owned and run by a middle-aged woman named Anna Sayn, who was also a member of the Amitié Chrétienne. This was to be my base of operations for the next two years.

I spent about two weeks recuperating from my surgery, becoming familiar with farm life, and getting to know the area. From my bedroom, I could see across a sparsely populated plain to the Vercors Massif. It was a beautiful and tranquil part of the world. I had never before lived in such an idyllic rural setting. Besides Anna Sayn, I was the only person living at the farm.

The plan was that I would spend some time becoming assimilated into the rural community before being given actual assignments for the Underground. When I was well enough, I started helping Anna around the farm feeding dandelions that I gathered in the field to caged rabbits. Some days I mucked out the stable and brought in fresh hay. I even made one or two attempts at milking Olivia, the cow. Apparently she didn't appreciate my technique. She kept swinging her tail frantically as I pulled at her udder, something she never did when Anna milked her.

I had heard very little news since I had been taken from Grenoble. There was no news in the camp or the hospital. At Anna's I was able to catch up by reading the local papers and by listening to Swiss radio, which was less censored by the Vichy or the German governments. I was somewhat aware that quite recently the tide had seemed to be turning in the Allies' favor. The Americans had entered the war after the Japanese attack on

Pearl Harbor on December 7, 1941. At the same time, the various factions of the Resistance were gaining new members, and the momentum of the Resistance in general was accelerating, especially around Lyon and Valence. It was gathering information about German troop placement throughout France and sending that information to the Allied forces in London. Jean let me know that I would be playing a part in this intelligence-gathering operation, but it wasn't exactly clear to me at first what that would be. It became clear anon.

In 1942, the British air force began a campaign of bombing industrial sites throughout Germany that would continue until the end of the war. The Americans had begun sending military equipment and supplies to Russia to help in the Soviet Union's struggle against the German invasion that had begun in 1941, when Hitler broke his pact with Stalin. There was no Allied action as yet in France itself, but the hope was that a joint invasion of American and British troops would soon liberate France; but almost a year after the Americans entered the war, this had not materialized. The British under Field Marshal Montgomery continued to commit their ground forces to resisting Rommel's army in North Africa and to defending the Suez Canal. That theater was in a virtual stalemate.

Rommel's army meanwhile had to be supplied, and one of the ways that was happening was from French ports on the Mediterranean where the Germans were stationed. Intelligence about German installations on the Mediterranean coast was of great use to the Allies. I was to play a large part in gathering it. I learned something of the overall state of the war from

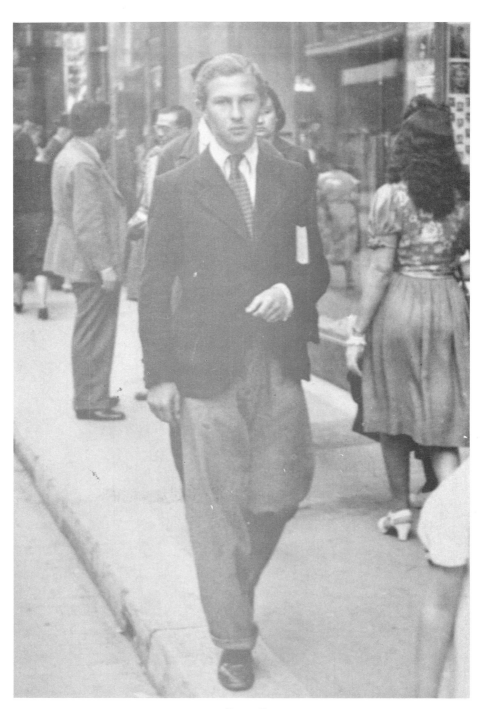

Marseille, Fall 1940.

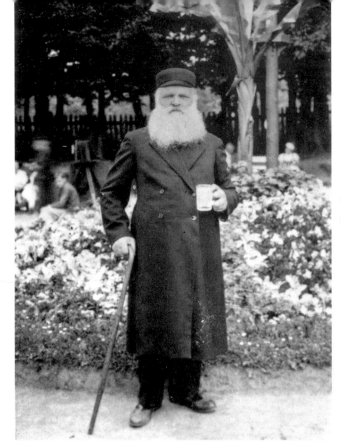

Szymszon Rozenberg, my grandfather, "taking the waters" at Krynica, Poland.

My father (right), posing with a friend, in the Polish *shtetl* of Mlawa.

Jacob and Bluma Solarski Rosenberg, my father and mother.

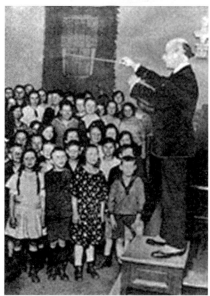

Martin Rosenberg (Rosebery d'Arguto) conducting his children's choir in Berlin, 1925.

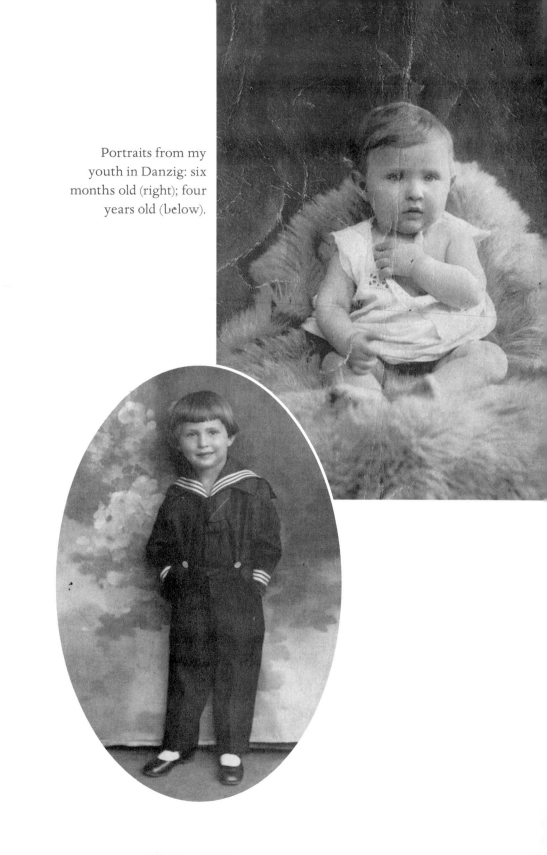

Portraits from my youth in Danzig: six months old (right); four years old (below).

Scenes from a lost world: snapshots of carefree school life before the war. I am circled.

UNIVERSITÉ DE PARIS

Cours d'Extension universitaire de la Société des Amis de l'Université

DIPLOME D'ÉTUDES

DE

Civilisation française

Degré Supérieur

Monsieur *Justus Rosenberg*,

né à *Dantzig*, de nationalité *polonaise*,

inscrit aux Cours de Civilisation française de la Sorbonne pour le semestre d'*hiver* de 19*38-39* et ayant subi avec succès les épreuves de l'examen de fin d'études, est déclaré digne d'obtenir le présent diplôme pour les enseignements ci-après, **avec la mention :** **MENTION ASSEZ BIEN**

LITTÉRATURE DU XVIIᵉ SIÈCLE	HISTOIRE GÉNÉRALE DE LA FRANCE (Nouveau Régime) (1ᵉʳ Sem.)	LITTÉRATURE DU XIXᵉ SIÈCLE
LITTÉRATURE DU XVIIIᵉ SIÈCLE		VIE FRANÇAISE

Paris, le *25 février* 19*39*

Le Directeur des Cours
de Civilisation française,

Le Recteur de l'Académie de Paris,
Président du Conseil de l'Université,
Vice-Président de la Société des Amis
de l'Université de Paris.

Les Professeurs, Membres du Jury
d'Examen,

My diploma from the Sorbonne, February 1939.

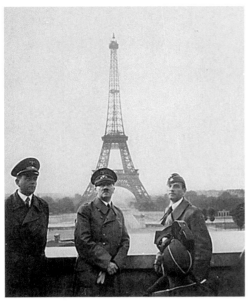

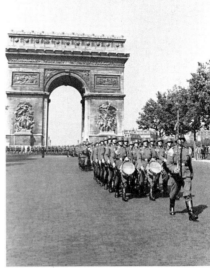

In the summer of 1940, the Nazis occupied Paris and my journey took another twist.

Map of France as of the Franco–German Armistice of 1940.

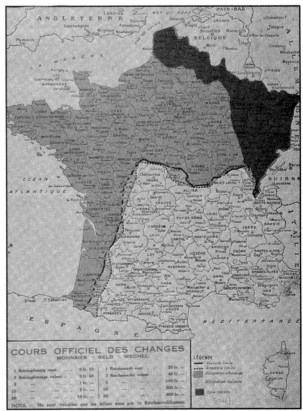

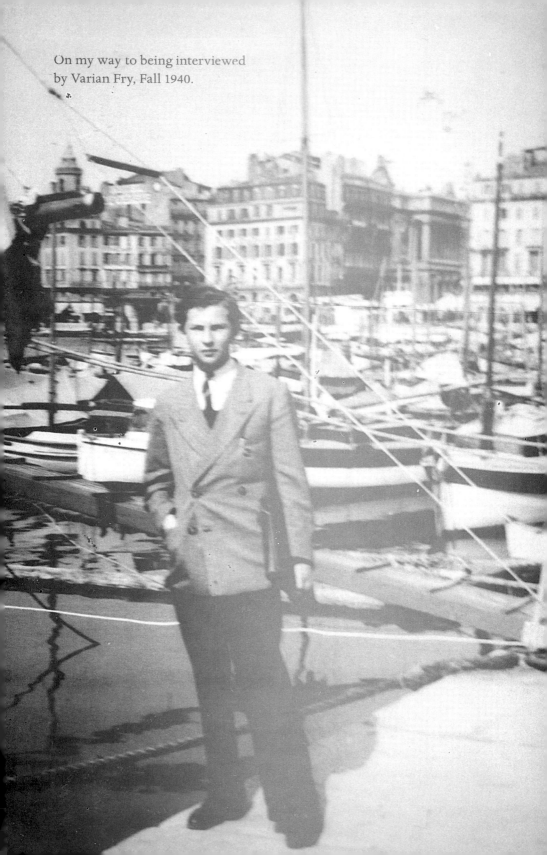

On my way to being interviewed
by Varian Fry, Fall 1940.

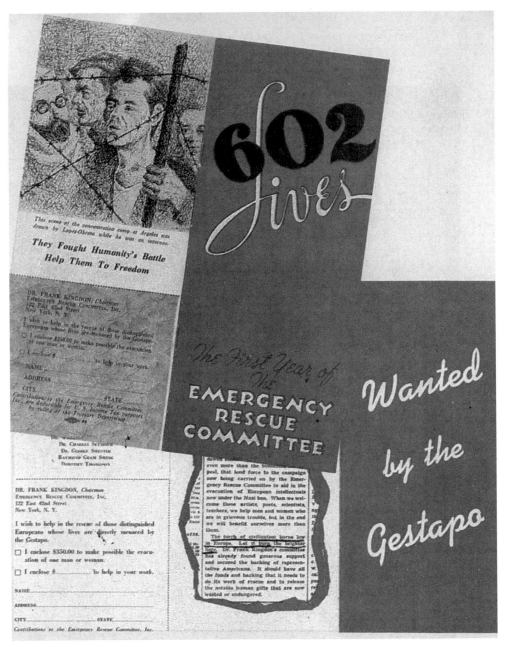

A brochure highlighting the work of the Emergency
Rescue Committee (ERC).

Working with Miriam Davenport
at the ERC. I am pictured at
the typewriter behind her.

Miriam Davenport and Varian Fry.

A caricature of Miriam Davenport,
drawn by Bill Freier of the ERC.

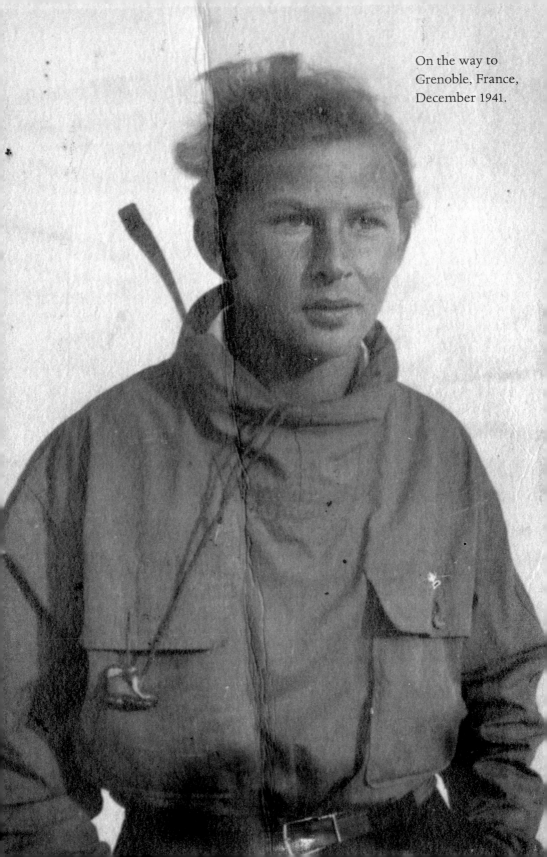

On the way to
Grenoble, France,
December 1941.

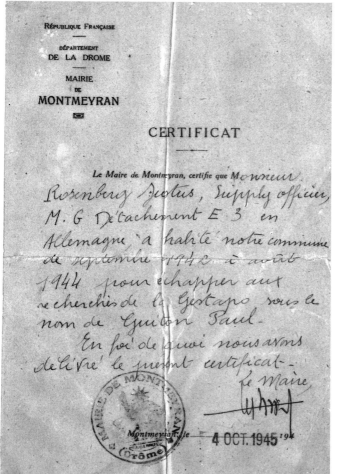

A French gendarme's report concerning my arrest at
the Spanish border in 1941.

Document from the
French government
certifying that
I was living in
Montmeyran during
the war under the
name "Jean-Paul
Guiton."

Sitting above the harbor in Marseille.

In my new suit in Marseille, with the mafioso don's nephew and one of his girlfriends.

Poster for the film *Villa Air Bel*, about the famed ERC "safe house" in Marseille.

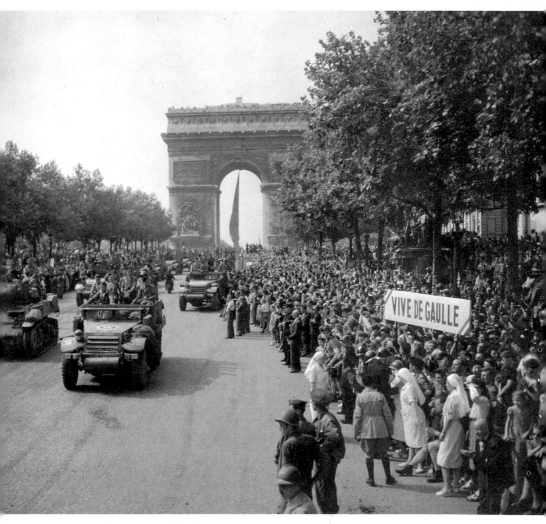

Liberation: Allied troops enter Paris, August 25, 1944.

GÉNÉRAL DE F
NEW YORK

Receiving the French Legion of Honor medal from the
French ambassador to the United States in New York in 2017.
(Courtesy of the Consulate General of France in New York)

Jean and the others in Lyon, but much of my understanding I had to put together for myself from what I heard on the radio. One was not supposed to be listening to Swiss or English stations, so even though Anna's farm was relatively isolated, you never knew when some inquisitive official might show up. It was obviously not a good idea to have the radio blasting with forbidden news programs. I had to listen with the big bulky "earphones" as they were called and that were the only ones available in those days. When I learned of the movement of armies—Allied, Russian, or German—I followed them on the maps I had from Jean. I was by now pretty adept at interpreting cartography and analyzing the significance of what I could visualize with the maps' aid.

Wherever I was in the struggle, I always wanted to understand how I as an individual was a small cog in the larger machine. Wherever possible I kept a map with me so that I could see the positions and movements of forces in the war. The newspapers and radio broadcasts never contained such details, so a map was essential for following what was happening. Even in Grenoble I had a map and was always afraid if it were discovered it would give me away as being something more than a young student; but I'd learned a trick from Varian Fry in Marseille of hiding the map in the back of a mirror and only taking it out when I knew that there was no chance of being seen with it.

To this day habits developed in the Resistance remain with me. Whenever I have a document or text of special importance, I look for a place to conceal it—inside a lampstand, under a table, in an inconspicuous compartment in some article of furniture. I

learned from Jean how to find the safest place to situate myself when in public. In a restaurant I try to get a table with my back to the wall where I can take in the whole room and observe if anyone is observing me! When one has lived underground as long as I did and practiced many things to ensure one's safety, such practices become part of one's personality. Old habits don't only die hard, as the saying goes, they seem to be immortal!

FOR THE NEXT two months I underwent a very vigorous and thorough training course in Underground activities that were considerably more adventurous than observing the attitudes of university students. Jean sent an operative named Robert to begin my training and provide me with a new identity. Robert wore a beret, a scarf, a light cotton sweater. He chain-smoked Gauloises, the superstrong cigarettes favored by members of the Resistance. Recalling the image, I'd say he looked the part.

Robert was all business. He began to train me right away.

"From now on you are Jean-Paul Guiton. Listen carefully."

I listened.

"First of all, here are your papers."

He showed me my identification card, my ration card, my Catholic baptismal certificate, and all the other papers necessary for travel between locations along the Mediterranean coast— Nice, Cap d'Antibes, Cannes, Saint-Raphaël, Toulon, and so forth.

He explained, "You were born in Saint-Malo on January 23, 1927. Saint-Malo is a town in Brittany. The offices housing its municipal records were destroyed by bombs early in the war.

Your mother is an Alsatian and your father was a navy officer killed when the war began. If you were to be arrested and they ask you where you live, you say Montmeyran Drome. You can say you are staying with Anna Sayn. She is one of your father's relatives."

The attention to detail in creating my identity was impressive. For instance, having my mother be Alsatian would explain why my otherwise perfect French was tinged with an ever-so-slight German accent.

I spent the next few weeks dedicated to forgetting who I was and becoming the person the Underground needed me to be— Jean-Paul Guiton. Some members of the Underground were being trained as typists, some as telegraph operators ("pianists" as they were called), some as dynamite experts, some as sharp-shooters. I was being trained for intelligence work. A large part of it involved conditioning me to identify myself convincingly with this Jean-Paul Guiton. To test my conditioning, Robert would stop by at random times, even in the dead of night, to question me about my identity. At first, I felt, when being inter-rogated in this way, like a young boy trying on his cousin's hand-me-down suit in preparation for a big family wedding: nothing felt right about it—the sleeves were too long, the shoulders too narrow, certainly not tailor-made for me. The role of Jean-Paul Guiton was far more complex than any of the characters I had played in *Around the World in Eighty Days*.

In spite of my unease, I was perceived as playing my part pretty well. After a few unanticipated interrogation grillings, Robert told me, "It's easy for you to parrot these details back

to me right now. But imagine being under the harsh lights of a Nazi interrogator, forced to recall every detail of your imaginary life. It will not be an easy matter to keep your story straight under that kind of pressure. Be prepared now for some rather punishing conditioning."

During the next few weeks, we rehearsed and coordinated again and again all the details of my, that is, Jean-Paul's story—how "my" parents met, the age of my father, when and how he died, where I went to school, what French Catholic parochial school was like. Robert's visits arrived more and more unpredictably. One evening he showed up and, without any warning, tied me to a chair, sat across from me, and told me that I couldn't eat, drink, or go to the bathroom until I had answered all his questions to his satisfaction. He certainly knew *his* part, acting like any sadistic Gestapo interrogation professional. My interrogation went on for three hours.

On another occasion he snuck into my bedroom while I was asleep, shined a bright flashlight into my face, and dumped ice-cold water over my sheets. He worked me over till the sun rose.

Robert explained early in this process that eventually my job would be to reconnoiter the towns I mentioned along the Mediterranean coast. I was to report which areas were off-limits and provide descriptions of the kinds of German troops I came across. To justify my traveling around in this area, my alibi was that I was a door-to-door salesman, selling advertisement space in telephone books.

After a few weeks—in late November 1942—I seemed to

Robert to be adequately prepared. I now simply waited for further training regarding my main assignment.

During this period, the political situation in France itself changed. By October 1942, Rommel had reached the border of Egypt and was approaching the Suez Canal, from which he hoped to advance northward through Syria and Iraq to the Central Asian oil fields. But during October and November, at the Battle of El Alamein, the Allied forces led by Field Marshal Montgomery and supported by armaments supplied by the Americans defeated the German army. Rommel withdrew from the Egyptian border to Tunis, and, in a reversal strategy, was recalled by Hitler, who was essentially abandoning the African campaign. To prevent a possible invasion of southern France, Germany put an end to the relative independence of the Vichy government and now occupied the whole French nation. The relative ease with which one could evade German surveillance (if one was not under direct suspicion or if one was not known to be an alien Jew) was over. There would be German soldiers throughout France now.

During my training and for much of the time while I was at the farm over the next two years, in many ways I lived as a young relative of the woman who owned it, simply there to help her. Anna, a devout Huguenot, played the harmonium at the church in Montmeyran. She loved the fact that I went with her to services each Sunday and that I sang the hymns along with the congregation. The pastor and his wife took note of my singing voice and invited me to join the Christmas choir. They thought that I was Catholic and knew through conversations

with me that I was in essence a freethinker, but they nourished the hope that I would come to see Christianity through their eyes. On my birthday, January 23, 1943, they gave me a small copy of the New Testament and told me that the only way to know God was through the study of scripture. Inside they had written, "So that Jean-Paul, the skeptic, may find truth."

A few weeks after my birthday, the pastor asked me to teach Sunday school. He thought the children would enjoy being taught by someone closer to their own age. I told him I'd never taught anyone anything before, let alone the Bible.

"You can read, can't you?"

"Of course."

"Then you can teach them the Bible! Just read them the children's stories. We'll show you what."

There were nine children in the class, all between the ages of five and nine. The first story I read them was the tale of David and Goliath from the Old Testament. Then I read them the Gospel story of Jesus multiplying the loaves. I must have been an effective reader, for the children were mesmerized. Over the next few months I read them many stories: Adam and Eve, Jonah and the Whale, the Parting of the Red Sea, the Gospel stories about Jesus walking on water, healing the blind, and resurrecting Lazarus from the dead. I had been largely unfamiliar with them myself. They were wonderful stories that grabbed the children's attention and my own, though I did not believe a word of them. As was the case with my visit to my grandfather before leaving for France, exposure to these stories left my "freethinking" intact.

The pastor at the church, who was naturally very involved in civic life, was a friend of the coach of the local soccer team. I had mentioned that I myself was a soccer player, and he arranged with his friend for me to join the team. I played whenever I could during my two years in Montmeyran.

SO THINGS WENT on for many months. Then, one late-winter afternoon, a young man named Aristide stopped by and gave me the secret password known only by members of Jean's network. I have kept the secret even to this day. Anna invited him in for supper, and he chatted with us for a while. When she left us to continue preparing the food, Aristide drew his chair closer to mine and whispered, "It is time for you to begin intelligence work in earnest. After dinner you will come with me outside to my bicycle. I have things to show you."

After coffee, when we got to his bicycle, he reached into his saddlebag and took out what looked in the moonlight like a list of some sort. It was in fact a series of images of German military uniforms and insignias, keyed to their ranks and significances.

"Study and memorize these. I'll be back in a week to see how you've done. If Anna asks what you are up to, simply ignore her." Though Anna knew in general that I was working for the Underground, it was best she be kept in the dark about the details.

My homework seemed easy enough, but it turned out to be harder than I thought. Each member of the Wehrmacht (the German "defense force") wore a stylized eagle three inches

wide above the right pocket of his uniform. For enlisted men it was either Jacquard woven or machine embroidered in silver-gray threads. For officers it was hand embroidered in white silk, or with aluminum wire. For generals it was hand embroidered gold bullion. The Wehrmacht used a complex mix of Gothic and Latin initials, Arabic numerals, and Roman symbols to designate the various branches, sections, and divisions. The collar patches were just as intricate in design and as varied as the signifiers of branches, affiliation, and rank. I was also given images of military equipment, types of artillery mainly. There must have been in all a few hundred different insignias I had to become familiar with.

Aristide came back a week later, on a Thursday afternoon, three minutes after Anna had left to practice harmonium, perfectly timed to find me alone. By the time she returned, I had demonstrated to his satisfaction my ability to identify the full complement of Wehrmacht insignias. He then gave me complete instructions regarding the mission I was now to be entrusted with. I would be traveling along the Mediterranean coast doing reconnaissance. Before entering on a journey of this kind, I would tell Anna that I was going on a business trip. She never, in fact, asked me to explain the nature of my "business." I would be traveling from town to town pitching advertising space to store owners. "For ten francs you can get two extra lines of space, beyond the general listing," I would offer.

The companies selling these advertisements were legitimate, though they were in fact sympathizers with the Resistance and allowed us to work in this way. I didn't make many sales. Most

of the businesses I tried to sell ads to lacked the money to buy the extra lines. Of course, my "employers" couldn't care less if I didn't meet my sales quota. What I was actually doing was biking around southeastern France and spying on the German army. I went from town to town, noting insignias on the soldiers' uniforms, as well as the types and quantities of artillery pieces at the crossroads—tanks, equipment, and so on. It was my job to make an inventory of it all. Also I reported on where the troops were constructing small fortifications like pillboxes, usually armed, along the beaches. The Germans didn't know where the Allies were going to land, and it was useful for the British to know where they *thought* they would be arriving. That way the British could use misinformation to divert German construction to the periphery.

I also spent a good deal of time in bars and bistros favored by off-duty officers and enlisted men. They didn't suspect that this fresh-faced "teenager" would be listening in on everything they were saying as they feasted on bread, wine, and their beloved sausages and copious pitchers of beer, when they could get them. Of course, as the evenings went on, they tended to get more raucous, voluble, and free with what they allowed themselves to say. I joined in just enough to set them at ease. When they got curious about what so young a fellow was doing there, I would tell them frankly that I was trying to get the owner of the establishment to buy an ad. If they wanted to know how I came to know German (which I was pretending to speak poorly and with a heavy French accent), I told them I had studied it in high school until I had been forced to stop attending. If they

wanted to know why I wasn't in school, and was loitering about a bar, I told them about my dead father and widowed mother, and they would usually leave me alone. While in their company, I had to concentrate very hard on everything I saw and heard and commit it to memory. I couldn't write anything down. If I were caught with notes and interrogated, I'd end up in a concentration camp.

I stayed in local hotels. At night I did have to jot down the information I'd gathered, place it in an unaddressed envelope, and as soon as possible deposit it in our network's box in Valence. A courier would retrieve it and take it to another depot. There it would be evaluated and the pertinent information delivered to our pianists, who transmitted the information by telegraph to London. The telegraph operators were jokingly called pianists because of their skill in tapping out the complex Morse code messages on the telegraph equipment.

When I began participating in this intelligence-gathering operation in January of 1943, the Resistance movement was not a monolithic, top-down organization. Instead of operating under one banner, the many individual groups of partisans and freedom fighters were organized as separate entities. To keep the Germans from infiltrating them, each developed its own codes, security procedures, and ways of communicating with one another. For example, each member of Jean's intelligence network, including myself, only had operational contact with two or three other members.

One of my assignments besides selling phonebook ads involved attending a lycée at Romans-sur-Isère. The Germans

had been using a section of the school for training some sort of fighters. The Resistance wanted to learn as much as it could about what they were being trained to do. For a few weeks I went to classes, did homework, and took tests. But during the midday break, I would mix with the soldiers and try to learn what I could through innocent, casual conversation. Some of them wanted to practice their French. I remember pretending to admire the impressive display of ribbons and medals that adorned one captain's uniform. He grinned with pride and told me he had earned them fighting in Russia and was here training soldiers in tactics to eliminate guerrillas. "Thank you very much," I muttered under my breath. It was just the kind of information I was there to gather. When vacation time came, I left for good.

Whenever I returned from an assignment, I usually spent two or three weeks luxuriating at Anna's farm. I read, taught Sunday school, and played soccer.

By the end of the winter of 1943, the German intelligence and police units were deploying equipment lodged in "directional finding" vans to locate the sites from which illegal radio transmissions were being sent. These vans were accompanied by detachments of military police specially trained to determine the sites from which the signals emanated, and who was sending them. In large cities they had difficulty in pinpointing precise locations, but they had somehow devised a technique for doing so. In Valence, where I dropped off my findings, our pianists were identified and arrested by this procedure and never heard from again. Once Jean realized this was happening,

he immediately had me stop gathering information and devised a new job for me.

MANNA FROM THE SKIES

November 1943–May 1944

AFTER THE ARREST of the pianists, I became involved in a different kind of underground activity. Many of the military squads in the Underground army, though ready to harass isolated German garrisons, were short of arms and radio equipment. The Resistance was divided into different groups with different functions: publication of pamphlets, intelligence, and military guerrilla operations, for instance. The British agreed to supply guerrillas by parachute airdrops. One day in November 1943, Aristide showed up at the farm and informed me that I had been assigned to a unit that received these airdrops.

Jean's headquarters would let me know on what specific evening, at what time, and at what precise place—usually not more than thirty miles from Montmeyran—I was to arrive by bicycle with a reliable flashlight. There I would meet eleven Underground members coming from different parts of the Drome Department.

We were told to station ourselves to form a large square—one man at each corner, two in addition on each side, making twelve in all—in an open field. At a given signal we flicked our

flashlights on and pointed them to the skies. The British pilots, flying slow and low overhead, knew when and where to release the large leather bags attached to parachutes. They were stuffed with submachine guns, ammunition, pistols, rifles, plastic to make hand grenades and other explosives, currencies, and radio equipment. Once the bags landed, we would help another special team retrieve and drag them to their gasogene trucks parked on a nearby country road. (Because of gasoline rationing we were forced to use this wood-derived substitute.) Once the bags were safely inside the covered truck, the twelve of us who had come by bicycle would ride back to wherever we had come from.

Each operation was a race between German *Einsatztruppen*—squadrons specializing in rooting out guerrillas—and us. It always ended in our favor, as we knew the spot in advance and always got there first. I participated in many runs from January 1944 to May 1944. The last contest, on a clear starlit night, was a close one. The parachutes floated slightly outside the perimeter within which they were supposed to land. We sprinted as fast as we could to retrieve the bags and helped the other team get them on the truck. Just as I was about to hop on my bicycle to return to the farm, the engine of the truck refused to start. The gasogene converter thumped erratically and petered out in a dreadful silence.

I heard a voice in the darkness.

"What now?"

"Let's try it again," came another. The driver tried to turn over the engine again. This time not even the thump.

"The Germans will be here in no time," said a comrade standing next to me.

"It's busted—" This from someone shining a flashlight on the converter itself.

Of course, we feared capture by the Germans if they got to us, but we also didn't want them to get their hands on the supplies, particularly the weapons. One of us, a plastics expert, knew how to make bombs and grenades. We decided to sacrifice the truck and its contents. He assembled a bomb, placed it in the truck, lit the fuse, and we all took off. (I never found out how the team that came on the truck got back to their bases.)

In retrieving the air-dropped supplies we had another advantage over the Germans besides knowing the time and place of the drop. The people living in this rugged area where the drops were being made supported us, and we could count on their help. One local beekeeper donated beehives, under which we could hide the retrieved bags in case the truck was stopped and searched. The driver had built a contraption that would allow him to overturn the hives from the driver's cabin. The idea was to deter the Germans from looking too closely at the contents of the truck, buzzing with angry bees!

DURING THE SECOND half of '43 and the first part of '44, the drops had become quite frequent. But there was still plenty of time for reading, though I was now being asked to identify concealed, forested, and mountainous areas in the southern part of the Drome Department for *maquisard* camps. The word comes from *maquis*, "an area in the brush." My new task was to

find places for people to hide when they refused to join Vichy France's obligatory labor force, an obligation that continued to be imposed once the full German occupation began.

For some time, the German army had been stretched between two theaters, Russia and, until Rommel's defeat a year before at El Alamein, Africa. But even after that defeat, there was a German army in Africa, and the Russian campaign was requiring more and more troops. To fill the army's ranks, young Germans working in munitions and other factories had to be conscripted. Industrial workers, however, were as vital to the war effort as soldiers, so to replace them France was required to supply laborers—slaves essentially. Many Frenchmen refused to serve in this way and ran away to the woods. These were the maquisard. Inconspicuous campsites had to be found to hide them.

My task was to bicycle on back roads through the relatively unpopulated areas northeast of Valence looking for forest trails. When I found one, I'd park my bike and hike into the woods till I came upon a clearing that I thought might be suitable for building a camp. Then I'd return to Valence and drop a message to that effect into one of Jean's mailboxes. Someone more knowledgeable than I about campsite requirements would come to Anna's farm and we would set out for the place I had discovered. By now there were police even in these remote areas looking for people such as myself performing subversive tasks, so we had to be prepared with appropriate stories. Generally my companion and I were cousins riding our bikes for a picnic, or some such thing. I would only be involved in this

activity for a few months, as it turned out. Before long I myself would be asked to join a maquisard camp.

LAST DAYS ON THE FARM

June 1944

THE LAST AIRDROP in which I participated had come a few weeks before the landing of the Allies at Normandy on June 6, 1944. Anna and I heard the news while listening to the BBC in the kitchen. We were of course overjoyed, though we realized that the war was far from over. The Allies had still to drive the Germans out of France and then defeat them on their own terrain.

For the moment things continued as usual. The following Thursday, as was her custom, Anna went to the Huguenot church in Montmeyran carrying a large basket filled with fresh vegetables, eggs, and live chickens with their legs and beaks tied up. Her practice was to drop them at the door of the homes of people she knew needed them, ring the bell, and leave. She practiced true charity, the kind my grandfather had spoken of, where the donor remains anonymous. On my visit to him, he had told me a traditional Jewish story of how in the olden days, a pious person might walk about with little bags filled with coins attached to the backs of their garments. Anyone in need might take the coins. The pious donor would not know to whom the

gift was granted, and the recipient would have no idea who the donor was, obviating any sense of obligation either way. Though not wealthy, Anna was a wonderfully generous person, both because of the liberality of her gifts and the way she so graciously took upon herself the risk of harboring me.

That Thursday, while Anna was away, I sat on the patio reading and putting my diary entries in order. The flowers and foliage around the patio were very popular with birds and bees, and that morning they were particularly busy about the patio. I was so absorbed in my novel—Flaubert's *Sentimental Education*, borrowed from the pastor's library—that I failed to hear Aristide's arrival.

"What are you reading?" he said, startling me.

I looked up and smiled at him: "A book about love and war."

"Very appropriate," he said with a grin. "It's one of my favorites, and I'd love to talk about it with you, but I must come right to the point. We want you to join a maquisard group at an encampment about twenty-five kilometers north of here."

"Does this have anything to do with the landing at Normandy?"

Aristide nodded. "Our network is going to support the invasion by harassing the Germans. The maquisards will now become guerrilla fighters."

"I'd be happy to join them," I said, "but I have no military training—the only gun I ever fired was aimed at mechanical ducks at the Danzig fair."

"You'll receive all the training you need at the encampment."

I didn't need any convincing. The prospect of fighting the

Nazis directly was terribly exciting. "When and where do I report for duty?"

"I'll pick you up at dawn tomorrow. It's more than a half-day's walk. Pack only absolute necessities: clothes, cooking utensils, shoes, and as much food as possible."

"What should I tell Anna?" I had lived on her farm for two years. We had become very fond of each other. Before I arrived, she lived alone, and I knew my departure would be a sad thing for her.

"That's up to you." He looked around and said, "Sorry. I have to leave now." He was gone as suddenly as he had come.

Anna returned within the hour. As soon as she saw me, she knew that something unusual had happened. Her raised eyebrows were asking what had occurred without saying a word.

"I have to leave tomorrow," I said in a low voice to minimize the sad news.

"Another one of your business trips?"

"I'm afraid this time it will be . . . longer."

"Two weeks or more?"

"I don't know."

She understood. She went to the wine rack and removed a dusty bottle, handed it to me with a corkscrew, as was her custom. Then she went to the kitchen for two glasses and sat down next to me. We let the wine breathe for a while.

"I always knew the time would come when you'd have to leave. I hoped you might stay till the war was over."

I took her hand and held it for a long while.

At last, she broke the silence. "Well, the impending libera-

tion calls for more of a celebration than a glass of wine. I'll catch the plumpest chicken in the yard and cook your favorite potato dish—a *gratin dauphinois*. For dessert, a *souffle au chocolat*.

Watching her bustle about the kitchen stirred up a storm of emotions—sadness, concern, even some guilt about leaving her. It took me back to the day I left my family in Danzig. There, my excitement about what was to come outweighed my sadness. Today, a different kind of excitement lay beneath my mood, but I was genuinely sad. During dinner, we made small talk and enjoyed each other's company as always.

BECOMING A GUERRILLA

June 1944

EARLY THE NEXT morning, the sky was still dark when Aristide met me on the patio. We walked down the path a little distance, and I turned to look back at the house. Branches hung over the path in a natural canopy that had no doubt been evolving for several centuries. I often walked it in the darkness without thinking about its qualities, but this time I gave it my full attention. I wanted to remember that canopy forever, knowing that I would never see it again.

Soon we were joined by two other people. The day was dawning. We would spend the better part of it hiking trails that cut through densely wooded areas and pastures where farmers

grazed their herds. The maquisard encampment, naturally, was in a remote area so as not to be discovered. We stopped to rest every three hours or so, but only for a few minutes, for we wanted to arrive before nightfall. The sun had just begun to disappear behind the peaks of the Jura Mountains when we got there, providing just enough light for me to survey my new surroundings.

The encampment was in a clearing in the forest, its periphery marked by stones and big logs, the whole area perhaps six hundred yards in circumference. Two men who had arrived the day before, together with a few maquisard already living there, were repairing several crude sheds, formerly used by shepherds during the summer months, by hunters, or, hundreds of years before, by Huguenots hiding from the Catholic Church. Henry, another maquisard, greeted us.

"Let me show you around, and then we'll get you something to eat." The largest shed functioned as a common meeting and dining room, and dinner was just being served—a sort of beef bourguignon—not bad considering that it had been concocted on a small, portable primus stove that was really little more than a lamp. Its virtue was that it produced no smoke and therefore could not give away our location.

After dinner we were led to a converted storage shed: its shelves were now bunk beds, covered with straw to serve as a mattress. Without further ceremony I elbowed myself into a comfortable position on one of them and was out like a light.

When I awoke, most of the camp was already up and about.

Out of doors someone was building a series of wooden boxes whose open front sides were being covered with chicken wire. Henry noticed my inquisitive look.

"They're for rabbits—the easiest animals to take care of, and prodigious suppliers of meat."

I knew about rabbits from my time at Anna's, and about the remarkable quantity of dandelions they consumed. My job at Anna's was more to feed them than to cook them!

"Where can I wash up?" I asked him.

He pointed to the woods. "That small path leads right to a running stream."

The stream was just a trickle. In a few spots, rocks jutted out from the banks to make small waterfalls—ideal for washing up or doing laundry.

Guerrilla training began around 8:00. It was conducted by a tall fellow in his forties, whose voice and bearing gave him away as a professional military man. His name was Pierre. I glanced about at my fellow trainees, fifteen of them, all of different ages, who had come to the camp to avoid working for the Germans. They were no more soldiers than I.

"Put your hand on the right shoulder of the man next to you and establish an arm's-length distance between you. I will want you to line up in this way every morning."

For the next forty-five minutes we did jumping jacks, sit-ups, and push-ups. Finished with that, we paired up and jogged around the perimeter of the camp for a long time. Then weapons training. This, fortunately (for we were rather exhausted by this time), involved for the most part sitting around in

a large circle taking weapons apart and putting them back together. They consisted of Sten submachine guns—lightweight with collapsible stocks and simple components that could be replaced easily. They were the same type of gun the British had dropped by parachute and that I'd helped collect. We performed each step repeatedly until we could almost do it blindfolded.

Next, we were taught how to fire the guns while standing, kneeling, and prone. Not so easy. I knew nothing about kickback, where to plant my back foot, or how to compensate for the recoil. We only fired weapons to learn how to do this, never for target practice, so as to conserve ammunition and avoid revealing our camp's position. After days of practice, we knew how to walk with the muzzle down and our fingers on the trigger and how to crawl on our bellies with the weapon in front. Pierre showed us the way to lob grenades, using rocks for missiles and trees for targets. Finally, we learned basic first aid and the technique for hauling each other in a fireman's carry across considerable distances.

After ten days of training, Pierre took me and a few others aside and told us that we had been chosen for a raid. "Our objective is a depot outside a small town some seven miles from here. We believe it isn't guarded, so consider this an extended training program. Our aim is to grab as many useful articles as we can carry: blankets, socks, boots, guns, ammunition. Departure time will be four tomorrow morning. Make sure your guns are clean and oiled. I doubt we will need them, but you never know."

The plan was that three of us would stand guard at a warehouse, while Kristoff (another maquisard), Pierre, and I would go to the schoolhouse, where the local schoolteacher lived. Pierre said the schoolhouse would not be locked, but we'd probably have to force our way into the teacher's quarters. We would rouse him, apprehend him, and take him to the warehouse, to which he'd have the key, and grab whatever looked useful and not too heavy. Then we'd gag him, lock him up in the warehouse, and be out of there and back at camp before the village woke up. "The son of a bitch is not only a known collaborator," Pierre said, "but an active Nazi, so no need to be particularly worried about treating him as he deserves."

So far in my work in the Resistance I had done many things, but I had never directly committed an act of violence. If the schoolteacher put up a struggle, he would have to be dealt with. I suspected I would have some difficulty shooting someone at close range, but what Pierre said about the man being an out-and-out Nazi had done its job, and I put my anxiety out of my mind.

As expected, the school itself wasn't locked. Pierre told me to stay put in the classroom where we entered while he and Kristoff forced the lock to the teacher's quarters. As my eyes briefly surveyed the place, they lingered on a placard hanging above the blackboard bearing the motto of what had been the Vichy state: "Travail, Famille, Patrie." A portrait of Marshal Pétain hung in the center of the wall. A small bookcase stood beside the blackboard. I examined the book titles. I spotted three volumes that would be of great use to me, so I grabbed

them: a 1905 self-teaching manual for Frenchmen studying Russian; a small orange-colored book of English essays by Charles Lamb; and a tattered English-French dictionary. *What a bonanza!* I thought. They vanished under my shirt just as Pierre and Kristoff came back with the shaking and shivering schoolteacher in tow.

"Let's move!" commanded Pierre. "We're right on schedule. As for you"—he poked the back of the teacher with his Sten—"Not a peep." When we got to the warehouse, the teacher opened the padlock and removed the heavy chains. We entered in total darkness.

Pierre commanded the terrified Nazi, "Flip the breaker." Bulbs hanging from the rafters instantly lit up the place. The walls were eight feet high and lined with boxes of blankets, soap, woolen socks, combat boots, gas masks. No firearms or ammunition, however. We rummaged through the boxes and each of us took what he could. With the books under my shirt, I wondered if it wouldn't be wiser to dispose of them in favor of a couple of pairs of boots. I'm glad I didn't. For the next few months they proved to be sustaining fare, and my knowledge of Russian and English would serve me very well both in the late days of the war and after.

Everything we brought back was pooled and stored in one of the smaller sheds—except for the books—which I didn't conceal and was allowed to keep.

"Not bad for a practice run," said Pierre.

Over the next two weeks, our training became more intense and we were tested by increasingly daring missions, ranging

from loosening railroad track spikes to concealing land mines in bridge beds. In our free time we played soccer (using our jackets as goalposts) or played cards in small groups. The most popular game was called La Belotte, which I had learned at age ten from my mother under its Hungarian name of Klabrias and Derdel in Yiddish. My favorite pastime, though, was reading by the stream, five minutes from camp. The forest about it was dense, cool, and dark, except for a few spots of sunshine coming through the canopy.

HAUTE CUISINE IN THE CAMP

———

June–July 1944

FOOD FOR THE maquisards was tricky business. We had an ample supply of meat in our cage of rabbits, but cooking them was a problem. You couldn't just roast them over a freely burning open fire, because the smoke might give our position away. On the other hand, we were in a relatively remote region, and at this point of the war, the Germans were more concerned with sending troops north than flushing out maquisards. We cooked over as low a fire as we could, and simply chanced it.

Besides rabbits, our food came mostly from foraging the farm fields in the area for vegetables: carrots, onions, potatoes, leeks, turnips, squash, and pumpkins in season. We stole

them, though I don't think the peasants in the area minded. One peasant's wife occasionally cooked up a large amount of boiled potatoes (with the skins still on) and stuffed them into large milk cans, put the cans on a wheelbarrow and hid them under dung-covered straw from cow sheds. She would leave them at the edge of the field as if it were manure for fertilizer. The straw was easy to separate from the potatoes, so we were spared the aroma.

We took turns doing "KP," two of us on a detail. I loved to cook, though I had no experience doing so for a squad of sixteen people.

When my day came to cook, I thought of making rabbit stew. Once I got the rabbits out of the cages, my problem was how to kill them. My cooking-detail partner had the proper technique: To prepare the rabbit for cooking, I had to bleed him; this involved knocking him over the head with a big stick so he wouldn't suffer when I cut his throat.

With this solved, the next problem: before parting the rabbit into chunks, I had to get rid of his furry skin. How would I do that? Again my assistant had a method. He showed me how to make a small incision at the end of one of the rabbit's legs, then take a pair of pliers and pull the skin right off.

After that, no more problems.

Serving sixteen people required four rabbits. With some difficulty we caught four of them by the ears as they wiggled to evade us and killed them as mercifully as we could.

The men found it delicious, and each time it was my turn to cook, I was expected to serve my rabbit dish.

THE AMBUSH

July 1944

RETURNING ONE AFTERNOON from an hour or so spent reading by the river, I found my comrades cleaning their weapons, taking them apart and reassembling them. Some important mission was in the offing, and I joined in the preparations.

Late that night ten of us gathered on the grassy square between two of the sheds. What had once been a group of passive maquisard civilians was now a properly trained band of guerrilla warriors. A dense blanket of clouds obscured the moon and stars—perfect conditions for an ambush. After a few hours of walking in the dark, each man walking arm's length behind the other as we had trained, we reached a dirt road where two trucks (running on gasogene) were expecting us. We broke into two squads of five, mounted trucks that were loaded with cartons of hand grenades and two heavy submachine guns, and headed farther into the valley. At a certain point the trucks pulled over to the side of the road. We climbed out and camouflaged them with foliage and branches.

The last stretch of our journey was on foot. Three A.M. was approaching. We had to reach the position for our ambush before dawn, after which we would be visible, and we wanted to remain unseen as long as possible. The idea was to attack any German military convoy traveling north to join the German army, which was now trying to confine the Allied forces

to Normandy where they had landed a month before. The ambush would be staged two miles from where we hid our trucks. After the surprise attack we would be able to return to them through the woods in relative safety.

The shoulders of the highway were slightly elevated. Stationing ourselves on top of them where we were virtually invisible from the road, six of us could spread out at forty-yard intervals. The idea was to keep as low a position as possible on the shoulders with our guns at the ready. Two of us operated one of the machine guns, placed at the edge of the forest on the right, one carrying the ammunition belt to feed the 40 millimeter gun that the other wielded. Two others manned the second machine gun a hundred yards back on the escape route. Dawn broke at 5:00 A.M. The sky turned from gray to deep purple, but long before I saw it, I heard the unmistakable sound of a German military motorcycle approaching on the road. Subject to frequent harassment by guerrilla groups, the Germans had learned to investigate what lay ahead of their convoys. The stretch along which we were positioned must have looked suspicious. The motorcyclist passed by very slowly, allowing the soldier in its sidecar to survey the area with his binoculars. Would he spot us? He gave a signal with a flag, and soon I heard the convoy trucks and felt the ground vibrating as the six heavy flatbed vehicles drew closer. They were carrying tanks and artillery, protected by soldiers with mounted machine guns.

When the first vehicle, passing us, reached the end of our line, Pierre blew a whistle, and the six of us on the road shoulders lobbed grenades, each targeting the truck passing oppo-

site where he was stationed. The Germans who weren't killed immediately jumped off the vehicles and began shooting at us as we ran back through the trees, our retreat covered by the machine guns we manned along our flank. As I was manning a submachine gun, I was one of the last to take off through the trees. Almost back at the truck, suddenly my lower leg went numb and I fell to the ground. Someone grabbed me by the collar, threw me over his shoulder, and hoisted me onto the truck and we raced off. One of the men looked at my leg and said it was only a flesh wound—my right calf had been grazed by a bullet. Even though he was correct that it wasn't very deep, it still was bleeding heavily. Pierre cut off a bit of my trouser leg and made a tourniquet. "That should do until our Dr. Durand can come from Valence to look at it."

Once in the camp, I was taken to a hut and lain next to one of our few stoves to keep me warm. Dr. Durand arrived early the next morning accompanied by a young woman. She was a nurse from an urban section of the Underground who had volunteered to participate in our raids and ambushes. While I was recovering, her presence inspired heated debate regarding whether women should be given combat roles. There was the immediate problem, for instance, of where she should sleep. Six of the sixteen members of our group—including myself—were in favor of their participation. She was in fact allowed to stay in the room where I was.

It only took two weeks for my wound to heal, during which time I studied my English and Russian. New recruits were arriving at our camp, and I helped with their general orientation.

One of them went down with me to my favorite reading spot on the creek.

"Oh, what are you reading?" he asked.

"I'm teaching myself Russian and English."

"That's a good idea! Those languages will be most useful when the war is over."

"What do you mean?" I asked. I knew perfectly well, but I wanted to draw him out. We talked for a while, and when he realized that though I was interested in philosophy and ideology but not very well read in those areas, he started to lecture me as if he were conducting a seminar at a university. I found him easy to follow and we met nearly every day. He had been a teacher of philosophy in a lycée in Valence. He started off by giving me a rundown on what he called the principles of "practice."

"Any philosophy is only an intellectual blueprint," he said. "Even *useful* concepts are only *concepts*. A blueprint is not a building. Sometimes the goal is to find the blueprint behind a preexisting structure; at other times, the goal is to design a structure superior to the one currently in place. But to do so," he asserted, "we must think deeply about the function and purpose of humanity and human society on earth."

He went into details about "human nature," and whether or not there actually *was* one. "What do we describe as human nature? Survival instincts? The need for food? The desire for sex? We call these things '*human* nature' but they are not unique to humans. They are not *human* nature—just *nature*.

"Political thinking begins with an attempt to define human nature on the basis of nature itself. Capitalism accepts nature

and human nature wholeheartedly but puts a premium directly on food and sex, and indirectly on the commercialization of these same things through fashions in apparel, hairstyles, and so forth. Marxism, by way of contrast, recognizes that capitalism is already regulating the essence of reality."

I was paying close attention and beginning to develop my own thoughts along with him. I asked him at this point, "Do the Marxists want to change human nature or nature itself?"

"This is a subtle point. Marxism is what is known as 'dialectical materialism.' By 'dialectical' is meant that its philosophical positions are themselves always subject to criticism and further thinking. It accepts the view of nature given by materialist science, but at the same time, it acknowledges that what we understand about nature is a historical process. If we can change the position of man in his historical circumstances, our understanding of nature itself will change, and with that, we may be able to find ways to change what we ourselves really are. Marxism is a philosophy of human possibility."

I still think that our concept of nature is a product of history and that *human* nature is capable of transformation; that is, that we have possibilities we have not explored or even discovered. But today, with the collapse of communism and the more or less total globalization of capitalism, hopes of historical change in this regard are pretty dim. We have little choice but to work with "nature" as our present techno-culture gives it to us and hope that its contradictions will not destroy life on earth, that a future humanity will be able to begin once again the process of transformation.

We touched on many other subjects. From my experience

with the young students at the Montmeyran Sunday school, I had given some thought about possibly becoming a teacher, so at one point I asked him what he thought about pedagogy. He summed his view up in a nice apothegm. Teaching should endeavor "to make the beautiful simple and to make the simple beautiful."

THE 636TH TANK DESTROYER BATTALION

August–October 1944

THE LANDING AT Normandy on June 6 was not the only arrival of Allied troops in France during the summer of 1944. On August 15, a force of some 150,000 men launched an invasion (code name: Operation Dragoon) along the Mediterranean between Toulon and Saint-Raphaël, an area I knew well from my days doing reconnaissance. Unable to fight effectively on two fronts, the Germans withdrew the southern army along the Rhône Valley, another area very familiar to me.

Not long after the landing at Normandy but before Operation Dragoon, the French Underground army—Resistance fighters waiting to join the Allied forces—had suffered a defeat in the Vercors Mountains not far from where my little band of guerrillas held camp. The Luftwaffe had launched an assault from Chabeuil Airport, using it as a base for glider planes. On July 23, some twenty-five gliders had successfully de-

livered twelve thousand battle-hardened SS paratroopers, tanks, and heavy weaponry to the Vercors plateau area and completely wiped out our Resistance fighters there. But Operation Dragoon more than compensated for this defeat. A second front in France was about to open against the Germans.

My guerrilla squad had not been informed that we would be participating in Operation Dragoon, but three days after the Dragoon landing, a messenger arrived to direct us to construct a roadblock near the Chabeuil Airport. The Germans were now in the process of abandoning the position—we already could hear detonations from the direction of the airport. They were blowing up all the equipment they couldn't take with them. The roadblock was to impede the German retreat. Since I had been living for two years in this region and knew all the roads leading to and from the Chabeuil Airport, I was assigned to take charge of the operation.

The morning after we established the roadblock, we expected the Germans to attempt to pass through. A young Frenchman named Jacques and I manned a machine gun from the hardwood grove some distance from our obstruction. The rest of the squad carried pistols, rifles, and grenades. We waited for the Germans all night without sleeping. At about 5:00 A.M. I had just begun to doze off, when suddenly Jacques elbowed me awake.

"Look over there!" he said, pointing his finger at three figures walking toward us on the road, but not from the direction of the airport. The sun had risen and was blazing behind them, so it was difficult to make out whether they were German

soldiers. Jacques, however, had made up his mind. His brother had been killed by the Nazis on Vercors plateau, and I knew that he was quite trigger-happy. "These are Bosch. I'm going to take them out." He raised his gun.

"Wait," I ordered. "There are only three soldiers there." I wanted to get a better look at them. Jacques took his finger off the trigger. They moved out of the sun blaze and now I saw them clearly.

"My god," I exclaimed. "They're NOT Germans. Those are not German uniforms. I bet they're Americans!"

The three men had no idea we were waiting in ambush. Soon they were right in front of our position. I drew my revolver and leapt out of hiding, shouting, "Stick 'em up!" My English, I must say, was not limited to Charles Lamb—I'd seen a Hollywood western or two.

I must have been quite a sight in my beat-up blouse and short pants, scraggly beard, and hand grenades tucked in my belt. That in itself must have startled them. They jumped back and pointed frantically at the American flags stitched on the arms of their uniforms.

"We're not Germans!" one of them cried in a French broken by an American accent.

"Are you Americans?"

"Yes! Yes!"

"Do you know where you are?"

"Near Chabeuil, right? But who are you and what are you doing here?"

"I'm in the French Underground—part of a guerrilla squad

waiting to ambush German forces as they come out of that air-port," I said, in my best English, no doubt broken by a *French* accent.

"And I am Lieutenant Rogers from the Reconnaissance Company of the 636th Tank Destroyer Battalion," he recited.

Rogers and I got acquainted, and when he realized that I was in charge of creating the blockade and obviously knew all sorts of things about German positions in the area, he took a map out of his pocket and asked me to mark on it what positions we were aware of and tell him everything I knew. I spent a few minutes doing what he asked.

"This is very helpful," he said. "Around the bend in the road up yonder we have three armored cars. I'd be obliged if you'd come with me to our battalion headquarters and tell our colo-nel what you just told me."

"Certainly," I said, "as long as you bring me back again."

Around the bend in the road there was indeed an armored jeep and two other armored vehicles. Soldiers stood about them, waiting for Rogers's return. They were a splendid sight. Just seeing them made me feel that the war would soon be over.

Rogers asked me to sit down next to him in the back of the jeep and ordered the driver to head for Montmeyran. In twenty minutes we were at his battalion headquarters. It had been months since I'd been in town, and it was strange to see what was usually a quiet square now filled with American tanks and armored cars. Troops bustled about, conversed with shop-keepers, stood on street corners, and sat on the steps of a church.

We parked and went right into the office of the colonel in

charge. He looked me over and said, with what I already recognized, from the movies, was a Texas drawl, "What do we have here!?"

"Something I think you'll be very interested in," Rogers said. "This fellow knows all the German positions between Valence and Chabeuil."

"Is that so?" the colonel addressed me.

"Yes," I responded. "I am a member of the French Underground and part of a guerrilla squad trying to ambush retreating German forces as they come out of Chabeuil Airport. In the Underground I'm known as Jean-Paul Guiton. My real name is Justus Rosenberg."

"And you know the area in general, not only the positions of the Germans?"

"Yes, I do."

"You speak some English. Are there any other languages you know?"

"German and French."

"Any Slavic languages?"

"Polish and a bit of Russian."

"I'll tell you what. There are Ukrainians and White Russians all over the place who have been fighting on the Nazi side. I need an interrogator. I want to attach you to the 636th."

"I see the need," I said, "but I'm in charge of an operation to disrupt the Germans coming out of Chabeuil—I will have to inform my comrades as quickly as possible."

"Yes, of course," said the colonel, and he picked up a telephone, dialed a number, spoke a few words, and handed me

the receiver. The colonel had called an official in the invading French army that had landed from England in the south in co-ordination with the American, Canadian, and British landing at Normandy. The French were concerned to integrate Resistance fighters into the overall Allied strategy, so it made sense that my new role should be reported to them.

An official said in French, "You are now attached to the Re-connaissance Company of the 636th Tank Destroyer Battalion."

Okay, I thought. *What next?*

Rogers and his driver accompanied me back to my ambush squad. I apologized to my comrades, assured them that they would be able to carry on without me, and said goodbye. They took this development stoically, I think, and continued with their operation.

Now we drove back to Montmeyran. At the headquarters of the battalion, I was presented with a spanking fresh American uniform, new shoes, socks, and a place to wash up and shave. The only thing they couldn't provide me with to establish my identity as an American GI was a pair of dog tags. "If you get captured," the sergeant dispensing these articles advised me, "just say you lost them. You are now a member of the 'recon' company, and you will take orders from Lieutenant Rogers and Captain Evans. The battalion has several hundred soldiers."

I soon found out that these soldiers were Texans to a man. They were very tall and all spoke with the familiar drawl.

When I joined my squad and was introduced by my possibly Jewish-sounding German name, one of them looked down at me and said in a voice that was half inviting, half off-putting,

and not a little curious, "I've never seen a *Jyoo* before." And we got to talking. Apparently everything in Texas was the best America has to offer: best cattle, best music, best women. Somehow it really did seem a little too much like cowboy movies! But the Texans had no movie images with which to assimilate their impressions of me, so in a sense I had an advantage over them. As things developed from awkward introductory conversations to sharing serious work and suffering serious dangers as we fought alongside each other, we got along fine.

MY JOB AT first was to interrogate the local population as we traveled across France to find out whether they had seen any Germans, what direction they were heading in, and so on. I stayed with the 636th Tank Destroyer Battalion from August 21, 1944, through October 1944. Its insignia was a tiger crushing a tank between its teeth, its mission "to seek, to strike, and to destroy." I traveled in a specially built reconnaissance jeep as a member of a crew of four. I always sat next to the driver, ready to jump out and interrogate any German stragglers we came across, or to run into a farm and ask its occupants if they'd seen any German army units passing by. Occasionally, we drove off the road, camouflaged the jeep, contacted headquarters by radio, and oriented our artillery toward Germans driving in our view.

Though I had been fighting as a guerrilla ambushing convoys and retreating to hiding places for many months, somehow the combat I was now engaged in disturbed me more than any combat I had been in before. One image that haunted me for a long while—and really haunts me still, more than seventy

years later—is that of a German heavy Panzer tank getting hit, catching fire, and ejecting human beings set ablaze by the blast. I saw them roll around in the grass to put out the flames. They were members of the most feared SS Panzer division, but I still felt compassion for them and imagined their pain.

I BEGAN TO develop a keen sense of how a professional army (as opposed to an underground squad of guerrillas) was organized and how it operated. I was impressed by the complexity and fluidity of its functioning. A giant machine of war was in motion throughout France, recapturing territory and pushing the Germans farther and farther back toward Germany. "Guerrilla" combat is, as its name implies, "small war." But the precariousness of that kind of combat, fighting against a full-scale occupying army, was anything but diminutive. The scale of the invading army, in contrast, and the fact that we were on the offensive, gave one a sense of relative protection, which of course was an illusion. We were often exposed to enemy fire and land mines.

Again, guerrilla warfare had been mostly a matter of choosing a time and place to strike. We had the tactical advantage and the element of surprise. Planning an operation might take weeks or even months. But *we* made the plans, rehearsing and practicing every detail about them. Even when we had begun an operation, changes in the immediate situation could cause us to stop, adjust tactics, and begin again. In contrast, the war machine planned and directed operations on a far grander scale. We were responsible for our part in a vast operation. But it

wasn't *our* operation in the same sense. And we were now the ones experiencing vulnerability in relation to hidden raids, sabotage, and unexpected land-mine explosions.

IN LYON, OUTSIDE of La Grange Blanche—the very hospital from which I had made my escape—I chanced upon a German soldier sitting on the ground sobbing and cradling the head of a wounded friend in his lap. He was no doubt under the illusion that he could somehow get his friend into the hospital. I asked him what unit he belonged to and in what direction the unit was headed. Of course, he gave me his name, rank, and serial number and refused to reveal anything else. His friend was losing a lot of blood and would clearly die very soon if he didn't get serious medical aid. I was touched by the man's sorrow, but I also saw an opportunity to obtain valuable information.

"Listen to me," I said. "If you tell me what you know about the movement of your unit, I'll call an ambulance and get your friend to an American field hospital." (La Grange Blanche was not accepting German soldiers.) He wanted to go with his friend, but that was not possible. He was a prisoner of war now. I would have to call in an officer specializing in dealing with prisoners. He would be taken to a temporary war camp, and so on. He agreed to my offer anyway. I never learned whether his friend survived, but our side of the deal was well worth the arrangement. I learned from my prisoner that all the bridges crossing the Rhône River around Lyon had been blown up. The next morning, the 636th Battalion was supposed

to cross that river and send patrols on north. How would we do that?

One of the radio operators in my recon squad—a fellow named Bergan—doubled as a communications specialist. He and I were now sent along the Rhône River to see if we could find a location to place a pontoon bridge. As we were standing next to the river, a shot rang out. Bergan keeled over, fell into the water, and was swept away. The suddenness and swiftness of the event was terrifying. Though I myself had received a flesh wound in an earlier skirmish and had witnessed the disturbing scenes of enemy casualties at some distance, I had so far escaped experiencing combat violence in close proximity to my own person. This was the first time a comrade of mine was killed while literally standing next to me. Was it luck that determined who got killed, was it destiny? Yes, I was truly shaken, and not only because it could easily have been me.

OUR UNIT GENERALLY traveled by night on back roads without headlights and of course without streetlights, so there were serious road accidents and consequently serious injuries not inflicted by the enemy. Daytime travel, however, was also hazardous. The enemy could see and ambush you. European back roads were narrow and winding, and rarely little more than trails for carts drawn by animals. There were by this time in the twentieth century major highways, but these had long been torn up, or, when intact, subjected to intermittent shelling or strafing. Even where the back roads were better than trails, there were often signs put up by the Americans

warning that the shoulders of the road had not been cleared of mines.

During one of our missions, we sighted two companies of German infantry moving along the Rhône River valley and led by two German Mark V tanks. We set up an observation post on a hill half a mile away above them, from which we could observe their movement and direct artillery fire at them. The first blast from our six-inch guns fell slightly short of the target but alerted them that they were under attack. We saw German soldiers scurrying like ants about the valley. We adjusted the coordinates on the artillery and ordered a second barrage. They threw German nets and tree branches over their guns, trying to camouflage them. More soldiers ran from their emplacements, toting artillery pieces, and hauling themselves into a truck trying to escape our assault. They didn't make it. The second salvo hit the mark. There was the sound of explosions sending up smoke and dust. More artillery fire, more noise, new clouds. Through the smoke we saw a rather grand assortment of German armaments in the process of being abandoned to the Allied forces. It turned out that there were in addition to the two Mark V, eight Mark IV; four Mark VI tanks; three 88 millimeter, self-propelled artillery guns; two armored reconnaissance and eight ammunition vehicles; sixteen personnel carriers; and six command cars. Once the bombardment ceased, members of the 36th Infantry Division, to which the 636th was attached, descended into the valley and captured, in addition to all this equipment, 215 enemy combatants.

THE TELLER MINE INCIDENT

October 11, 1944

THE WAR SITUATION at this point was as follows. The Americans, Canadians, and British had landed at Normandy on June 6, 1944, and were pushing the Germans eastward toward Germany. On August 15, an Allied force consisting of Americans, Canadians, British, and French troops from their African colonies and from Italy (half of which had been liberated) landed in Provence, and the Germans were retreating northward. The 636th was part of that operation. On August 25, the Allies entered and liberated Paris.

The closer the Germans, being pushed from their positions in the south of France, were to their border, the more fiercely their armored battalions fought to allow their withdrawing divisions to establish a strong defensive position in the Vosges Mountains. After the liberation of Dijon on October 11, 1944, the reconnaissance squads of the 636th Tank Destroyer Battalion fanned out northeast to get as much information about the strength of the remaining German forces as possible. In the armored jeep I was assigned to, I always sat next to the driver to help him get through the maze of small villages and country roads whose signs the Germans had removed and the numbers on whose milestones they had flushed out. I had local maps and was in charge of figuring out what direction to go in the absence of such markers. For the most part I led us in the right direction.

We often stopped at some isolated farm to ask its inhabitants to mark their location on our map and tell us how long it had been since they had seen Germans go by and how many of them there were. The information was immediately communicated to our headquarters by the two radio operators sitting in the back of the jeep, equipped with a powerful radio transmitter. Spare space in the back was occupied by cartons of K-rations (bars of chocolate, cigarettes, instant coffee, toilet paper, and other things the French had rarely seen since 1940). While I was gathering information, the other members of the squad might be attempting to barter—with sign language and a few French words—K-rations for a plate of scrambled eggs and a tall glass of milk. Since I was the only one who actually spoke French, I did all the actual talking. On one particular occasion, I got involved in casual conversation with the farmer, much to the impatience of the other three, who marched off back to the jeep.

"I never thought Americans could speak French so well," he complimented me. "To express my gratitude for coming so far to liberate France, I would like to give you something." He stepped closer and placed a small bottle of homemade brandy in a pocket of my army trousers.

My comrades had already reached the jeep. The driver beeped the horn twice, while one of the radio operators hopped onto the front seat next to him, so I had to head for the back of the jeep while they made gestures to the effect that they were about to leave without me.

As soon as I hopped in we were off. We had driven about

four hundred yards down the unpaved road when the jeep's right front wheel rolled over a seemingly innocuous bump. There was nothing innocuous about it. It set off what must have been a German teller (plate) mine. The explosion blew off the driver's right leg and completely obliterated the radio operator who sat in *my* seat next to him. The other operator and I were thrown several feet up in the air and out of the jeep. In the perhaps two seconds I was spinning head over heels, I can't say I saw my whole life go by me, but I did think I had been killed and was, in spite of my firm disbelief in an after-life, hurtling toward who knows what metaphysical destiny. I landed on my head and, though I wasn't knocked out, blood was pouring from a gash on my cranium and I felt severe pain in my sides. The radio man was unhurt and crawled to the radio on the ground nearby us. It was blasting through the static, "Is everything all right?"

"It is not," he shouted. "We hit a mine. One of us is dead; two need your help right away."

He gave them the coordinates of our position and in ten minutes a US army field ambulance arrived. A medic and two litter bearers jumped out of its back and hoisted me into the ambulance to administer first aid. The explosion must have broken several of my ribs, for the pain was excruciating every time I took a breath. They gave me some morphine, wrapped my torso, and bandaged my head, which appeared to be but a scratch in spite of the heavy bleeding. As soon as we got to the field hospital, nurses, doctors, and orderlies scurried around me and assured me, probably to make me feel better,

that I could anticipate being back to full health within a few weeks.

At the field hospital, I observed once again the difference between the operations of a professional army and those of a guerrilla force. There were plenty of doctors with various specialties, not just one who handled all problems like the physician who had attended to my bullet wound when I was with the maquisard. Field hospitals were set up near combat zones, well equipped to take care of casualties on-site until transport to more permanent facilities became possible. They were manned by competent professionals and organized efficiently.

I spent one week in the field hospital and two weeks at the French hospital in liberated Dijon. On November 8, the doctors pronounced me well enough to return to the 636th. By then, the battalion had reached the Vosges Mountains where the retreating German army had been able to establish a stable defensive position.

Lieutenant Rogers seemed genuinely happy to see me as I reported to him for duty. "You couldn't have picked a better time to join us," he said with a grin. "Because of the rain, snow, and mud we can no longer go out on reconnaissance missions. This will allow us to rest until we resume them—in Germany."

While I was recuperating, Lieutenant Rogers and I became good friends. He was impressed by what he called my "courage" and told me all about the campaigns in Italy and other places he had been a part of. He had seen active combat duty since the Americans entered the war, virtually without a break,

and was decorated with four Purple Hearts. He told me much about life in America and stimulated my curiosity to experience something of this country whose support and participation was contributing much to what now seemed assured victory. I in turn told him of my life, particularly how I hadn't had any contact with my family for what now was many years.

A week or so after I returned to duty from the mine incident, this battle-hardened officer, whom I was now calling Pete, told me that his plans for me had changed. Instead of sitting around freezing in the countryside, he was granting me a leave on condition that I drive with him to Paris, which he had never seen. I would be his tour guide. We would enjoy two weeks in the liberated city and then return to the battalion.

HOMECOMING TO PARIS

December 1944–February 15, 1945

PETE ROGERS AND I arrived in Paris—only a three hours' drive from Dijon—two weeks before Christmas of 1944. Paris was a city of great joy as it celebrated both the holidays and the continuing glow of liberation that could still be felt even after four months. Paris had survived the long German occupation largely intact. The general in charge of the military government of Paris, Dietrich von Choltitz, had disobeyed his Führer's direct command to destroy the city. Von Choltitz later

said that he spared Paris because he knew its destruction was of no strategic relevance, because he felt affection for French culture, and because he was convinced that by this time Hitler was quite insane. Von Choltitz surrendered Paris to the Free French Forces and survived his own defection by being taken prisoner.

Paris had taken the occupation in stride and was now returning to old routines, as if the events of the past four and a half years had been nothing more than an interlude. For me, returning there was very much a homecoming. It was the city in which I had spent many of my formative years, a place whose backstreets, grand boulevards, and arrondissements I knew by heart. I had enjoyed innumerable hours sauntering, tarrying, walking virtually everywhere. Modern Paris had been planned—and thankfully remained—a city built for walking rather than for motor vehicles rushing down the thoroughfares, unlike so many other more modern metropolises. The Parisians felt keenly that one cannot appreciate marvelous architectural facades, pleasant fountains, or the distinct aromas and local vitality of such a living human world from the inside of a car or bus whose only use for the streets is to trample over them on the way to somewhere else.

During my time in Paris while acting as a tour guide for Lieutenant Rogers, I found a place to stay in the Latin Quarter on rue du Sommerard once again and resumed, whenever possible, my life as a flaneur. Paris was even more lively than I remembered. The confluence of the Christmas holidays and liberation made for a jubilant mood and a general sense of fra-

ternity. Everyone was free. Everyone was equal. Everyone was brothers.

Each night the International Red Cross, the USO, and other organizations held public events in dance halls and other venues for GIs on leave in Paris and invited throngs of young Frenchwomen to come to "jitterbug" with the soldiers. I had no civilian clothes to speak of, so I wore my GI combat fatigues when I attended these soirees. Speaking French quite well, donning a "decorated" uniform, and (I must say) being a good dancer with a young but seasoned and intelligent mien, I was a fairly popular partner at the dance halls.

Paris itself was in an almost continuous state of celebration even as the war dragged on, because, by this point, it was fairly clear that Germany would be defeated. The Russians had forced the invading Germans out of Russia and were pressing them farther westward through Poland and into Germany. The German army was attempting to hold them back while at the same time keeping the Allied armies out of Germany on the Western Front. As early as July 1944, the German High Command was split over whether to come to an accommodation with the Allies and perhaps entice them into helping resist the Russians. The USSR was in fact on the verge of extending its control over the Near East, establishing a buffer against any future German incursion and in the bargain extending the Revolution.

Hitler was vehemently opposed to such an accommodation. The split in the High Command was no mere difference of opinion. The fate of the German nation was at stake. To prevent utter destruction of the Reich, the last of many attempts

to assassinate Hitler was undertaken. On July 20, 1944, a bomb that had been planted under a table in front of Hitler in the chamber where the High Command met exploded; several in attendance were killed, but not Hitler. He interpreted his escape as a providential sign that the war on two fronts should continue. Hitler believed that a secret attack on the ill-defended Allied position in Belgium would divide and demoralize the Allied advance and create conditions for a peace settlement more advantageous to the Reich than suing for peace in lieu of defeat.

The Germans' last military effort against the Allies, the Ardennes Counteroffensive, or the Battle of the Bulge (as the American press dubbed it after the apparent "bulge" in the Allied lines under attack), lasted from mid-December 1944 to mid-January 1945. It was the most costly battle of the war in terms of American casualties, and though it failed utterly, Hitler continued to fight until May. While Pete Rogers and I were sporting in Paris in December of 1944, the Battle of the Bulge was in full swing.

During my first week back in Paris I made a visit to the Sorbonne, which had reopened as soon as the Germans were driven out of Paris. I had heard that special programs were being offered to returning veterans and students whose studies had been interrupted by participation in the Resistance. I had actually completed many classes and continued to educate myself as much as possible in French literature. I was eager to resume and complete my studies. Though I was still officially in the military, it was possible to register for courses, so I registered.

While I was on the premises, I stopped by the office of Al-

bert Bayet, the professor whose analytical acuity had most impressed me when I was a student five years before. He was there, and I was happy and surprised that he remembered and recognized me at once. I briefly summarized my experiences in the Underground and told him I was thinking of pursuing an academic career and had registered formally to continue my studies at the Sorbonne. He lauded my intentions, but he may have noted some hesitation on my part. From our conversation he also could see that I was tuned in to the political and social situation of postwar Europe. He expressed the view that, frankly, at the present time I might put my experience and abilities to better use than returning immediately to my studies.

He said that an organization had been founded by the United States two years before, prior to the Allied landing in France, devised for dealing with the vast number of persons whose lives had been disrupted by the war. The Allies had become acutely aware of them whenever they liberated territory from the Nazis. He said that it was called the United Nations Relief and Rehabilitation Administration (UNRRA). (The organization was to become part of the United Nations when it was founded later in 1945. "United Nations" in its title referred to the fact that many nations were participating in its activities.) In May 1944 the Supreme Headquarters of the Allied Expeditionary Forces estimated that there were close to twelve million refugees in western Europe alone, excluding displaced Germans. (By the end of the war over sixty million people had been displaced throughout Europe, North Africa, and the Middle East.)

"UNRRA," Professor Bayet said, "is desperate to find people

to work with the refugees. It strikes me that you are exactly the kind of person they sorely need. You speak French, German, Polish, English, and Russian. Besides, you are familiar with the Jewish population of eastern Europe. You speak Yiddish, too, don't you?"

"Yes," I said.

"There are millions of people wandering throughout Germany—people who have survived concentration camps; others who were part of the German army or came to Germany to fight against the Russians. There are Russians whom the Germans had taken as prisoners. You have been through combat and have dealt with the very sorts of people who are now displaced. You are energetic, intelligent, mature, and accustomed to dealing with nearly impossible situations."

During the last months of the war—once it was clear that the Nazis would inevitably be defeated—I had given a lot of thought to what the world would be like once the conflict was over and what sorts of skills would be needed to get along in it. In retrospect, my curiosity about the Russian and English languages that led me to take those textbooks during our raid in Valence proved to be propitious. Who knew what direction the world would take: Soviet-style communism or American-style capitalism? It was obvious to everyone that the alliance between the United States and the Soviet Union would not survive the peace and that conflict between the two ideologies was inevitable. Being fluent in the main language of each of them might prove to be a practical matter, indeed a survival skill. I was not particularly interested in choosing sides between the

two ideologies. My political beliefs, which were well formed even at this stage of my life, were such that I knew I could never be fully satisfied with either system.

Furthermore, I had no clear idea where I would end up after the war. Would I rejoin my parents, if they were still alive and I could find them? Would I stay in France? Return to Danzig? Would I settle in Palestine, Russia, or the US? And how would I make a living? An academic career was possible but not assured.

It is true that I wanted eventually to have an academic career in literature, but I was not sure I was ready for full academic life. What Professor Bayet told me was intriguing. I asked him how I might contact UNRRA.

"They have an office in Paris, and I know that they are at this very moment energetically recruiting people to conduct their operations."

Of course I would have to clear this with Lieutenant Rogers. When I told him of my desire to join UNRRA, he pretended to disapprove and made up a completely nonsensical reason why I was needed in the 636th, but when he saw that I didn't see that he was joking, he smiled and said it was a great idea. There would be no problem having me discharged from the US Army.

The next day I reported to the European headquarters of UNRRA. I was ushered into an office and interviewed thoroughly. The official was apparently selecting from applicants those he thought appropriate for important positions, for I was then taken to the head of the European branch of UNRRA. After only a few minutes of talking to me, it was clear he was anxious to have me work for UNRRA, for, to my astonishment,

I was offered the position of "supply officer" on the spot. Without further ado I had a job and a means of supporting myself. I would work for UNRRA and continue my studies as time allowed. This seemed a perfect solution for me.

GRANVILLE

February 15–March 8, 1945

AFTER SEVERAL WEEKS in Paris, on February 15, 1945, I traveled west by rail to Granville, to be trained for my work at UNRRA. Granville was a small resort town on the English Channel, which, since the Allied invasion, had served as a port receiving supplies for the French and the Allied armies. I was given lodgings just outside of town in a place called Hôtel des Bains that was being renovated adjacent to a larger hotel already filled up with UNRRA trainees and where the training would take place. I had a room of my own on the second floor of Hôtel des Bains. I would not be sleeping in a tent, in a makeshift shed, or wrapped in a blanket under the stars. There was running water and, most importantly, a small reading desk, which I positioned by a window that overlooked the Channel and at which I often sat late into the evenings reading French novels.

During the day, UNRRA presented lectures and classes training new employees in the various skills that "logistics offi-

cers," as we were called, were required to possess. We would in fact be faced with a variety of tasks and duties. One of them was to coordinate the dozens of organizations dispensing supplies to displaced persons in need of them. Much of this training involved dealing with pamphlets containing hypothetical scenarios that were borrowed, I suspect, from foreign service officers' training manuals. I was already very familiar with them.

Several American officers lived on the first floor of the Hôtel des Bains, but I never spoke to them at any length. For the most part, my life consisted of classes during the day and sitting at my desk reading in the evenings. Most of the rooms on my floor were undergoing renovations, so there was always a good bit of construction noise in the daytime, but at night it was quiet.

On the evening of March 8, while reading in my chair by the window, I saw something very strange down on the water, maybe thirty yards below. Three small boats—no more than rubber dinghies—filled with five men apiece, rowed their way to the shore, dragged the boats onto the sand, and disappeared from view. Seconds later I heard the metallic sound of ladders smacking against the rock wall below the hotel.

What were they doing? I wondered. Was it some sort of Allied military operation, an exercise of some kind? My confusion was short-lived, for the men came popping out again from behind the wall. They gathered on the street in front of the hotel and rushed its main entrance.

Now I understood. I could see their German uniforms clearly and hear them yelling in German. It was a German raid, here in Granville!

I stood up from the desk. For a second, my mind came to a halt and I grew very alert. The mind works quickly when it must, or at least mine does! There weren't many alternatives. Boisterous commands and other noises were coming from below the window and from the first floor. Suddenly the firecracker sound of automatic gunfire drove home how real and dangerous the situation was.

What to do. I had three choices, as anyone *would* have in that situation. I could run, I could fight, I could hide. The first two options were easy to rule out. There was nowhere to run to, and it was unlikely that jumping out of the hotel window would do me much good. I would probably break my leg, get shot, or both. Fighting was not an option. I had no gun. I had to find a place to hide.

Down on the floor below they were kicking in the doors, probably rounding up American officers. A few shots from a revolver, then return submachine-gun fire. It wouldn't be long before they made it upstairs, I thought.

My own room was not a suitable hiding place. The door could not be barred, and there was no place within my room to conceal myself. I had the presence of mind to unscrew the lightbulbs and make my bed look like it hadn't been slept in, so they wouldn't think its occupant was hiding somewhere on this floor. Should I run up onto the roof? I'd be an easy target. When I first came to the hotel, my curiosity had led me to explore the unoccupied floor above. I knew there were several rooms there being used for storage. I could hide in one of them if I could find one unlocked. I scampered up the stairs without

making a sound. The first door I tried opened easily. Haphazardly stacked furniture filled the room. Propped up against the far wall I saw two mattresses with just enough space between their bottoms and the wall for me to crawl into—a crawl space if you will. I made my way through the stacked sofas, armoires, tables, and desk chairs to get to the crawl space, dropped down on my knees, and pushed my way as deep behind the mattresses as I could and waited. How absurd! After all I had been through, that I might die hiding under a mattress!

The Germans worked their way up to the third floor. They started at the far end, methodically kicking open the doors one after the other, door by door, getting closer. Two doors away—one door—MY door! I held my breath. A flashlight scanned the room as they examined the scattered furniture. It seemed unlikely that they would take apart the knot of stored furniture to get to the mattresses. "No one here," one said to the other, and they just moved on.

I stayed hidden for perhaps half an hour, though I don't believe they were on the third floor for more than fifteen minutes.

What was going on? It turned out that the Germans had come to the hotel to kidnap officers as part of a much larger raid that was being carried out in the town of Granville, along the harbor, and in a POW camp not far away. The raid was perhaps one of the Germans' last successful military actions of the war. But it would be eight weeks before I understood the full story of that night's events. In essence, it was as follows.

Two and a half months earlier, in December 1944, four German paratroopers and a naval cadet had escaped from the

American-run POW camp in the hills outside of Granville. They slipped into the harbor, stealing an American landing craft, and found their way (using a compass and a hand-drawn map) back to the Channel Islands, which had been held by the Germans since the invasion of France. On the islands, the escaped prisoners were hailed as heroes by the twenty-five thousand Wehrmacht troops still stationed there.

Unable to get food and fuel from the mainland since the landing at Normandy, these men were hungry, cold, and demoralized. Using information provided by the escapees, the German garrison commander planned a raid to obtain coal and food in Granville. In February, bad weather had turned back the Germans. But the first week in March, a Frenchwoman who worked at the Hôtel des Bains (and who was a collaborator) managed to get word to the islands' garrison that an unusually large contingent of Allied officers was staying at her hotel, awaiting the arrival of several ships loaded with coal and other supplies. The German commander decided to make a second attempt.

On March 8, as midnight approached, a flotilla of three speedboats, six minesweepers, three barges carrying 88 millimeter cannons, and a seagoing tug took off from the Channel Islands and headed through the Gulf of Saint-Malo toward Granville. The boats carried six hundred men, comprising teams to destroy port installations, to blow up vessels, dynamite the radar station, steal coal and food supplies, and free the remaining German prisoners in the POW camp.

The speedboats dispatched fifteen infantry toward the

Hôtel des Bains. Their goal was to prevent US commanders from getting down to the harbor in time to direct Granville's defense. The inflatable dinghies that I saw had been aboard the speedboats.

After landing, the Germans mined the harbor and badly damaged three British freighters and one Norwegian merchantman. They captured a ship with 112 tons of coal, freed sixty-seven POWs, and took thirty-nine Americans prisoner.

The Allies reported none dead but thirty wounded in the attack; the Germans, five wounded and one missing. Fortunately, none of the UNRRA trainees living in the other hotel were hurt, since the Germans didn't attack it. They were only interested in the Hôtel des Bains and the American officers stationed there. Within a week, we resumed our training.

My hometown of Danzig had been the scene of the first battle of the war. And now I had been witness to what was probably the last successful German operation.

UNRRA

April 1945–October 1945

O N MARCH 22, the US Army crossed the Rhine between Mainz and Mannheim. During the next six weeks, the Third Reich would be vanquished, though devastating bombings that would add millions to the lists of displaced Germans

would continue to the end, when the Herculean task of helping millions of people put together their shattered lives would begin.

I was assigned to UNRRA's office in Darmstadt, Germany, in early April, two weeks after the American Fourth Armored Division captured the city. The war went on until May 7, 1945, when German delegates signed the surrender document in Reims. On May 8th, the Third Reich ceased to exist as a diplomatic entity; there was no longer any central government or authority capable of assuming responsibility for the reconstruction of the German towns and cities and for the maintenance of order.

Germany was now subject to the administration of the armies of each of the Allied governments: British, French, American, Russian. Each country was responsible for a zone: Britain for the north, France the south and the west, America the center (where Darmstadt was situated), and Russia the east. The governments of the Allied countries had assumed supremacy over every German state, municipality, and other local authority. Since there was no German authority in place, practical responsibility for assuming these powers fell upon the military governments assigned to each region.

In view of the thorough penetration of every single function of government, economy, and society by the Nazis, restoring democratic rule to Germany was a formidable challenge. For twelve years the Nazis had applied the principle of *Gleichschaltung* ("Forced synchronization") in which all aspects of life—familial, communal, professional, religious, and governmental—fell under a centralized, pyramidal system of control and coercion.

The Nazi regime sought submission to the *Führerprinzip*—the "leader principle"—that is, absolute loyalty to Hitler. Children were taught to honor Hitler before their parents. The Reich co-opted clerical, educational, and professional organizations, turning them into adjuncts to the Nazi Party.

Though membership in the party was not compulsory in the beginning, it became increasingly indispensable for advancement in any profession. Industrialists were able to circumvent party membership but only by supplying financial or material support. Everyone was being absorbed by functions within the party hierarchy, which, as in Ionesco's *Rhinoceros*, grew and grew and grew, leaving little outside its own being. One was either in the party or suspected of being an enemy of the state and therefore in mortal jeopardy, at least potentially.

The consequence was that people belonged to the Nazi Party for a great variety of reasons: some were cynical and self-serving, some were professionals with technical or bureaucratic expertise, and of course some were idealistic, or frankly fanatical, Nazi true believers.

For these reasons, the reconstruction of Germany was not going to be limited to replacing institutional structures and manning them; it would involve a transformation from the ground up of how to think about public administration. It involved a full-scale conversion to the principles of democracy.

All this was very exciting to me. I felt I was at the grass roots of reconstructing something that was more than German public administration—that I would be in a position to actively help reroute the circuitry of postwar German thinking.

ONCE DARMSTADT HAD been liberated (in early April), I and three others who would be part of the UNRRA team in Darmstadt drove there from Granville, a journey, including crossing France, of about 460 miles. The drive through the German countryside, through the towns and cities that had just been liberated, was shocking to me. There was evidence of the bombing of Germany. For the past three years the Allied air force had systematically bombed industrial plants and cities all over the Reich, reducing much of urban Germany to rubble. There were displaced people everywhere. At one point we stopped along the road to ask directions from a group of young German soldiers, in uniform but unarmed, apparently plodding along on their way home. The towns and cities were all in ruins. People lived in roofless, windowless apartments and in cold cellars. I remember particularly the devastation of Cologne and Frankfurt. Only women and old men were available for doing the work of making their towns livable again. The young men for the most part had either been killed as soldiers or were wandering through Europe trying to get back home. The women and old men were picking up bricks from bombed-out buildings that lay all over everything including the thoroughfares, and lining them up in neat piles by the roadsides so that cars could use the roads again. Wherever we went white flags hung from windows—the same windows that had only recently proudly draped flags with swastikas.

Darmstadt was no exception to the ruin visited upon German cities. The previous September, the British Royal Air Force had dropped thousands of incendiary and explosive blast bombs on

it, setting off a Dresden-like firestorm that killed eleven thousand people and left more than sixty thousand homeless. Of course from my trainee's perspective, it was an extraordinary time to be in Darmstadt. The Nazis had just been defeated, but civil life had to go on.

The questions seemed endless: Who was to become the mayor? Who the head of the police? Who would shelter and feed the massive numbers of homeless and displaced people?

During the final weeks of the Third Reich, many civilians, governmental officials, and military personnel throughout Nazi Germany committed suicide, most commonly by consuming cyanide capsules. One evening in April 1945, members of the Hitler Youth distributed cyanide pills to its members during the last Nazi-era concert of the Berlin Philharmonic.

Many of the people who were still in a position to hold administrative office were Nazis who had not committed suicide. They certainly couldn't be trusted with the power to build a democratic Germany.

UNRRA TEAM 9, to which I belonged, consisted of a deputy director, medical officer, two supply officers, three drivers, and a warehouse officer. I was one of the supply officers. We were responsible for taking care of seventeen thousand displaced persons (DPs), among them Poles, Latvians, Lithuanians, Estonians, Yugoslavs, Jews, Russians, and Ukrainians. Most of the DPs had been in labor, POW, and concentration camps. They were traumatized, malnourished, and in poor health. They longed (more than anything else) to be reunited with their

families. They faced an uncertain future. I had expected to be placed at a DP camp for Jews, but there were no DP camps for Jews as such.

For many DPs the end of the war was not the end of suffering. UNRRA organized the DPs into camps by nationality—Poles with Poles, Russians with Russians, Germans with Germans, and so on. But the system was far from ideal. Too often, Jews found themselves in a German DP camp with Nazis, or in a Polish DP camp surrounded by violent anti-Semites. In the same camp there would be Russians who wanted to be repatriated, together with Russians whose greatest fear was to be sent back to Russia where they'd be shipped off to a labor camp in the Gulag. I was brought to Darmstadt because there were eleven thousand Russians in the Russian DP camp there and I spoke Russian. My team, among other tasks, supplied the Russian DP camp.

The general idea was to repatriate Russians to Russia, Ukrainians to the Ukraine, and so forth; but there were many who did not want to return to their original countries. Russians who had opposed the Soviet regime and fought for the Nazis faced probable execution if sent back to Russia. As for Polish Jews who had survived the concentration camps—where would they go? The walled ghettos no longer existed, the towns where they had lived were destroyed, their property had long ago been confiscated. Of the hundreds of thousands of Jews some were Russians, some Poles, some Germans. As supplies from the Red Cross grew scanty, the military authorities were less and less willing to help DPs who refused repatriation. UNRRA was in the middle of these difficult problems.

In the Russian camp, there were Jews who, probably because of my name, found their way to my office looking for help. They had no homes to return to, and life in the camp was in many ways intolerable. UNRRA was trying to locate their surviving relatives, but often not successfully. In many ways, except for the fact that I had a job, my situation was no different from theirs. Where was my family? What was my homeland? Romania? Palestine? I could not help myself, so what could I do for them? Often, nothing at all. But I did have significant work in the DP camp and I did what I could.

As one of the two supply officers, I was in charge of a large warehouse full of shoes, clothing, blankets, toilet paper, medical supplies, and food. In the morning I'd meet with leaders of the various DP camps, learn who needed what, and figure out how and when to deliver the supplies to them. I'd make arrangements for the local bakeries to bake and deliver fresh bread to the camps.

Besides these duties I served as UNRRA's liaison with the American Office of Military Government in Darmstadt. It was in this role that I became deeply involved in German reconstruction.

In August 1945, the Americans issued a directive that established democratic principles to be implemented pertinent to all political activities on the county level. The many political parties of prewar Germany were putting themselves back together. On the left, Communists and Social Democrats were resurrecting their local units. At the center and to the right, the Christian Democratic Union and the Liberal Party were

reestablishing their organizations. It was hoped that the local elections would give the Germans an opportunity to learn democratic principles before elections in larger political units would be undertaken.

The Americans had trained a total of three thousand US Army personnel in the work of administering the military governments throughout the American Zone. A team of these people were sent to each location. Often they were bewildered by the human and administrative chaos in the places over which they were given jurisdiction. In Darmstadt, I became useful beyond my work with UNRRA because it was easy for me to have direct contact with the people the Americans were trying to organize, and I could speak both German and English.

This work for the Americans was the most interesting work I did during these months. I helped them communicate with the Germans and translated their directives into German so that the local officials could understand them. But my work went beyond translations. Before elections could be organized, administrative positions had to be filled, and it was officials in the American Military Government office who had to choose citizens to fill them. There were plenty of people in the counties out of work at the end of the war competent for those positions, but the problem was that many of them had been local Nazi officials; others were Nazi sympathizers with various degrees of commitment. It was necessary to weed out from these people those who were genuinely Nazi partisans from those who just occupied bureaucratic positions without necessarily

holding National Socialist views. The process became known as "denazification."

Since the Americans who were brought in didn't know how to distinguish between Nazis and non-Nazis, they had to rely on hearsay among the local population. For instance, at one point, the head of the American Office of Military Government had to appoint a mayor for Darmstadt. He consulted with a local pastor, and the pastor recommended someone, who, after he became mayor, turned out to be a Nazi. Once established as mayor, he appointed an ex-Nazi as chief of police, and so on down the chain. It was imperative that real Nazis not be allowed back into power in such a fashion. In this case, once it became apparent what was happening, the Military Government office head dismissed the mayor. But the danger of such things was always there. He frequently consulted me to figure out if a given person was suitable for office.

At the same time there was a real shortage of people to fill administrative positions. Mayors and county executives were sometimes selected from lists drawn up by priests, school teachers, and former members of the SPD—the Social Democratic Party of Germany—an important party before the war that had quickly put itself back together. Candidates also were found, as I mentioned, through hearsay. I myself was involved in the selection of more than one of them.

As a supply officer in UNRRA, I had to make sure that a large baking factory in Darmstadt would supply the camps with bread. As I went to negotiate with them, one day I met a young German secretary and we became friends, because,

among other reasons, I did not hold the view, current among many of the conquering Allies, that the German people collectively should be punished for their guilt during the war. Not every German was a Nazi, not everyone was an opportunist or collaborator, not everyone turned a blind eye to what was going on. If in fact every German was a Nazi, the horrendously repressive tactics the regime deployed upon the German people themselves would have been unnecessary. But they had been necessary. To treat every German as a Nazi and to punish the Germans en masse would have been no more justified than any other form of generalized condemnation.

The secretary I met had been eight years old when the Nazis came to power, she told me, and her father, who was a Social Democrat, had not joined the Nazi Party, though he was left alone by them. She said she had wanted to join the BDM (Bund Deutsche Madchen)—the Nazi organization for young girls parallel to the Hitler Youth, but her father wouldn't let her join. Because he had been part of the SPD, I was able to get him on the list of possible officials.

In any case, it was clear that hearsay and recommendations were far from foolproof methods for recruitment. Consequently, every applicant for an administrative position— however they had been selected to apply—had to fill out a *fragebogen*—a very detailed questionnaire revealing everything about their life. If someone had been a member of the Nazi Party, that did not automatically disqualify them from holding public office. Five categories were established: "major offenders," "offenders," "lesser offenders," "followers," and "exoner-

ated persons." Pursuing denazification too scrupulously would make it impossible to create a functioning, economically efficient democratic society in Germany. Enforcing the strictest sanctions against lesser offenders would prevent too many talented people from participating in the reconstruction process. Still, *real* Nazis had to be kept out.

This is where I came in. I was used not only to translate the questionnaires but to interpret them. As a matter of fact, my denazification work eventually turned out to be pertinent to the Nuremberg Trials, since I was not only eliminating Nazis from further public office, but beginning the process of identifying those who had been the most egregious perpetrators of Nazi crimes.

By the autumn of 1945, I had become aware that the policy of denazification was taking a back seat to the necessity of maintaining law and order. There were just not enough people around whose anti-Nazi credentials could be verified. But also the Americans had begun to realize that they had other uses for ex-Nazis than just filling administrator positions. There were Nazi scientists, for instance, whom the Americans very much wanted to employ during the postwar period. I learned much later that the CIA wished to deploy—and did deploy—Nazi intelligence operatives to root out Communists in America. What I learned of all this did not sit well with me; and besides, it was high time for me to attend to matters in my own life. I wanted to return to my literary studies at the Sorbonne, and I wanted to locate my parents, about whom up to this point I had heard nothing. I resigned from UNRRA toward the end of October.

ON APRIL 13, 1945, the Allies had liberated Belsen and Buchenwald and on April 25, Dachau. The accounts I heard firsthand from American liberators left me with little hope that I'd ever see my parents, my sister, my grandfather, or Uncle Martin again. As more information surfaced about the concentration camps, I became vividly aware of what would have been *my* fate if I hadn't escaped from Vénissieux.

On May 7, a week after Hitler committed suicide, the Allies accepted Germany's surrender. The war against the Nazis was over. I had witnessed the devastation of Germany firsthand and was horrified by the news from the liberated concentration camps; still, the resilience of the DPs heartened me. I marveled at how quickly they had built churches, synagogues, and schools in the UNRRA camps; how fiercely so many of them embraced life again. I will always remember the party on the seventh of May at the Soviet DP camp to celebrate the defeat of the Germans. They had a band, they were dancing, they were making toasts to victory, to Russo-American friendship, to the Russian army—each toast requiring a half glass of vodka downed in one gulp. To insulate the stomach against that many glasses of vodka, with each one you took a piece of herring, a pickle, or a chunk of boiled potato. You could not refuse to participate. I never drank so much vodka in my life.

My work with UNRRA must have been effective, for I received several letters of commendation from various officials under whom I worked.

In early June, Colonel Kompaniets, my main contact at the Russian camp, completed the arrangements to repatriate eleven

thousand Soviet DPs. He thanked me for my role in restoring their strength and health.

"For the hungry and poorly dressed citizens exhausted by the forced labor in the Nazi camp, the organization of normal and uninterrupted supplies, particularly food, has been of the utmost and decisive significance," he wrote in a letter thanking me. "The commanding staff of the repatriation station notes with gratification your personal and exceptionally caring attention to this matter."

In appreciation of my performance, Major Leon P. Ervin, the American Office of Military Government's man in charge of Darmstadt, wrote that he considered the job of supply officer "the most difficult in DP work." He noted my "unusual ability as an organizer and administrator," and how I was "reliable, trustworthy, and eager to accept additional responsibilities." As a displaced person myself, I felt both motivated to do this work and honored to receive this recognition.

TO AMERICA

October 1945–July 13, 1946

I RESIGNED FROM UNRRA on October 23, 1945, so that I could return to Paris and take final exams in the courses I had registered for at the Sorbonne. This had more or less always been my plan. The university didn't care if students who had been

part of the French Underground attended classes, only that we read the required books and passed the exams. I did and received my Licence Libre ès Lettres, the equivalent of a master's degree.

Not long after graduating, and while contemplating what my next step should be, I received a letter from Thomas Poitras, an American I had met before the war in a class at the Sorbonne. We had resumed our correspondence, which had been interrupted by the war, and he was now writing to say that he had been appointed chairman of the Language and Literature Department at the University of Dayton, Ohio. Under the "GI Bill," veterans were attending universities in great numbers. There was a demand for competent instructors, particularly in foreign languages. Professor Poitras remembered my ability to speak French and German fluently and knew of my familiarity with Russian and English, so he invited me to join his department.

There was still no news of my family and I assumed the worst.

In March of 1946, I went to the American consulate in Paris and applied for a visa. The consul said, "Come back in five years."

"Excuse me! Are you serious?"

"Certainly I am serious. You and a million other Europeans are trying to get into the US. Come back when the line is shorter!"

I wrote to Pete Rogers, who was now back in America, bringing him up-to-date on the invitation I had from the University of Dayton and of my difficulty in getting a visa. He advised me to go back to the consulate and show them my certificate from

the US War Department attesting that I had been attached to the 636th Tank Destroyer Battalion. I did, and it took virtually no time at all for me to get the visa I required.

I was able to get a cheap ticket on a "liberty ship." These were large vessels built by the US for delivering goods to Europe for UNRRA and other relief organizations to distribute, after which they would return to the US empty of their cargo, but sometimes they accepted ticketed passengers for the vessel's six passenger berths. After dropping off a load at the French port of Le Havre in Normandy, on July 13, 1946, my ship took their passengers aboard and we departed.

NOT LONG BEFORE I was to leave France, the American Red Cross had notified me that my parents and sister had survived the war and that they were living in Haifa, in the British Mandate of Palestine. When I heard this joyful news, I wanted to visit them right away. I wrote immediately to my father. My family of course wanted to see me, but he was worried that my traveling outside the US before I became a US citizen might put me at risk of once again being "a man without a country." He urged me to continue on to the US and to apply for citizenship as soon as possible. Once I had a passport I could visit them. I agreed to this, but that meant it would be another six years before I was actually reunited with my family.

THE TRIP TOOK two weeks. I had my own cabin and was free to wake up and go to bed as I pleased. In the mornings I'd go on deck to watch the flying fish, which were plentiful in the

part of the Atlantic we were sailing through. Then I'd go up-stairs and visit with the captain, a middle-aged navy officer with great seafaring stories.

I'll always remember my first sighting of land. It was a little before dawn, July 27, 1946, and suddenly I saw a chain of lights stretching like a string of pearls on the western side of Manhat-tan Island as we were approaching from the south. We were still a few miles from shore, but as the liberty ship approached New York, I could see that in fact the pearls were reflections of sunlight shining on the roofs of hundreds if not thousands of automobiles in fender-to-fender traffic, making their slow determined way down the West Side Highway of Manhattan. Americans on the road, and off to work, preparing to make the most of a new day.

EPILOGUE:
WHAT HAPPENED TO . . .

My Parents and My Sister, Lily

THE LAST TIME I had heard from my family was in the letter from my father in 1939 when he told me that they were in Romania on their way, they hoped, to Palestine. After that it became impossible even to write to them through my mother's relative in Philadelphia, though I tried, as I mentioned, until the war was over. From Romania my father, mother, and sister had traveled on a ship chartered by the Jewish Agency (the de facto government of the Jews in Palestine before the formation of the State of Israel) to sail by way of Turkey—a lot of the crew members were Turks—and to try to break the British blockade and reach Palestine but failed to do so.

During the war, Jews attempting to flee the Nazis were prevented from emigrating to Palestine by the British government, which in the MacDonald White Paper of 1939 established a blockade against any ships aiding them in doing so.

After the First World War and the dissolution of the Ottoman Empire, the Near East was a European satrap, essentially.

The White Paper was issued under the British government by Neville Chamberlain in response to the 1936–1938 Arab Revolt. It limited Jewish immigration to seventy-five thousand over the following five years. At the beginning of World War II, uprisings and threats of uprisings against British rule continued to spring up in many Arab countries. When Rommel was poised to capture the Suez Canal, there were Arabs who welcomed the Germans as if they were a liberating army. The British wanted to maintain their hold on Arab countries and were placating the Arab leaders by preventing a further influx from Europe— namely, the Jews.

The voyage that my parents hoped would take them to Palestine was one of more than one hundred such "illegal" voyages organized by the Jewish Agency and its unofficial army, to break the British blockade in the Mediterranean. When the ship was a mile offshore, a British destroyer intercepted it. My parents, my sister, and all the other Jewish passengers were herded onto another ship and taken through the Suez Canal to the island of Mauritius. This was a British colony twelve hundred miles off the southeastern coast of Africa, where Jews were held in an internment camp until sometime after the end of the war, when organized Jewish pressure forced the British government to end the blockade.

Living conditions in the camp were, of course, difficult, but the British did not ill-treat the prisoners or force labor upon them. Food and shelter were adequate, and charitable contributions from Jewish organizations made internment life somewhat more tolerable. The inmates set up schools, worked

crafts, and tried to go on with life. My parents wanted my sister (who was thirteen in 1940 when they arrived there) to learn French, which was not offered at the makeshift school. They found someone who had been a student of French literature at a Czech university to tutor her. In due course Lily and her tutor fell in love—a relationship that outlasted their internment. They were eventually married and raised a family in Palestine after the war.

Among the supplies provided by charitable organizations were more blankets than were needed, and, by good fortune, a simple pedal-driven sewing machine. One day, my mother, who was an able seamstress, fashioned a colorful hat out of a blanket to protect my father against the hot sun. It was permissible to leave the camp and wander about the local villages on the island, as long as one returned to the camp by a fixed curfew. On one such jaunt, my father and his colorful cap attracted the attention of some villagers, who offered to trade fruits and other goods for it. My father realized that if my mother were to make a supply of hats like it, he could continue to trade them for much-needed local products—mangoes and papayas, even eggs. So together my mother and father established a business based on barter, retrading what they acquired in the villages with other prisoners in the camp. In fact, this is how they paid for Lily's French lessons. Among the villages my father was known as "Jacoub la Casquette"—Jake the Hat! (Mauritius had originally been a French colony and the people spoke a *patois*.)

I finally became a US citizen in 1952, acquired my passport, and made arrangements to go to Israel. At my father's urging,

I included a stop in Helsinki, Finland, on my itinerary and bought tickets to see the XVth Summer Olympic Games, which for the first time featured competitors from the new nations: Israel, the People's Republic of China, and the Soviet Union.

There was a reason my father insisted on my attending the historic competition: in 1935, when I was fourteen, he had promised to take me to the 1936 Summer Olympics in Berlin, but we had been unable to attend.

In Helsinki, I was thrilled to watch two of my all-time favorite athletes—the Finnish long-distance runners Paavo Nurmi and Hannes Kolehmainen—light the Olympic flame. I also got to see Emil Zatopek, the great Czech runner, earn gold medals in the 5,000 meter, 10,000 meter, and marathon races.

From Helsinki, I took a boat to Copenhagen, trains to Paris and Marseille, then a boat to Naples, where I bought a large smoked ham and four Italian hard salamis—as per my father's request.

The night before our ship reached the port of Haifa, there was a party on board for young people like me who would be seeing the State of Israel for the first time. I was still sleeping off this gathering when the boat docked. I woke up and rushed to the railing of the boat. There was a man who looked vaguely familiar sitting by the gangplank, anxiously watching passengers as they disembarked. Memory does strange things over time. In the many years since I had seen my father, of course I had thought of him many times, but somehow the image I held in my mind of him was of what he looked like when I was a little boy. What I saw was a middle-aged man with graying

hair who sort of resembled my father! I looked hard at him and grew confident that it was he. I suddenly remembered something my sister and I used to do when one of us got separated from our parents: I whistled the refrain from the Free State of Danzig's national anthem! My father looked up and whistled back. I hurried from the ship. My mother, who got to the ship a few minutes later, broke down at the sight of her only son.

Lily was there too. And I must say it was startling to see her all grown up—she was now twenty-five years old! At dinner that first evening together, I didn't tell my parents about my guerrilla experiences, because they would have died a thousand deaths just thinking about the dangers I had faced. Instead, we talked about my being a professor, which they considered a very big deal—so much so that they never pushed me to leave the United States and my budding career and make *aliyah* to the Land of Israel, which would have entailed moving there and becoming an Israeli citizen. ("To make *aliyah*" means for a Jew of the diaspora to return to the Jewish "homeland.")

LIFE IN THOSE days was hard in Israel. There had been a massive wave of Jewish immigration not only from postwar Europe, but out of Arab countries, from which they were expelled after the creation of "the Jewish State." There was a shortage of housing and of food. Every two weeks, I sent my parents "care packages" from the United States, and occasionally hard-to-get appliances, such as a refrigerator and a stove.

Every other year I went back to Israel to spend a few weeks with them. My father liked me to accompany him on his daily

walk in the foothills overlooking Haifa. And it was hard for me to keep up with him: in his age group, he was Israel's national "competitive walking" champion.

On one visit I rode a Lambretta motor scooter all over Israel. Before I returned to the States, I gave it to my father as a gift. Later I found out he sold it as soon as I left—not because he didn't appreciate my gesture, but because he preferred to get around by public transportation and, of course, by walking. My very fit and competitive father would go swimming in the ocean for an hour each day, then play paddle tennis on the beach with younger men and boys—which is how he died at the age of seventy-four: from a massive heart attack, while playing paddleball on the beach. My mother said it was the perfect way for a man like my father to go. She died a year later from stomach cancer.

AS I WRITE, Lily is ninety-two years old and living in Tel Aviv. Her three children are in their sixties and seventies, with grown children and grandchildren of their own. Altogether, my sister is the progenitor of forty people and counting, which is a blessing given the fact that so many members of our family—sixty-four out of sixty-eight at the start of World War II—perished in the Shoah.

Elisabeth Schulist

DURING THE WAR it was impossible to be in touch with Elisabeth, and sadly she did not survive it. In 1945, when the Russians were moving into Germany, the Germans withdrew from

the territory surrounding Danzig, but they held Danzig itself as a well-fortified "porcupine position." Unwilling to leave an armed German fortification in their rear or to storm the well-defended city, they surrounded it with artillery and continued to shell it from without. Because Danzig is on the sea, the Germans were able to evacuate some of its citizens and many soldiers. One day in January of 1945 the "mobilized liner" *Wilhelm Gustloff* was mistakenly torpedoed by the Russians, killing some six hundred passengers, Elisabeth among them.

Szymszon Rozenberg (My Grandfather), Aunt Leah, and Her Husband, Moishe

BEFORE THE NAZIS conquered Poland in 1939, I received several letters from my grandfather. I missed, however, the last one, which is dated July 10, 1941. He didn't know where I was so he sent it to Philadelphia hoping that they would be able to forward it to me. I only saw it after the war. In it he wrote, "Please note my address. Do not send letters to where we lived before the war [in Mlawa], because they may not get to me." This letter is postmarked "Warsaw." My guess is that he, Leah, and her husband, Moishe Cytryn, had been forcibly moved to the Warsaw ghetto, the last stop on their way eventually to Auschwitz.

Martin Rosenberg

MY UNCLE MARTIN and I corresponded for a year after my visit with him in Berlin; then his postcards stopped coming. The

Gestapo arrested Martin on September 13, 1939, and sent him to Sachsenhausen concentration camp, along with seven hundred other Germans of Polish origin—both Jews and non-Jewish persons known for anti-Nazi activism. At Sachsenhausen, Martin organized a clandestine people's choir of twenty-five Jewish prisoners. With the help of non-Jewish inmates, his secret choir rehearsed and performed at the camp for three years. On October 21, 1942, Martin learned that Sachsenhausen's Jews were going to be sent to Auschwitz. He reacted to this news by writing the lyrics to "Judischer Todessang" ("Jewish Death Song"), which was composed in parallel to the verses of the Yiddish folk melody "Tsen Brider" ("Ten Brothers"). Each of the first nine verses speaks of the disappearance of one of the brothers until only one is left (something like the English "Ten Little Indians"). Between the verses, the narrator addresses himself to two itinerant Klezmer musicians—the sort that played in shtetls throughout eastern Europe. But here the narrator urges them to perform a funeral dirge for each of his brothers and ultimately himself. The song's refrain goes:

> *Yiddel with your fiddle*
> *Moishe with your bass*
> *Play a little song*
> *While they lead us to the gas.*

The last word in the original song in German is *gass* meaning "street," but is obviously a dark pun on "gas," which is the same in German as in English.

As in the song's haunting refrain, Martin and his choir died in the gas chambers of Auschwitz a few months later. Aleksander Kulisiewicz, a non-Jewish musician who survived Sachsenhausen, made it his task to get "Judischer Todessang" performed throughout the world.

Charles Levasseur

WHEN CHARLES AND I separated outside the Paris recruitment office, it didn't occur to me that it would be the last time we saw each other. The whirlwind of war was about to spin us in different directions. I am sad to say that I do not know what happened to him.

Miriam Davenport

IN APRIL 1941, following the annexation of Ljubljana by Italy, Miriam and her fiancé secretly married. Having acquired their visas, they sailed from Lisbon to the US on the Friday following Pearl Harbor.

After I came to America and was an associate professor at Dayton University (it must have been around 1950), I wrote to Miriam's alma mater, Smith College, and was able to locate her. I wrote her the following letter:

If you recall Marseille, France 1940/41, "Le Centre Americain de Secours" [the American Rescue Committee] with its assortment of sometimes odd, also original and lovable characters, Mary

Jayne Gold and her escapade with the "Legionnaire," then perhaps you might also remember me, a bewildered young chap who went by the nickname "Gussie" and who acted more or less as a valet a tout faire. Despite the confusion, those were very formative days and I have kept of them a very lasting impression; among them you always occupied a very central position, since it was partly to you that I survived in those trying days.

A week later I received this response from Miriam:

My Dear Dr. Rosenberg!

How very formal and improbable it seems to be addressing "Gussie" as a Herr Associate Professor Rosenberg! It was when I came to "Gussie" that I saw through your reincarnation and simply shrieked with joy! I remember a great deal about you—you were a symbol of sorts to me in those days. Everyone was moving Heaven and Earth to save famous men and antifascist intellectuals, etc. And there you were, a nice, intelligent youngster, with no family, no money, no influence, no hope, no fascinating past. I remember one evening [writer] Hans Sahl tried to tell you how much worse in danger he was than you. And I recall telling Sahl (to his horror!) that he was a helluva lot better off than you, since many Americans would do everything possible for him, but that you were just another kid, a Jew, a "nice boy, but there's nothing we can do" (as Fry said to me when I pressed him to help you).

It's strange how that brief period in Marseille looms so large in retrospect. We are "a people apart" somehow. It was a curious nightmare—it seemed awful at the time—but it must have been

happy too. We all had a purpose, a highly moral task to perform. And we and our friends had to survive no matter how. We were unencumbered by baggage and freed of all pretense of middle-class respectability. All joy was intense because of imminent danger. Will our wits and vision ever be so sharp again? I wonder.

Miriam married three times and died in September 1999.

Mary Jayne Gold

AFTER OUR EXCHANGE of letters, Miriam told Mary Jayne Gold that she had been in touch with me. Mary Jayne wrote me, but we never got together until 1966 when she organized a reunion of the Fry group (see below). Mary Jayne earned a measure of celebrity in 1980 when her memoir about her year with Fry—and Killer—was published. She called it *Crossroads Marseille 1940*. She died at her home near Saint-Tropez on the Riviera in 1997 at the age of eighty-eight.

Raymond "Killer" Couraud

IN 1966, MARY Jayne Gold staged a twenty-fifth anniversary reunion for several members of the Fry group at her luxurious apartment on Manhattan's Upper East Side. It was the first time the few of us who attended had been together since the war. We exchanged souvenirs and remembrances and gossiped about the famous people we had known and what had become of them. Of course everyone pressed Mary Jayne about "Killer"

and his gangster friends. After he left Marseille (and Mary Jayne), Raymond "Killer" Couraud became a highly decorated member of the British army. He was wounded in both legs while participating in a commando raid on Saint-Nazaire; and before D-day, he put together a six-man assassination unit that targeted high-ranking Nazis. By then, he had long left behind both his Legionnaire past (he deserted not long after I met him) and his days with the Corsican mob, through which he helped Fry contact the mafioso don. In England, he re-created himself as "Jack William Raymond Lee" and was eventually awarded the Victoria Cross for gallantry in battle.

Walter Mehring

ON FEBRUARY 3, 1941, Mehring was able to leave France for Martinique and go from there, by way of Miami, to Hollywood, where he married the artist Mari-Paule Tessier and worked as an MGM scriptwriter. His application for US citizenship was denied because of his known anarchist sympathies. In 1953, he returned to Europe, lived in Ancona, Switzerland, and earned his living by giving lectures and attending conferences. He died in Zurich on October 3, 1981.

Varian Fry

IMMEDIATELY AFTER HIS expulsion from France in 1941, the dissolution of the ERC, and his return to the US, the life of Fry, which was considered by many to have been heroic, fell apart.

After the war, he wrote a self-congratulatory memoir of his time in France, titled *Surrender on Demand*, after the anxiety-provoking "Article 19" of the armistice agreement. It didn't sell particularly well. Over the next two decades he tried to become an editor, a businessman, and a high school teacher. He had several marriages and three children. For the most part he was a forgotten man. He was not remembered fondly by those he worked with, and the famous clients who had put their fate in his hands in Marseille had no time for him.

Eventually, Fry did get some recognition. In 1966, the French government awarded him the Croix Chevalier de le Légion d'Honneur for his contributions to freedom. He died six months later at his home in Connecticut at the age of fifty-nine.

Though the ERC did help many intellectuals and artists to find their way out of France, in my opinion Fry himself does not deserve very much credit for accomplishing this. He was, however, in charge of it, and his reputation as "the American Schindler" grew in 1994 when he became the first American to be recognized as one of the "Righteous Among the Nations," an honorific title given by the State of Israel to non-Jews who risked their lives to save Jews during the Holocaust.

Jean Gemähling

FOR HIS SERVICES in the Underground army, in 1946 Jean was given the rank of lieutenant colonel in the Free French Army (the term for the Gaullist forces that was then the army of

France). He became the founder and director of the *Bilans Hebdomadaire*—a weekly publication summarizing economic and political issues. In 1955, he was appointed director of the Atomic Energy Commission of France. He retired in 1975 and died on May 2, 2003. He was made Commandeur de la Légion d'Honneur, Companion de la Liberation; he also was given La Croix de Guerre avec Palmes (1939–45).

Victor Brauner

BRAUNER NEVER LEFT France but managed to survive hiding out in a small village on the outskirts of the town of Gap. He died in Paris in 1966.

Daniel Bénédite

AFTER FRY LEFT and the ERC dissolved, Daniel continued to work for the Underground by opening a communal wood-cutting business preparing charcoal with a camp in Var Province, which also served as a refuge for people hiding from the Nazis. He survived the war doing so and remained a somewhat covert socialist revolutionary militant until his death in 1990 at the age of seventy-eight.

Heinrich Mann

HEINRICH MANN AND his wife arrived in the US on October 13, 1940, and traveled to Santa Monica, California, because Warner

Brothers offered him work. In 1949, the Deutsche Democratic Republic (East Germany) named him president of the Academy of the Arts in East Berlin. Just as he was about to return to Germany, he died in his home in Santa Monica. He was seventy-nine.

Nelly (Kroger) Mann

NELLY'S AMIABLE BOTTLE of brandy on the trek over the Pyrenees was in fact an ominous indication: she was an alcoholic. Held responsible for a fatal DWI automobile accident in 1944, on December 17 of that year she took her own life.

Franz Werfel

AFTER ARRIVING SAFELY in America, Werfel was able, I don't know why, to become a citizen in 1941. He was suffering from angina pectoris but continued to write. His play *Me and the Colonel* was produced on Broadway under the title *Jacobowsky and the Colonel*. He had to rewrite the script three times to satisfy the producers. The play concerned the cooperation of a Jew, with his ingenuity, and a Polish officer, with his derring-do and courage, to get out of France. He died in August 1945.

Alma-Mahler-Gropius-Werfel

THE WIDOW OF both Gustav Mahler and Walter Gropius, but famous as a socialite in her own right, returned to Vienna in 1947 for a short time, but only to apply for "restitution" of property

appropriated by the Nazis. In 1951, she moved from LA to New York, where she lived a culturally elevated and eccentric life. According to her friends, she rose every day at 6:00 A.M. and indulged herself with sipping champagne and playing for an hour on a harpsichord. Many of her friends stopped seeing her when her memoirs revealed that she was quite anti-Semitic in spite of her marriages to famous Jews. She died in 1964 in New York.

Victor Serge

WHILE SERGE WAS in Paris, before the German invasion of France, he worked as a translator for Trotsky, but had refused to join Trotsky's Fourth International. He was POUM's correspondent in Paris before coming to Marseille. He boarded the ship bound for Martinique with Breton and the others and found his way to Mexico, where he died of a heart attack in a taxi in 1947. Since he had no nationality, no Mexican cemetery could legally take his body, so he was buried as a Spanish Republican.

Both before and after he left Europe, Serge wrote prolifically and tellingly about his times—novels, short stories, and biographies of Lenin, Stalin, and Trotsky.

Anna Sayn Mari Elisebeth

ANNA WAS BORN in 1892. I have her identity card that interestingly identifies her "profession" not as a farmer but "cultivateur." Though I returned briefly to Montmeyran when I joined

the 636th Tank Destroyer Battalion, I was unable to get to Anna and her farm. Some years ago I visited her tomb in the cemetery of Montmeyran. She had died in 1969.

Lieutenant Pete Rogers

PERHAPS THE CLOSEST friendship I formed during the war was with Pete. We remained in touch until he died in 1991. He served in the infantry of the American army from 1940 until 1948, fighting in six campaigns in Europe and Africa, then in Korea as a member of the Missouri National Guard, where he became a lieutenant colonel. He married a Polish woman who had been in a DP camp and settled down in Kansas City, where he became in turn executive secretary to the mayor, acting city manager, a city council representative, and a commissioner on the Clay County Board of Elections. In 1986, he gave me his copy of *Search, Strike, and Destroy, a History of the 636th Tank Destroyer Battalion*. The inscription he wrote on the inside cover means a lot to me: "To my very dear friend Gus, now Dr. Rosenberg, who I held in the highest esteem, a brave intrepid soldier of the Maquis and American Army and my comrade in arms. I am honored to call him and be called by him friend."

Others

THERE WERE OTHERS who played important roles in my story, but about whom I know nothing, for the simple reason that working in the Underground involved our knowing as little

as possible about each other. I don't even know the last names of Robert, who trained me for undercover work, and Aristide, who relayed information to me at Anna's farm. I do not know anything about the nurse at the hospital in Lyon or the priest from the Amitié Chrétienne who brought me clothes and a bicycle to make my escape, or again, the woman in the Citroën who drove me to Montmeyran.

Justus Rosenberg

I WILL NOT write here of my extensive travels in the Soviet Union and its satellites during the Cold War, in Cuba just after the revolution, in the People's Republic of China, of my visit with the Sandinistas in Nicaragua, or of the interesting material I found about me in my FBI file under the Freedom of Information Act. Nor will I explore my years of teaching at Swarthmore, the New School for Social Research, and Bard College. I hope to deal with all these things in future memoirs.

Live long enough and people will start to write about you. In the spring of 2016, a reporter named Sarah Wildman profiled me for the *New York Times*; suddenly, as the generations of the Holocaust and World War II were dying out, I became a "person of interest" to the world. And then, to my complete surprise, I learned that I had been selected to be promoted to the rank of Commandeur de la Légion d'Honneur, France's highest honor. Since 1802, when Napoleon Bonaparte created the Légion d'Honneur, only thirty-two hundred people have achieved that rank, including just a handful of Americans—though among

them US Army generals George Patton and Billy Mitchell, and the First Lady and humanitarian Eleanor Roosevelt. I felt honored and humbled to find myself in their company.

When I heard that the ceremony was to be held at the French consulate in New York City, it struck me that "consulates" had played crucial if often frustrating roles in my life. Eighty years earlier I had gone to the French consulate in Danzig to get my visa to study in France, and more than a decade after that I had picked up my preferential visa to the United States at the American embassy in Paris. And of course relationships with consulates—or their inaccessibility—had a lot to do with helping Fry's "celebrity refugees" get out of France. In that sense, receiving this honor and in such a context seemed an ultimate irony: after the hundreds of hours I had spent anxiously waiting for word of visas and passports at consulates in Paris, Toulouse, and Marseille, now Gérard Araud, the French ambassador to the United States, would be traveling from Washington, DC, to bestow his nation's highest honor on me.

On March 30, 2017, across from Central Park and the Metropolitan Museum of Art, in an elegant high-ceilinged room with a crystal chandelier and nineteenth-century paintings on the wall, one hundred of my colleagues, former students, and journalists from around the world sat watching as Ambassador Araud stood face-to-face with me and said:

"The Legion of Honor is France's highest honor and one of the most coveted in the world. And the President of France has decided to promote you, dear Justus, to the coveted but rarely attained rank of Commandeur, illustrating France's deep

gratitude for your exceptional bravery and sacrifice during World War II, your remarkable career as an academic, and your selfless engagement against anti-Semitism and intolerance." (The latter refers to the work of the Justus and Karin Rosenberg Foundation, which my wife and I started in 2015.)

As the ambassador went on to list my achievements, my mind flashed back to events that had occurred seventy-five years before—my parents standing on the platform at the Danzig railway station, waving goodbye to me; Hitler exhorting his followers in Berlin; my last night onstage at the theater in Paris, as I pointed, in my captain's costume, to Liverpool. And there was the long line of refugees fleeing Paris; my first meetings with Miriam and Fry.

As the ambassador went on, saying words I didn't hear, more images floated by: the surrealists and their "Exquisite Cadavers" on a Sunday afternoon at Villa Air-Bel; then in rapid succession: bullets careening down a hotel hallway; Darmstadt in ruins; a night of vodka-fueled revelry with a Russian colonel, and an endless line of cars at the dawn of a new day.

The ambassador finished his speech and placed the medal, on a red sash, around my neck, and now it was my turn to thank France—not for the medal, I said, but for how that nation had inculcated the principles of liberté, égalité, and fraternité in me as a young man. "These are indeed the three principles I kept with me and brought to the United Sates," I said. "Along with *tikkun olam* [Hebrew for "repair the world"], they have been my guiding principles."

MINE HAS BEEN a life rich in incident, and not an incidental life. For that I am grateful. Every new semester, a student feels emboldened to ask, "Why do you think that you survived when so many others perished, Professor Rosenberg?"

A Catholic priest at the University of Dayton once told me, "It's obvious that God had his finger on you. He wanted you for a specific purpose."

"It's not obvious to me," I told the press.

My experiences during the war did absolutely nothing to diminish my lifelong ambivalence toward God; nor did the ten years I taught at a Marianist university whose motto was *Pro Deo et Patria*, Latin for "For God and Country."

On one occasion the president of the university invited me to attend a Dayton "Flyers" basketball game with him. As the game proceeded, and the players on both sides made the sign of the cross before they took their foul shots, I slyly looked at my companion and asked, "On whose side is God today?" The good father did not hazard an answer.

Having just survived the Holocaust, I had absolutely no faith in the existence of an all-knowing and all-loving God, nor did I have any sense that divine providence had a secret if benevolent plan for my or any of our existences.

So how do we explain the fact that this child of Jewish parents in Danzig survived Hitler and concentration camps, bullet wounds and land-mine blasts, and then found his way from those stateless, uncertain years in war-torn Europe to this long and purposeful life in America?

Certainly luck played a role, as did my ability to detect danger,

the skills I learned in my training as a guerrilla, and the appearance, at crucial moments, of people like the nurse in the infirmary and Anna Sayn, who were inclined to hide, feed, and help me, often at great danger to themselves.

Imagine if I had looked stereotypically Jewish instead of Aryan—or my real age, instead of the fourteen-year-old people consistently took me for. Would I have been able to spy in plain sight on the Nazis? If I hadn't known German, French, Polish, Russian, and English—a consequence of being born to parents who valued education above all else—would Jean Gemähling, the 636th Tank Destroyer Battalion, and UNRRA been interested in availing themselves of my services?

Of course not.

Time and time again, there was what I call "a confluence of circumstances" that presented me with a window of opportunity, or a moment to be seized. At each juncture, a combination of factors enabled me to seize that moment or slip through that window. That's my best explanation for how I survived.

At the Legion of Honour ceremony, I was thinking of a brave young woman who did not survive the war: Hannah Senesh, a Hungarian-born poet who lived in Palestine and had parachuted into Yugoslavia to assist in the rescue of Hungarian Jews destined for Auschwitz. The Nazis arrested Senesh at the border, then imprisoned and tortured her. In "Ashrei Hagafrur," the last poem she composed before she was executed, Senesh wrote: "Blessed be the heart that has the strength to stop beating for honor's sake." As Senesh at her own death knew, a hero must be willing to sacrifice his life for something greater.

But I was also thinking of something Bertolt Brecht wrote in one of his plays: "Pity the nation that is in need of great heroes." Senesh was a hero, and so were thousands of other people during the war. But why? Because the times required heroes. As long as there is hatred, intolerance, and hunger for power in the world, there will be heroes. We should dream of the day when they will no longer be needed.

Tikkun olam is the idea that Jews bear responsibility not only for their own moral, spiritual, and material welfare, but also for the welfare of society at large. And, in this way, we can contribute to repairing the world. For me, teaching literature is a vehicle for *tikkun olam*. Within literature you can express and explore any idea, even ones that may be unpopular or considered anti-American, or, yes, anti-Semitic. Because those ideas are in a book you can discuss them—and hold them, along with your own beliefs, up to the light. I believe that it is wrong to censor ideas on college campuses, even the ones most people find offensive; doing so fuels ignorance, prejudice, and strife, and makes destructive ideas even more powerful than they really are.

We need to teach young people about the Holocaust—both the Jewish one and other "holocausts" in history and around the world—so that future generations will know where humankind's worst instincts and political ideologies can lead.

We need to champion the notion that all human beings are equal and deserve to be treated as such.

We need to be alert to the dangers and nip them in the bud.

ACKNOWLEDGMENTS

I WANT TO acknowledge Brandon Hicks, whose senior project I directed at Bard College in 1995, with whom I have remained friends over the years, and whose challenging questions helped me focus these memories; and Charles Stein, who assisted me in organizing my notes and bringing them to a proper conclusion. I also want to thank my principal editor, Peter Hubbard, for his kindness, his professionalism, and his intelligent supervision of my project from its inception.

INDEX